The Drawings of BRUNO SCHULZ

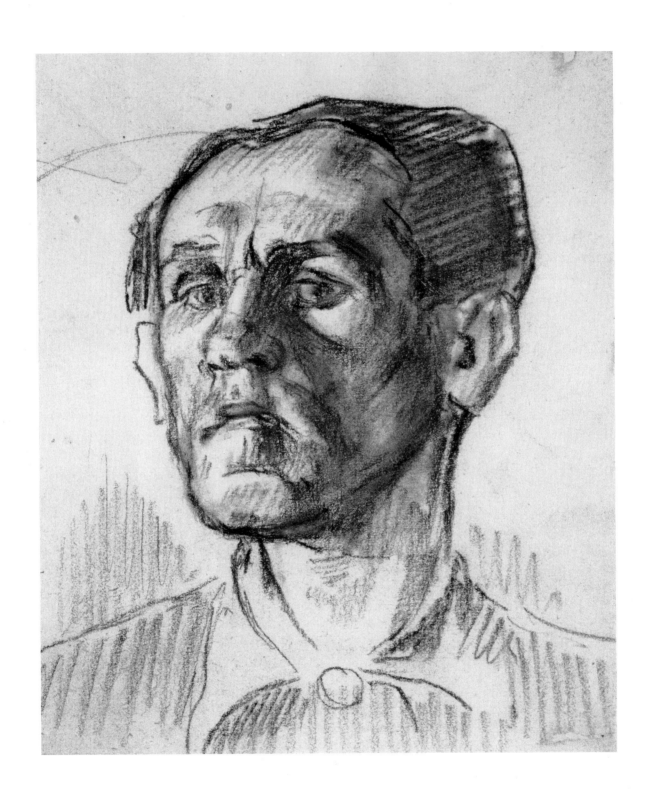

The Drawings of BRUNO SCHULZ

Edited and with an Introduction by Jerzy Ficowski

With an Essay by Ewa Kuryluk

Photographs by Adam Kaczkowski

Northwestern University Press Evanston, Illinois

Design by William A. Seabright, William A. Seabright Graphic Design

Northwestern University Press
Evanston, Illinois 60201

Library of Congress Cataloging-in-Publication Data

Schulz, Bruno. 1892–1942.
 The drawings of Bruno Schulz / edited and with an introduction by Jerzy Ficowski ;
with an essay by Ewa Kuryluk ; [photographs by Adam Kaczkowski].
 p. cm.
 ISBN 0-8101-0964-6 (lib. bdg.). — ISBN 0-8101-0965-4 (pbk.)
 1. Schulz, Bruno, 1892–1942—Catalogs. 2. Erotic drawing—Poland—
 -Catalogs. I. Ficowski, Jerzy. II. Kuryluk, Ewa 1946–
NC312.P63S382 1990
741.9438—dc20
 90-44849
 CIP

Contents

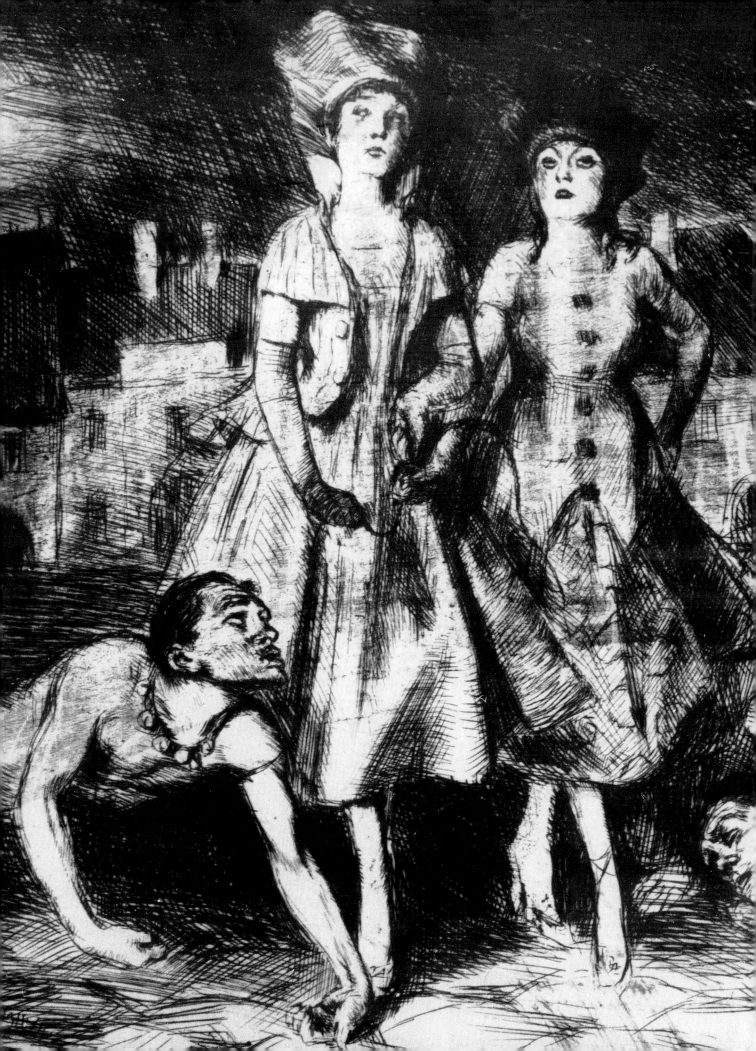

Introduction

I

Long before he was known as a writer of dazzling prose, Bruno Schulz, one of the greatest Polish authors of the twentieth century, had been active as an engraver, drawer, and painter. These artistic inclinations were revealed early in his childhood. He writes about them in the story "The Age of Genius," where the narrator describes a young boy's almost spasmodic process of recording his visions on old journals and piles of scrap paper.

These pictorial manifestations of a child's enchantment should be read as something more than mere literary fiction: they are a record of the author's true memories. This important biographical information is confirmed in a direct confession in one of Schulz's letters to the outstanding painter, novelist, dramatist, and philosopher Stanisław Ignacy Witkiewicz:

> The beginnings of my graphic work are lost in mythological twilight. Before I could even talk, I was already covering every scrap of paper and the margins of newspapers with scribbles that attracted the attention of those around me. At first they were all horses and wagons. . . . From age six or seven there appeared and reappeared in my drawings the image of a cab, with a hood on top and lanterns blazing, emerging from a nocturnal forest. . . . I don't know how we manage to acquire certain images in childhood that carry decisive meanings for us. They function like those threads in the solution around which the significance of the world crystallizes for us. . . . There are texts that are marked out, made ready for us somehow, lying in wait for us at the very entrance to life.[1]

Schulz remained faithful to these earliest motifs until the end of his days—a carriage horse, his wingless Pegasus, would never leave his drawings and his prose, as in the story "Cinnamon Shops," where a diminutive, almost disappearing pony carries a little boy through a snowy night. Writing understood as an artistic task appeared much later in Schulz's life, though his early attempts, known only indirectly, reach back to his school days, his teenage years. One of his free compositions was a story about an imaginary horse and its fabulous adventures. This work met at first with the incredulity of his teachers, who doubted its authenticity, but later it provoked a small sensation. Teachers circulated it among themselves. These literary beginnings were mere harbingers of his great literary talent, which revealed itself only decades later. Did he write other things in his early youth without confiding in anybody? We cannot be sure, but his works published much later—many of which had waited at least ten years in his drawer—were so mature in their expression and so finished in their form that it is possible that Schulz shaped and polished his prose for years without telling anybody about his work.

Yet he never interrupted his drawing, engraving, and painting and never concealed his art from friends and galleries, as if he considered drawing his main, if not his only, vocation. For a long time he felt more comfortable as a graphic artist than as a writer, unaware that in the written word he would reach a mastery far surpassing his graphic achievements. And yet these achievements were considerable, and the author did not abandon his drawing even when writing became his highest and unquestionable claim for glory. He kept drawing until the end of his life, and that activity became not only a means of artistic expression but also a breadwinning occupation. For many years Schulz earned a modest livelihood as an art teacher in a local gymnasium. Toward his tragic end, as he handed his drawings to an officer of the Gestapo, an art collector, they became the strange currency that purchased yet another day of life.

The author's father, Jakub Schulz, immortalized in Bruno's prose as the author's alter ego, the Great Magician, the Heresiarch, was a man of commerce and the owner of a textile business. Still, he appreciated his son's talent and in 1907 published a photocard of a sculpture labeled "The work of Bruno Schulz, 6th grade student at the Franz-Joseph Imperial-Royal Gymnasium in Drohobycz." The teenage artist dreamed about studying at the Academy of Fine Arts. These dreams were never to be fulfilled. Upon the advice of his father and his older brother, Bruno Schulz enrolled in the Department of Architecture at the Lvov Polytechnic. His studies, started in 1910, were often interrupted by his failing health and finally abandoned altogether after his father's bankruptcy, illness,

and death, followed by the outbreak of World War I. Instructions in art and drawing technique received in the Department of Architecture were Schulz's only artistic education after graduation from the gymnasium. One could safely say, therefore, that as a drawer, engraver, and painter Bruno Schulz was an autodidact, just as in his writing he was the disciple exclusively of his own talent.

After the cataclysm of World War II, after Schulz's death, followed by the eradication of most of the traces of his existence—what we know is only a small part of his graphic work. Most of it was destroyed or dispersed in the Drohobycz-Lvov region incorporated into the Soviet Union. Until recently any search for the remnants of his art, in an environment in which he was virtually unknown, was all but impossible.

The earliest among the surviving works are drawings from 1919, mostly portraits in pencil but also figurative compositions that seem to be a prologue to *The Book of Idolatry,* his only series of engravings, created in 1920–24. To judge by the few existing works of this period, Schulz was preparing sketches, or prototypes, for the "idolatry" cycle. The engraving *The Enchanted City* (cat. nos. 16, 21) was preceded by the drawing *Undula Takes a Walk* (cat. no. 28), whose figurative composition and iconography clearly point toward the later version. Similarly, *Pilgrims* (cat. no. 14) is only a slightly altered version of an earlier drawing (cat. no. 29).

The Book of Idolatry, which opens this collection, had the greatest chance of surviving the time of extermination and destruction because it existed in several printings prepared by Schulz himself. Its rather rare technique, known as *cliché-verre* (glass plate), is not considered one of the "pure" engraving methods.[2]

The mode of expression and the subject matter of this early cycle of engravings are governed by the principal idea of "idolatry"—veneration of a Woman-Idol by a totally submissive Man-Slave. That motif dominates all of Schulz's graphic works—the proclamation and celebration of *gynocracy,* the rule of a woman over a man who finds highest satisfaction in pain and humiliation at the hands of his female Ruler. Suffering does not kill but nourishes and intensifies love.

In their obsessive sexuality these pictures are a far cry from the childish fascination with the world recalled by Schulz in his confession about his artistic beginnings. He paid tribute to these fascinations in his writing, in the universal mythology of the prosaic, where the masochistic Eros occasionally shows his face, yet without claiming exclusive dominion. Enchantment with the visible and intuitive world ruled by the magic of imagination and mythology reveals its

richness and generosity only in Schulz's prose. In his graphic works this charm seems to confine itself and focus on the dark areas of the primeval instincts—at the very source of Schulz's creativity. The author was fully aware of the divergence of these two realms. Yet he was also aware of their genetic unity. In his letter to Witkiewicz he wrote: "If I were asked whether the same thread recurs in my drawings as in my prose, I would answer in the affirmative. The reality is the same; only the frames are different. Here material and technique operate as the criteria of selection. A drawing sets narrower limits by its material than prose does. That is why I feel I have expressed myself more fully in my writing."[3]

With all the figurative deformations and synthetic simplification of some of the compositions, Schulz's drawings are basically realistic, and they usually depart from the realistic-expressionistic convention only in their enigmatic, anecdotal message. In his prose he wanders away from empirical reality and informs it, through a "mythologizing" metaphor, with a new "heretical" meaning. Schulz's drawings capture the very moment of departure, or arrival, in these transformations. As he himself correctly observes, it is the result of the different capabilities of graphic and literary art. But also something more: the disparity between Schulz's potential as a writer and his ability as an engraver, drawer, and painter.

2 _____

The Book of Idolatry—an early work—reveals condensed masochistic elements already expressed to a varied degree in the pencil, ink, or sepia drawings preceding the cycle. The vast majority of these drawings were destroyed or lost beyond the present Polish borders during the war. We know three portraits in pencil bearing the date 1919: the author's self-portrait (cat. no. 99), a portrait of a friend, Stanisław Weingarten (cat. no. 115), and a portrait of Maria Budratzka (cat. no. 119). Characteristic of these works is a certain ambiguity of composition—a realistic, even somehow academic main figure and a stylized background or frame, often a picture within a picture, full of imaginary scenes, mythological pastorals, nymphs and rococo *gloriettes* inspired by Watteau, Plater, or Boucher. But even here, as later in *The Book of Idolatry,* the bucolic vision is tainted by a dash of satanic, sweet poison. In Weingarten's portrait the poison is still mild: a figure watching nymphs has the look and posture of lustful humility. But in Schulz's self-portrait the orgiastic cruelty of women stares from the framing, their power evoking the enchantment of a believer, identical with pain and a promise of ecstasy. Yet it isn't Goya's demonism, full of protest and warning, but the magnetism of a fetish, the attracting and creative force of sexual torment that fertilizes the imagination of the artist.

In *The Book of Idolatry* the author brings in those regions, until then separate and contained in frames, as an omnipresent element of the composition. The scenery, which in the portraits was viewed from the outside, now surrounds its creator and engages him as a character in the drama. Thus the creator becomes the product of his creation—a broad metaphor suggesting the confessional and autobiographic character of *The Book of Idolatry.*

Schulz started *The Book of Idolatry* cycle in 1920 and worked on it for several years. He collected his prints in special cloth-bound portfolios he made himself. There were probably several dozen of them, though only a few survived. It is difficult to form an opinion of the whole series since each folder was different, not only in the selection of engravings, but also in the cover and frontispiece design. Sometimes the cloth cover showed only the title written in ink, sometimes the title was accompanied by a drawing—different on each folder. Each frontispiece had a distinctive graphic composition. Sometimes, in addition to the title and occasionally the list of contents, it contained a picture of a woman (cat. no. 3), a self-portrait surrounded by female figures (cat. no. 2), or a figurative composition of a different sort.

The portfolios were usually of vertically elongated format. All engravings were attached to sheets of white cardboard with the author's signature and sometimes the title of the work. Occasionally titles of the same work were different in different folios. For example, *Dedication* (cat. no. 4) is sometimes titled *Introduction. Mademoiselle Circe and Her Troupe* (cat. no. 19) is referred to simply as *Circus*, and *The Enchanted City II* as *Revolution in City* (cat. no. 21).

Schulz's engravings existed not only in folios, as series or cycles, but also as separate works. Some of these individual works survived, but their negatives were lost, together with the artist's whole archive and all his sculpted work.

In these drawings the stigma of slavery marking the faces of the men (sometimes little Negroes, as a symbol of slavery) is combined with teratoid deformation of their whole figures, their dwarfing and animalization—in short, with a metaphor of degradation. Such a caricature or "black-magic" transformation affects only the Idolaters and never the Idol. The woman is untouchable, not only free of deformation but idealized, as if presented with greater care for her beauty and charm than for the pictorial quality of the drawing, its stylistic and formal unity. She is being worshiped not only by male dwarfs but by the whole drawing, which becomes a part of the ritual, an act of celebration. She is the masterpiece, *The Book of Idolatry* seems to suggest. The drawing, form, creative mastery, have no right to compete with her self-contained perfection. All a picture can do is to record that perfection as faithfully as possible. . . . Thus even the line of the drawing is different: it is not constructing the figure but copying it—submissive and caressing, flattering and not blasphemous.

One of the demonic elements of *The Book of Idolatry*—apart from the dominant sadomasochism combining love and suffering—is fetishism elevated to the rank of ritual. A woman's shoe or stocking is more than a prop, it is . . . Pandemonium. The elements of feminine attire partly assume the magnetism of their owners; they attract and emanate the powers of Eros. Fetishes in Schulz's world are not an addition to the magic of the Idol but constitute the Idol's essence.

One of the characters in the story "The Age of Genius" from the volume *Sanatorium under the Sign of the Hourglass* is a small-town philosopher and thief, Shloma.

> *"God did not say anything of the kind," he said, "and yet my conviction is total. I cannot find any argument to the contrary. These lines are irresistible, amazingly accurate, and final, and like lightning illuminate the very centre of things. How can you plead innocence, how can you resist when you yourself have been bribed, outvoted, and betrayed by your most loyal allies. The six days of Creation were divine and bright. But on the seventh day God*

broke down. On the seventh day he felt an unknown texture under his fingers, and frightened, he withdrew his hands from the world, although his creative fervour might have lasted for many more days and nights."[4]

This completion, the self-appointed continuation of the work of Creation, the product of the Seventh Day—is the fetish of a garter, a ribbon, a black stocking, a shoe, those supplemental (from the point of view of the Creator) parts of feminine anatomy joined with the rest of the body by some kind of metabiology. *The Book of Idolatry* displays many such fetishes. In *The Beasts* (cat. no. 20) a shoe that has slipped from a naked foot becomes the locus of desire. *Procession* (cat. no. 13) depicts a vast fetishist celebration. A naked woman in black stockings and shoes with ribbons walks in front of the temple followed by a young man carrying her robes; behind them moves a procession of fetishists, idolaters carrying a banner with the sacral image of a shoe. . . .

In the engraving *Undula with the Artists* (cat. no. 8) the heroine, seated in an armchair, receives the homage of worshiping men. Each of them brings her his work—paintings and sculptures that exalt her beauty and perfection. Undula casually glances at these gifts and lets them slip to the floor. Her bare leg pointing toward the idolaters makes them fall on their knees in adoration. Her magical powers are larger and more overwhelming than the masterpieces. But it is she who is their encouragement and the creative stimulus. Her disdain for the spirit is the spirit's inspiration. Such is the dialectics of Schulz's *The Book of Idolatry.* Art erects temples for a deity that treats art with scorn.

The debasement of man often mentioned in connection with *The Book of Idolatry* is only illusory. Matter, which disdains spirit, elevates it through humiliation. We have traveled far from the simple image of sexual cruelty and submission. Schulz's vision takes on a much more universal meaning that points toward the fertile struggle between spirit and matter, toward the pain of creation, the identity of opposites. It involves a larger set of perceptions, which find their partial and metaphoric expression in *The Book of Idolatry.*

The personal beauty with which Schulz informs his work makes it original and unique, although it is also deliberately eclectic, deriving from both Viennese expressionism and the old masters. This "sexpressionism," to coin a new word, reaches in *The Book of Idolatry* a confessional, cultist, and sacral level. Fetishism as a sexual category is combined or identified with the fetishist beliefs of primitive cultures. Masochism as a sexual deviation becomes a ritual of prostration in front of the idol. Sharp erotic undertones of the rite do not dissipate in the process, but are elevated from the profane to the sacred level.

The figures in *The Book of Idolatry,* including its main heroine of the fantastic name Undula, are anonymous. It is perhaps of little significance that all of them—the imperial women and the dwarfish men—have faithfully portrayed faces of the author's Drohobycz acquaintances, his friends, colleagues, and girlfriends. His own face also appears in his pictures. This was not insignificant to the artist, however. In creating the reality of *The Book of Idolatry* he wished to contain in it the image of the perceived world, to inform it with a sense of authenticity. He wanted to expose the real, empirical roots of his visions, in which moonlike hybrid creatures, half-men, half-dogs, and half-leopards, were furnished with the physiognomies of Drohobycz people, the participants of the real biography of the artist. These faces are not the only proof of a relationship between the act of creation and the creator's place in the world. A similar role is played by the authentic fragments of the Drohobycz landscape placed in the background as witnesses to the idolatrous rituals: houses in the market square, the tower of the town hall, the facade of the Catholic church, the Orthodox church with its onion-shaped dome. . . .

Schulz's universalism coexists with real topography also in his writing, but his prose incorporates the recognizable elements into an all-inclusive mythological paradigm. It is a practice well known to artists of past epochs: faces of saints and apostles displayed the artists' own features, or those of their acquaintances and sponsors, while biblical landscapes blended with views of the artists' native lands. Elements of late baroque or rococo ornamentation abound in *The Book of Idolatry,* filling the interiors and providing the sacred and sensual adornment of the *templum.* Convoluted calligraphy of the rocaille, twisted columns or posts of a fantastic bed, rich trusses of furniture coiled in volutes—all this seems to signify feminine perfection, excess, the crowning of the woman's rule, a satiated and self-satisfied excellence. This deliberate archaization is combined with traditional drawing technique, sometimes almost calligraphic, meticulously precise, rarely succumbing to sketchy disorder.

The dynamic arrangement of figures and bright spots carved out of the surrounding darkness are a sure sign of Goya's influence. One could venture to say that we have here a whole collection of Goya's motifs from many different areas: his *Los Disparates* (The Follies) and the sharpness of *Los Caprichos* (The Caprices) are accompanied by *Naked Maja*—Schulz's Undula saturated with her own beauty, undisturbed by the grimace of the disheveled surroundings in which her beauty finds its source.

The youthful *Book of Idolatry* is by no means the apogee of Schulz's artistic creativity. It is merely one of the initial stages of his development—full of

promise and signaling his departure from inherited styles. We are still in the antechambers of sexual drives, mythology, physiology, and demonism. It is a secret hatchery of masocho-fetishes, still treated in a rather literal way and lacking in visual expansiveness, although already possessing an aura of mystery. The visionary elements are in their larval, embryonic stage: an introduction that does not reveal but rather conceals new regions of imagination. We are led into an alcove-inferno with the aroma of brimstone and perfume—and a little window opening into infinity.

Demonism and sanctity mix, or replace one another, amid strange ambivalence and perversity: the condemned are saved, defeat turns into triumph, and heaven unites with the abyss.

3 _____

After *The Book of Idolatry* Schulz never returned to engraving. His plans, voiced in letters to his friends, of learning woodcut and other engraving techniques were never realized. The everyday drudgery of a schoolteacher's life and his first secret literary attempts compelled him to give up more-specialized artistic education. Yet he never abandoned drawing: he even expanded his subject matter as an illustrator of his own literary works. "Idolatry," or the motif of sexual submission to a woman, remained the dominant theme of his sketches until the end of his life.

This persistent, obsessive faithfulness to himself was one of the reasons for Schulz's steadfast immunity to contemporary artistic trends that reached, in due time, even the Drohobycz provinces. The same faithfulness explains why he remained a separate and, in his own way, a unique phenomenon even though his drawings can be traced back to Viennese and German expressionists, or even to Goya, Rops, and Munch. One of the greatest mythmakers in literature, capable of magic rationalization of the irrational by means of some sort of "mytho-logic," proved totally immune to the currents of surrealism in contemporary art. The irrationalization of the world performed by the surrealists proved—despite apparent similarities—completely alien to his vision and radically different from his own pursuits.

Almost all surviving works by Schulz, with very few exceptions, were made on thin, inferior, easily yellowing paper. Some of these sheets contain two pictures, one on each side. They are mostly sketches in pencil, sometimes in ink or black crayon. After *The Book of Idolatry,* which opens this collection, we move on to a series of drawings entitled "Masochistic Scenes." Although I have placed these drawings in a separate category, works of similar character can also be found in other sections of the book. In fact, the vast majority of Schulz's drawings contain the "idolatrous" element. Yet "Masochistic Scenes" comprises works in which the element of submissive adoration is especially sharp, dominant, almost exclusive, as if fulfilling the principal promise of *The Book of Idolatry.*

These drawings repeat in many variants the iconographic message of *The Book of Idolatry,* but in their form and technique they differ substantially from the earlier works. They are simplified: Goya's dark backgrounds, typical of Schulz's earlier pictures, fade or dissolve altogether; the line, more liberated and spontaneous than before, becomes the main structural element. The figures of

naked women, usually resting on their beds, are clear and polished and constitute the basis of the composition. The deformed figures of men are often barely sketched, sometimes reduced to simple graphic signs, fleshless, almost disappearing. In this duality the feminine figure is closer to calligraphy, while the male figures resemble hasty scribbling.

In a separate section I have gathered Schulz's illustrations of his literary works—or quasi illustrations, which, although not referring to any particular passage in his prose, were meant to be printed as an addition to his text in the first edition of *Sanatorium under the Sign of the Hourglass*. But even when a drawing does not function as an illustration *sensu stricto*, it has a quasi-illustrative character as a graphic composition dominated by a particular subject. As much as one talks about the *pictorial* character of Schulz's prose, one can also point to the *literary* character of his drawings. When considering the quality of his graphic and literary works we have no doubt that what we have here is a writer who draws rather than a drawer who practices writing. The means of expression he employs in his writing are incomparably richer and more innovative than those he commands as a graphic artist. It is true that in the best and most accomplished cases his pictures reach the level of genuine artistry. And yet we tend to judge them differently: they deserve our attention as works by the same hand that wrote such masterworks of literature as *Cinnamon Shops* (or *The Street of Crocodiles,* as it is known in English) and *Sanatorium under the Sign of the Hourglass*. It is rather unfortunate for Schulz's drawings that they are overshadowed by the grand format of his literary work. These drawings are so separate, homogeneous, always recognizable as the work of this particular artist that they possess unquestionable original value. Characterized by a growing formal restraint free from the deliberate archaization of *The Book of Idolatry,* they could be compared with the art of Alfred Kubin or Karl Hofer.

When looking for sources of the artistic motifs in Schulz's drawings, we usually talk about the artist's deviation being responsible for the emotional intensity of his expression: about the innermost perceptions of the creator-idolater. Of course, we do not have to share these perceptions in order to feel the full impact of their articulation. S. I. Witkiewicz, an enthusiast of Schulz's work, wrote in 1935: "In my opinion by her very nature a woman . . . must be a spiritual sadist and a physical masochist, while a man must be a spiritual masochist and a physical sadist. Schulz carried the expression of these two spiritual combinations to the extreme and saturated it with almost monstrous pathos."

In the twenties and later, the engravings from *The Book of Idolatry* were shown at several exhibitions, but they were hardly noticed by the critics and

were discussed more extensively only in the Jewish press in Poland. His later drawings, with the exception of illustrations to his own works, were never presented to the public. Available only to a few trusted friends, they rested in the artist's drawer, just as his literary manuscripts had done in earlier times. Schulz had reasons enough to avoid displaying his graphic art. The intimate subject matter, bordering on the indecent, was not conducive to public display, and he had to take into consideration the possible damage to his reputation as a teacher in the local gymnasium. Besides, the reservations were mutual; some artistic circles did not look too favorably upon the "dilettante." Some circles of influence, especially in the provinces, rejected his work as mere pornography. . . . Under such circumstances his drawings could see the light of day only as illustrations complementing his literary work.

To judge from the surviving dated drawings, the author started illustrating his stories as early as the twenties, ten years before his literary debut, when no one knew about the existence of his prose works.

For example, the ink drawing illustrating the story "Sanatorium under the Sign of the Hourglass," published in a book edition only in 1937, shows the date of 1926 (cat. no. 130). The desire to illustrate his own prose had been nagging at Schulz for a long time and made him think about studying different engraving techniques. In a letter to the Polish psychologist and philosopher Stefan Szuman he wrote about *Cinnamon Shops,* at that time still in manuscript, "I thought about illustrating this piece with woodcuts within the text, as in books from the beginning of the 19th century, but I know I would never be able to do it." He never carried out this plan. The matter was decided, it seems, by the publisher, who wanted to cut production costs. Nevertheless, Schulz made a series of drawings to illustrate *Cinnamon Shops.* After publication of the book with only a jacket vignette designed by the author, Schulz glued the originals of the drawings into one of the copies and sent it as a present to his friend and sponsor, the outstanding Polish novelist Zofia Nałkowska. This copy was later destroyed. After the enthusiastic critical reception of *Cinnamon Shops,* the same publisher accepted three years later Schulz's second and last book, *Sanatorium under the Sign of the Hourglass.* This time he agreed to include the author's illustrations in pen and ink. Most of the thirty-three illustrations refer directly to the text, though some have only a loose connection with the story. Just like the earlier book, *Sanatorium* appeared in a dust jacket of the author's design (cat. no. 129). A publisher's note on the cover explained: "The author illustrates his work by himself. This very striving to finish the task with his own hands makes us think about the inspiration of priests and craftsmen of the Middle Ages."

Before the illustrated book edition of *Sanatorium under the Sign of the Hourglass* appeared, some stories from that collection were published in magazines, also accompanied by illustrations—though sometimes different from those reproduced in the book. The illustrations to *Sanatorium*, existing in a subservient yet inseparable union with the written text, lose a lot of their meaning when reproduced separately in this catalog. I will attempt, therefore, to provide at least a fragmentary interpretation and to point to the appropriate passages.

The already mentioned drawing from 1926 depicting Father asleep in his bed and Joseph standing at his side refers to the following passage from "Sanatorium under the Sign of the Hourglass":

> *Under a small window, my father was lying on an ordinary wooden bed, covered by a pile of bedding, fast asleep. His breathing extracted layers of snoring from the depths of his breast. The whole room seemed to be lined with snores from floor to ceiling, and yet new layers were being added all the time. With deep emotion, I looked at Father's thin, emaciated face, now completely engrossed in the activity of snoring—a remote, trancelike face, which, having left its earthly aspect, was confessing its existence somewhere on a distant shore by solemnly telling its minutes. (S, 118)*

The illustration showing Joseph and Doctor Gotard (cat. nos. 131, 132) corresponds to the following fragment:

> *I cannot say whether Dr. Gotard accompanied me on that walk, but now he stands in front of me, finishing a long tirade and drawing conclusions. Carried away by his own eloquence, he slips his hand under my arm and leads me somewhere. I walk on, with him, and even before we have crossed the bridge, I am asleep again. Through my closed eyelids I can vaguely see the doctor's expressive gestures, the smile under his black beard, and I try to understand, without success, his ultimate point—which he must have triumphantly revealed, for he now stands with his arms outstretched. (S, 125)*

Joseph and the dog-man are from the same story (cat. nos. 133, 134, 135):

> *I don't want to be misunderstood. He was a dog, certainly, but a dog in human shape. The quality of a dog is an inner quality and can be manifested as well in human as in animal shape. He who was standing in front of me . . . his jaws wide open, his teeth bared in a terrible growl, was a man of middle height, with a black beard. . . . He looked more like a bookbinder, a tub-thumper, a vocal party member—a violent man, given to dark, sudden passions. And it was this—the passionate depth, the convulsive bristling of all his fibers, the mad fury of his barking when the end of a stick was pointed at him—that made him a hundred per cent dog. (S, 137)*

The next illustration to "Sanatorium" represents Father, Joseph, and the terrorists (cat. no. 136).

Approaching the city square one day, we noticed an extraordinary commotion. Crowds of people filled the streets. We heard the incredible news that an enemy army had entered the town. . . . We were told that the enemy incursion gave heart to a group of discontented townspeople, who have come out in the open, armed, to terrorize the peaceful inhabitants. We noticed, in fact, a group of these activists, in black civilian clothing with white straps across their breasts, advancing in silence, their guns at the ready. (S, 134–35)

Joseph on his way to the Sanatorium (cat. no. 137) corresponds to the following words:

The train was coming slowly to a halt, without puffing, without rattling, as if, together with the last breath of steam, life was slowly escaping from it. We stopped. Everything was empty and still, with no station building in sight. The conductor showed me the direction of the Sanatorium. Carrying my suitcase, I started walking along a white narrow road. . . . (S, 113)

The fantastic drawing of an automobile-telescope (cat. no. 138), taken as a purely graphic statement full of eerie expressiveness, is an invitation to a game of free associations. Yet it refers to one particular passage in "Sanatorium under the Sign of the Hourglass":

There followed a complicated description of a folding telescope with great refractive power and many other virtues. . . . I began to unfold the pleats of the instrument. Stiffened with thin rods, it rose under my fingers until it almost filled the room. . . . It looked, too, like a long-bodied model automobile made of patent leather. . . . Like a large black caterpillar, the telescope crept into the lighted shop—an enormous paper arthropod with two imitation headlights on the front. The customers clustered together, retreating before this blind paper dragon; the shop assistants flung open the door to the street, and I rode slowly in my paper car amid rows of onlookers. . . . (S, 124)

The drawing of the wax figure exhibition—an illustration to the story "Spring" (cat. no. 141)—is connected with a vibrant description of the exhibition, from which it might be useful to quote at least small fragments and, by reversing the original process, to illustrate the drawing with the literary text:

Can one consider it a coincidence that at about the same time a great theatre of illusion, a magnificent wax figure exhibition, came to town and pitched its tent in Holy Trinity Square? . . . Through a half-open flap we entered a brightly lighted space. . . . They stood in grim silence, clad in somber made-to-measure frock coats and morning suits of good quality cloth, very pale, and on their cheeks the feverish flush of the illness from which they had died. . . . At last I

found him, not in the splendid uniform of admiral of the Levant Squadron, in
which he sailed from Tulon on the way to Mexico in the flagship Le Cid,
nor in the green tail coat of a cavalry general he wore in his last days. He was
in an ordinary suit of clothes, a frock coat with long, folding skirts and
light-colored trousers, his chin resting on a high collar with a cravat. . . .
A few steps from us, in the first row of the onlookers, stood Bianca in a
white dress, accompanied by her governess. . . . She was standing immobile,
with folded hands hidden in the pleats of her dress, looking from under
her serious eyebrows with mournful eyes. (S, 59–60)

A later scene, which corresponds to the illustration depicting a charge of
wax figures from the exhibition (cat. no. 140)—a pencil sketch of a drawing
contained in the first edition of *Sanatorium under the Sign of the Hourglass*—is a
description of the rebellion of wax figures, their march from the exhibition, and
their attack on Bianca's villa: "Under cover of darkness we left the exhibition. I
walked at the head of the inspired cohort, advancing among the violent limping
and rattling, the clatter of crutches and metal. . . . Struck by a bad premonition,
I marched into the courtyard at the head of my warriors" (S, 76).

The organ-grinders from the story "The Book" appear in the back-alley
scenery in three of the drawings (cat. nos. 159, 160, 161):

These old men had long forgotten their names and identities, and, lost in
themselves, their feet encased in enormous heavy boots, they shuffled on bent
knees with small, even steps along a straight, monotonous line, disregarding
the winding and tortuous paths of others who passed them by. . . . they would
disentangle themselves imperceptibly from the crowd and stand the barrel organ
on a trestle at street corners, under the yellow smudge of a sky cut by lines
of telegraph wires. . . . they would begin their tune—not from the start but
from where it had stopped the day before—and play "Daisy, Daisy, give
me your answer, do . . ." And—strange thing—that tune, hardly begun,
fell at once into its place at that hour and in that landscape as if it had
belonged by right to that dreamlike inward-looking day. . . . (S, 7–8)

The father floating over the lamp (cat. no. 165)—an illustration to the story
"Eddie" included in the first edition of *Sanatorium* as an ink drawing and in this
catalog as a pencil sketch—corresponds to the following passage:

In Mr. Jacob's room a lamp is alight on the table, over which he sits hunched,
writing a long letter to Christian Seipel & Sons, Spinners and Mechanical
Weavers. On the floor lies a whole stack of papers covered with his writing,
but the end of the letter is not yet in sight. Every now and then he rises from
the table and runs round the room, his hands in his windswept hair, and as
he circles thus, he occasionally climbs a wall, flies along the wallpaper

*like a large gnat blindly hitting the arabesques of design, and descends
again to the floor to continue his inspired circling. (S, 154–55)*

And the last exercise in matching Schulz's prose with his illustrations concerns his story "The Old Age Pensioner" and his drawing of a man swept away by the wind (cat. no. 168):

*I made my way in the gale only with difficulty. . . . I was pushed outside the
gate and was immediately swept away. "Boys, help, help, help!" I shouted,
already suspended in the air. I could still see their outstretched arms and their
shouting, open mouths, but the next moment, I turned a somersault and ascended
in a magnificent parabola. I was flying high above the roofs. (S, 170)*

Curious readers may continue this game of correspondences on their own, but these examples will help us to read some literary content into the drawings and to discover their not always self-evident plot. What is more, such juxtapositions seem to confirm my opinion that despite their many merits the drawings cannot compete with Schulz's prose: they are simply far more conventional and direct. A literary description sparkling with multiple meanings and transformations of reality, the style capable of modulating the intensity of fictitious worlds—these do not have an equivalent in his drawings, but only a faithful, if inadequate, accompaniment. But is such artistic equivalence possible at all? Can we conceive of a graphic image that could equal the literary work of this writer of genius? Wouldn't any attempt to illustrate the work—though a dazzling illumination in its own right—be equally condemned to failure and fading in the light of his prose?

Among the drawings that survived there is yet another group created with possible illustrative intent. These pictures—several sketches in pencil and two ink drawings—stand out as a self-contained cycle. I have placed them under the common title "Jews." It is possible that originally they were connected with the unfinished and lost novel *The Messiah*, on which Schulz worked, with interruptions, for many years. Not much is known about this work except that its central idea and its plot involved the coming of the Messiah, who, having made his appearance somewhere in the eastern Carpathian Mountains, was making his way toward Drohobycz. . . .

These drawings are separate from the majority of Schulz's surviving works. They differ both in the outline of the figures and in the use of background. The scenes they depict are set in the narrow alleys of Jewish towns, among the crowds of the Hasidim in their traditional clothes, among rabbis and Orthodox Jews engrossed in religious rituals, prayers, and Talmudic or business debates at

long holiday tables. One can also find many biblical elements, like Jacob's well or a panorama of Jerusalem hovering above the horizon. In a manner characteristic of Schulz, but also of the Jewish religious tradition, myth mixes here with everyday life, ancient history with the present moment. The drawings, especially the pencil sketches, show a bold, nervous line, dynamic composition, and faithful representation of gesture. They reflect the specific atmosphere of pious waiting in the Diaspora and the joyful hope of the arrival of the Messiah—the consummation of ancient prophecies. Although deprived of any corresponding text, these drawings speak clearly to us in a way that exceeds the artist's original intention: they are an outspoken and powerful document preserving the images of a murdered world.

It is difficult to find in Schulz's surviving prose any fully developed motifs of a similar kind. Judaic elements are barely touched upon in his writing, and at most they are present as the shining behind his mythology. Among the preserved texts only the following description of a Passover night, not included in any of his book editions, shows a certain proximity to the "Jewish" cycle of his drawings:

> . . . and this grand theater of the Passover was driving onto the stage the whole
> multi-layered mystery of the primeval Egyptian spring: The magnificent and
> impenetrable feasting at long, white tables in the light of silver candlesticks
> shivering under the breath of this Passover night which was too spacious and
> empty. These Passover nights stood like a dark backstage behind the open
> doors of the house and swelled from inconceivable and immense things, while
> over the glittering parade of the table the signs of the zodiac—
> the Egyptian plagues—stopped for a moment in the sequence ordained
> by the Bible. And they scattered like star dust crushed in the quern
> of the night. . . .

My division of the collected drawings is based mainly on dominant theme. This method is far from precise, yet there is no reliable alternative system to classify Schulz's art. The section entitled "Masochistic Scenes" focuses on the motif of sexual submission, yet the same motif can be found, in various intensity, in all Schulz's drawings. Similarly, the series of seventeen self-portraits includes everything that could be found among the preserved portion of Schulz's work. Yet his face appears also in other drawings and engravings, and in *The Book of Idolatry*, which opens with a magnificent self-portrait, his likeness is almost omnipresent. In the "independent" drawings, in the idolatrous scenes, and also in his illustrations to *Sanatorium under the Sign of the Hourglass*, Schulz's figure, sometimes dwarfed and deformed, is part of almost every composition and is

often accompanied by the figures of his friends. This personal presence of the artist in his own creation is very characteristic of Schulz's art.

It should be stressed that Schulz was an exquisite portraitist who did not limit himself to depicting his own face, although among the surviving work self-portraits are more numerous than portraits of other people. He preserved, always with perfect resemblance, the face of his mother; the profile of a fiancée; the expressive physiognomy of a friend, Emanuel Pilpel, who died in 1936; and the face of Stanisław Weingarten, a sponsor of the arts and collector of Schulz's drawings. Two portraits (apart from several others in group compositions) and two ex libris designed by Schulz—that is all that remained of Weingarten, one of Schulz's closest friends, murdered by the Nazis in the Lodz ghetto.

I have already mentioned that some themes or iconographic signs were present in Schulz's work—as he wrote about it himself—from his earliest years. One such motif is a horse-drawn carriage, a cab or a chaise. In the "Varia" section we can find a geometric rendition of such a vehicle, and several more—carrying Bianca and her father in the story "Spring"—can be found under "Illustrations." There are also drawings of carriages with reclining naked girls. This image, not connected with any particular story, appears repetitively in the first book edition of *Sanatorium under the Sign of the Hourglass* as a persistent Schulzian motif.

What is striking in Schulz's drawings is a surprising poverty of objects, or rather, their limited number and persistent recurrence. Schultz rarely parts with his favorite items—bed, carriage, horse, house—to introduce other attributes of reality. Another one of these recurrent motifs is a table—a symbol of human contact, the Implement of Mutual Understanding, the conjunction of individual existences, the ally of community. In the story "The Book" Schulz wrote, "For, under the imaginary table that separates me from my readers, don't we secretly clasp each other's hands?" (*S*, 1). The central role of the table in some of Schulz's drawings led me to gather them in a separate section, "At Table," which excludes only the drawings of the Passover table from the Jewish cycle.

These are not feasting tables. Their function is not communal eating, but *communal being;* the white linen is sometimes adorned by a book, but most frequently it is empty—no food or table setting. In these drawings sitting at the table is something of a ritual, like praying on a kneeling stool. At table the ceremony of Life is played out, an attempt at common fate. Without gesture, without words that force the mouth to open, Schulz's silence, meditation, and numb awaiting of some sudden revelation of the sense of the world hover over the table.

The last section, "Varia," contains mostly drawings that reach beyond Schulz's typical categories in their subject matter, depicted objects, and formal

means of expression. Here, at the end of the collection, we can find some of the "offshoots," to use his own term, of his creativity, which must certainly have been more numerous and diverse in the lost part of his oeuvre.

I mentioned earlier the noble parentage of *The Book of Idolatry* and other Schulz drawings—the echoes of Goya, Rops, or Munch, and even more remote cousins like Alfred Kubin or Karl Hofer. They were Schulz's forebears, or "kindred souls," or—like the representatives of expressionism—guides whose footprints he followed while seeking his own paths in the wilderness. I should mention yet another, perhaps the most rudimentary, source of Schulz's art, which he himself speaks about in his story "The Book": advertisements and personal announcements from old magazines. Long-haired Anna Csillag advertising hair-growing ointment, Elsa, the Fluid with a Swan—a miraculous potion capable of healing invalids. Musical instruments: harps, zithers, accordions— "once played by consorts of angels"—barrel organs, and canaries from the Harz Mountains. The advertisement of the irresistible and imperious Magda Wang, capable of breaking the strongest male characters and possessing a secret formula to win their compliance. . . . Out of these evocative emblems of imagination Schulz forged in his poetic prose long chains of mythological sequences bringing the apparently dead pictures to life, making them tell their stories and unfurl their fantastic potentials. Literature is their exegesis. The function of magazine illustrations, like the function of Schulz's drawings, is merely to summon and develop strings of meaning, to kindle the myth. Their task is to initiate, nothing more; the rest depends on us.

4

The majority of the surviving works of Bruno Schulz are today in the possession of the Museum of Literature in Warsaw. Considering the destruction of war, and although Schulz's native land is today outside the borders of Poland, their number is quite impressive. Most of them are reproduced in this book.

They owe their survival in the first place to Schulz himself. In 1942, deprived of his home and resettled by the Germans in the Drohobycz ghetto, he became aware of the growing threat to his life and decided to save his manuscripts, letters, and graphic works. In the spring of that year he started making packages, each containing several dozens of his drawings. Some packages also contained manuscripts. These improvised folders made of two sheets of cardboard were entrusted to people whom he considered relatively less endangered by the Nazi terror. The depositaries were mostly Poles, and possibly also Ukrainians.

My search of more than four decades was able to locate, apart from individual drawings, two such deposits—one of them as early as 1948, the other in 1988. They were both still in the hands of the people to whom Schulz had delivered them and included over a hundred works. I managed to persuade both depositaries to sell them to the Museum of Literature. The first of these batches was purchased in 1964 and the second in 1988. Some engravings and drawings are located in other museums in Poland; some remain in my private collection and in the collections of other people both in Poland and abroad. It is still not known what happened to the rest of the deposits, which contained, among other things, Schulz's unpublished manuscripts. Perhaps some of them were destroyed, or are still kept in Schulz's native area, now incorporated into the Soviet Union, waiting for their discovery, perhaps by chance.

These lost or destroyed works included oil paintings and crayon drawings. Not a single work of this kind has been unearthed since the war. Schulz's paintings and color drawings deserve some mention, although they cannot be presented in this book. The only exception is a photograph of a lost oil painting (cat. no. 176). I managed to gather only scanty and fragmentary information about the paintings that belonged to Schulz's family in Lvov. The apartment of his brother, Izydor, was full of his drawings and paintings. There were oil portraits of Izydor and his wife and full-figure portraits of their children, Jakub and Ella, at the ages of eleven and twelve. The collection included also a large portrait of Ella in a blue dress and holding a rose, at the age of fifteen. There was a

large oil painting (100 × 120 cm) entitled *The Coming of the Messiah*—clearly related to the preserved "Jewish" cycle of drawings and the lost novel, *The Messiah*. Chromatically the painting was dominated by various shades of red. The composition depicted a crowd of learned Jews gathered around a well to greet the Messiah. The painting's subject and its figurative arrangement recall a preserved ink drawing of a crowd of Jews at a well (cat. no. 82). The Lvov apartment also contained a picture—oil or crayon—of a similar size which was a replica of a lost oil painting (cat. no. 176) of a young Jew holding a book and wearing a hat and a long coat. This main figure is bowing to a woman in a blue dress, who climbs the stairs of a palace accompanied by an older lady. The painting was cast in blue and purple tones. Another painting in the same collection—smaller than the ones previously mentioned—was an oil picture in bright reds entitled *The Madhouse*. It showed a fantastic building with swelled, balloonlike human heads looking out of its windows.

As a curiosity one should also mention a memory piece kept by Schulz's brother—a framed yellowed piece of paper with a drawing made by Bruno at the age of six. It represented a stooped, bearded old man sitting under an ancient willow tree. The young artist entitled his work *God*.

Before the war the City Art Gallery in Lvov displayed at least two oil paintings by Schulz: a landscape and a portrait. Schulz's Drohobycz home contained a rather large painting called *The Slaying of the Dragon*. Schulz's engravings, paintings, and drawings decorated many private homes in Drohobycz, Lvov, and Warsaw. In Warsaw they were burned together with the city in 1943 and 1944 during the period of the ghetto and the Warsaw Uprising. In other cities they disappeared without a trace—destroyed or stolen. With very few exceptions, the lost works were not even preserved in photographs. Some of them survived as reproductions in the first edition of *Sanatorium under the Sign of the Hourglass* and in some prewar magazines. Because of the inferior technical quality of these reproductions, I have decided not to include them in this collection.

There are (or perhaps there were) still other graphic works by Schulz that are not represented here, works created under the most unusual circumstances during the Nazi occupation of Drohobycz. These were wall paintings made by Schulz, a Jew marked for extermination, to purchase his right to live. In a prewar Jewish orphanage taken over by the occupying authorities Schulz painted a plafond over the main staircase. It is possible that it has survived under the layers of new paint. He also painted frescoes in the villa that used to belong to the prewar Polish mayor of Drohobycz. When the old headquarters of the

Polish police were taken over by an official of the Gestapo, Felix Landau, the new tenant ordered Schulz to decorate his little son's room with colorful fairy-tale pictures. A witness of and participant in this work, one of Schulz's former students, remembers the days in which these strange compositions were created:

> *Even then Schulz remained faithful to his artistic method: the figures of kings, knights, and squires painted in a fantastic, legendary scenery in the house of the Gestapo officer displayed distinctively non-Aryan features. Those were the people Schulz was living with at that time. Their emaciated, tormented faces were rendered with unbelievable resemblance. And these miserable people, transferred by Schulz's imagination from the world of tragic reality, reappeared in his paintings with splendor and glory as kings seated on their thrones in sable furs and crowns, as knights on white horses surrounded by their squires, as sovereign rulers riding in their golden carriages. . . .*

All these buildings survived the war, yet they are now outside Polish borders. Their new inhabitants did not seek out under the layers of paint the last fairy tale of Bruno Schulz—a fairy tale that, despite desperate hope, failed to save his life.

5 _____

Bruno Schulz's biography, which I have tried for almost half a century to reconstruct in all possible detail, still abounds in blank spots and question marks. Despite tremendous loss and destruction, the life of this great artist, our close neighbor in time, did leave its most important trace: his *work,* one of the most significant achievements of Polish literature in the twentieth century. And yet the war, the genocide to which he himself fell victim, the tragic death of his friends and family, border changes, resettlements, deportations to Stalinist concentration camps—all this resulted not only in the mass extermination of people but also in the eradication of memory and the blurring of all traces of their existence.

After the war such basic facts as the dates of Schulz's birth and death were unknown even to literary historians. The painstaking and lengthy attempts to re-create the author's curriculum vitae resembled the work of an archivist, a detective and . . . an archaeologist. And yet, it is easier to unearth remnants of buried ancient civilizations than to uncover this world that was trampled into the ground not long ago. Private and public archives were burned or robbed by the occupiers, and access to other pieces of evidence was blocked by state borders. The death of most of the people who knew Schulz personally and the dispersement of the survivors made the search for living testimony almost futile. It was a search conducted in a desert. Archaeology turned into a reading of ashes.

Attempts to save the memory of Schulz were also hampered by the "cultural policy" imposed on Poland by the Communists that proclaimed socialist realism the only legitimate literary approach. From the point of view of this destructive literary program, the products of Schulz's creativity had to be banned and all but excommunicated. His prose was not published, and the rare critical comments were invariably condemning and derogatory. Such was the situation during the first postwar decade.

It was in that period that I started my explorations into the life and work of Bruno Schulz. It was an effort whose results at that time had no chance of reaching the public. It was an effort that continues today. Seeking out miraculously preserved documents—among them over a hundred letters—making contacts with the still numerous people who knew Schulz personally and writing down their testimonies, planning difficult trips to Drohobycz, searching for his manuscripts, drawings, photographs and other memorabilia—these were

the main elements of my quest, whose results I have communicated in a number of books, including *Regiony Wielkiej Herezji* (The Regions of Great Heresy), sketches on Schulz's life and work, and *Letters and Drawings of Bruno Schulz,* a collection of Schulz's correspondence accompanied by my commentary and a biographical essay.

Bruno Schulz's life, though rich internally and spiritually, was exceptionally poor in facts and events. It was played out almost exclusively in the area of Drohobycz, which the author left rarely and only for short periods of time. And yet it deserves at least a brief summary, since it touches upon the life of his remote province and his environment, the shaping factors of his personality and his art.

He was born on 12 July 1892 as the third and youngest child of a merchant family. His given name, Bruno, corresponded to the Hebrew name Ber, which was the name of his maternal grandfather. Bruno's father, Jakub, was a textile merchant and the owner of a store. He had come to Drohobycz from the village of Sadowa Wisznia to marry Hendel Kuchmaerker of a local family of merchants and woodmakers. The couple settled in the house at No. 12, Drohobycz Market Square. The same building housed their store, under the sign "Henrietta Schulz."

The change of Hendel's name to Henrietta was a symptom of the Schulz family's gradual departure from Jewish traditions. The older son was given the name Israel-Baruch but stopped using it after graduating from high school, choosing instead the name Izydor. Bruno, younger by eleven years, was given a non-Hebrew name at birth. Drohobycz, Schulz's native town and the scene of almost all his life—his cradle and his grave—was a provincial town in eastern Małopolska. In the eighteenth century, after the partition of Poland, it fell under Austrian rule. Almost a hundred years after the breakdown of the Polish state, these provinces, known at that time as Galicia, gained a limited autonomy, especially in the area of education. Bruno Schulz, born a quarter of a century later, could from the beginning attend a school whose language of instruction was Polish, although it was named after the Austro-Hungarian emperor Franz Joseph.

The later years of his childhood witnessed the beginnings of a major change in economic and social relations. At the turn of the century Drohobycz and the neighboring town of Borysław became the local centers of oil production. Drohobycz soon expanded to over ten thousand inhabitants and became the hub of industrialization in the area.

In the shadow of these changes, representatives of the old, destitute merchant and artisan class vegetated on the edge of poverty and bankruptcy. Such

was the family background of Bruno Schulz. Not far from his birthplace the founder of Hasidism, Baal Shem Tov, was born and conducted his activities. It was a region of great minds and outstanding talents that gave the world many famous composers, musicians, artists, and scholars, some of whom made a lasting impression on American culture. Schulz was one of the greatest.

Polish was the language spoken in his home. The Schulzes were also fluent in German, which was used in the business and for official matters. His parents did not teach him Yiddish, a language he never acquired. The family belonged to the Jewish religious community. Bruno's grandparents were Orthodox Jews, though his parents had less conservative inclinations, choosing lay rather than Mosaic books and the store abacus rather than the synagogue menorah.

In the years 1902–10 Bruno attended a local public gymnasium, where he was known, despite frequent illnesses and absences, as an exceptionally gifted student. His achievements in Polish, drawing, and mathematics were far above school level.

Soon after the summer recess of 1910, acting upon his family's advice, Bruno Schulz took the entrance examinations to Lvov Polytechnic in order to study architecture. After the first year at the polytechnic, however, he returned to Drohobycz, where he stayed bedridden for six months with severe pneumonia and a heart infirmity. He returned to the polytechnic two years later, yet after another year he had to interrupt his studies again. In 1914 World War I broke out.

Soon afterward the Schulz house with the store and the living quarters was burned. The family moved to Bruno's sister's, whose home remained his place of residence almost until his death. He had to abandon his education plans. Toward the end of the war, in 1917–18, he tried to resume his studies in Vienna, but the approaching end of monarchy, revolutionary movements, war upheavals, and the prospect of regained Polish independence compelled him to abandon architecture, this time for good, and return home. His visits to Viennese art galleries and direct contacts with European masterpieces, however, convinced him of his artistic vocation. Unfortunately, he had to forgo his reveries and return to Drohobycz.

His home was still in mourning. Bruno's father had died in 1915, surviving his burned store by only a couple of months, which he spent in bed under the care of his wife and Bruno. Bruno's sense of emptiness was deepened by the fact that he considered his father the trustee of his dreams, his spiritual ally and protector. Jakub Schulz represented a breed of Jewish merchant—almost extinct by that time—who could combine business and philosophical qualities, everyday life and daydreaming, industry and artistic aspirations.

The war came to an end, and Poland reappeared on the map of Europe after more than a century's absence. Bruno was seeking a place for himself and his ambitions among the young aspirants of the arts—the new generation of musicians, artists, and writers. The several years before he took up his job as a schoolteacher were devoted, as before, to artistic activity and incessant reading. That period of relative freedom would have been impossible without Emanuel Pilpel, Schulz's schoolmate and good friend. His father owned a Drohobycz bookstore that became for Bruno an oasis of learning. During these postwar years Schulz created many of his paintings and drawings, including *The Book of Idolatry*.

In 1924 Schulz obtained a position as a drawing and crafts teacher, which he kept almost until the end of his life. Being without formal education, he had to take, and passed with outstanding results, a special examination at the Academy of Fine Arts in Krakow. Earlier, in 1922, he had participated in an exhibition with some of his new engravings, and in the following years he displayed his work in other Polish cities. The response was rather paltry and limited to the local press.

His native environment, with which he always maintained close contact, was the Jewish community of Drohobycz, especially the less Orthodox, partly assimilated elements that made up an important part of the local intelligentsia. Jews constituted the majority of the lawyers, doctors, merchants, and industrialists. Schulz's family bonds were his most essential link to that community, which included most of his friends and the loves of his youth. After he had gained a reputation as a writer, Schulz was able to enlarge his circle of acquaintances and friends. Nonetheless, as a born loner and a man of the provinces, he preferred to maintain his contacts through letters. Thanks to his books he won "comrades in writing," but not companions for his wearisome provincial life. Here he had to rely on his fellow teachers. With few exceptions, however, they were not capable of spiritual communion. Schulz was a conscientious teacher, yet he treated his occupation as a harsh necessity consuming his time and draining his creative energy.

Only one person knew about his early literary attempts—Schulz's friend, a Polish-Jewish writer from Lvov, Debora Vogel. His letters to her contain fragments of dazzling, fanciful prose. Debora Vogel strongly encouraged him to continue writing, but even without her encouragement he was quite confident about his literary gifts. Full of complexes, pathologically timid, prone to depression and self-doubt, he placed all his hopes in his creativity and was sure that in this particular area he was capable of great achievements. The fragments

included in the letters to Debora Vogel later became *Cinnamon Shops*. According to the majority of Polish literary critics, the book was a revelation. Almost overnight Schulz joined the ranks of the most outstanding representatives of Polish literature. Soon afterward he received a great distinction: the Golden Laurel of the Polish Academy of Letters.

But writing could not provide him with a livelihood, especially since he had to support not only himself but also his sick sister and her two sons. The inhabitants of 10 Floriańska Street in Drohobycz could survive only on Schulz's meager school salary and, for a time, on support sent by his brother. As a recognized author he applied for a six months' leave of absence, which he used to complete several stories and essays and to prepare his second book, *Sanatorium under the Sign of the Hourglass*.

In 1933 he met his future fiancée, who, with his consent, started efforts to move him to Warsaw and to find him a better-paying job. But the obstacles proved stronger than the desire to improve his existence. Schulz was not ready to leave Drohobycz. He sensed mortal danger in parting from his family and the microclimate that nourished his imagination. The engagement was broken off and Schulz remained in Drohobycz.

Sanatorium under the Sign of the Hourglass was published in 1937, and soon afterward Schulz tried in vain to have it translated into German or Italian. When a year later he returned from Paris—the only foreign trip of his life—he announced that he had given up any hope of "crossing the borders of the Polish language." He wrote a story in German, "Die Heimkehr," but it was already too late. It was almost 1939. He had also completed a book of four stories he had no time to publish. During the upheaval of the war they disappeared without trace.

According to the Soviet-German pact of 1939 Drohobycz was taken over by Soviet troops and the whole region was incorporated into the Soviet Union. During the less than two years of Soviet rule Schulz had absolutely no chance of publishing his works. Although he escaped deportation or exile—the fate of hundreds of thousands—any creative work was out of the question. The Stalinist model of political writing imposed with absolute rigidity was an anathema to artistic creation. The only attempt to find a publisher met with a derogatory rejection. He continued to earn his living as a teacher. He also took up jobs as a decorator for official events. That function gave him relative security, and refusal could have had the most unpleasant consequences.

He was still drawing for his own sake—to find artistic satisfaction, which had become a rare luxury. He could no longer write. And yet this period would appear as nothing in comparison with what was to follow. German troops

entered Drohobycz in June 1941, and Schulz, like thousands of other Jews, was excluded from any human law. An official of the Gestapo, one Felix Landau from Vienna, a murderer of many Jews, boasted that he had a Jewish artist-slave whom he kept alive on a slice of bread and a bowl of soup. That is how art, the vocation of Schulz's life, prolonged his existence for over a year. The Polish underground directed by the Polish Government in Exile in cooperation with the Home Army provided Schulz with false documents to facilitate his escape and going into hiding. The writer never had the chance to use his "Aryan papers." On 19 November 1942, during an operation against the Drohobycz Jews remembered by survivors as Black Thursday, Schulz was shot in the head by a Gestapo officer named Karl Guenther. A friend buried him at night in the Jewish cemetery. The exact location of his grave is unknown.

To Schulz, life made sense only as a creative effort. Creativity was the goal of his dreams and strivings. He said many times that existence unsanctioned by art would be unbearable and not worth the trouble. Such total internal unity between an artist and a man is a rare occurrence. He remains among us in what he has left behind—his work. His existence is more intense and universal than when he was an unknown drawing teacher in the remote provinces. Despite his doubts, *Cinnamon Shops* and *Sanatorium under the Sign of the Hourglass* were published in more than twenty languages in Europe, America, and Asia. This triumphant march of his work was late in coming. It happened without his personal participation and satisfaction. Schulz's fame is his posthumous child, yet it fulfilled itself as if confirming his thought expressed in the untranslated story "The Republic of Dreams": "It seems that no dream, no matter how absurd and preposterous, is wasted in the universe. A dream contains a hunger for reality, a striving which compels reality, which grows imperceptibly into a claim and a postulate, a promissory note that calls for compensation."

This fulfillment includes not only Bruno Schulz's writing but also his drawings and engravings. Those that were saved travel around the world and are exhibited in New York, Paris, Marseilles, Nantes, Jerusalem, Oxford, and other cities. On these pages they come together for the first time in such an extensive and representative selection.

I am happy to have been part of this fulfillment.

Jerzy Ficowski
Translated by Jarosław Anders

Notes

[1]Bruno Schulz, "An Essay for S. I. Witkiewicz," in *Letters and Drawings of Bruno Schulz,* ed. Jerzy Ficowski, trans. Walter Arndt (New York: Harper & Row, 1988), p. 110.

[2]"The method I employ," wrote Schulz to a friend, "is a laborious one. It is not etching, but the so-called *cliché-verre,* or glass plate. One draws with a needle on a plate of glass covered with black gelatin. The result is a kind of negative, which is later copied on photosensitive paper, developed, fixed, and washed, just like photographic film."

[3]Ibid., p. 112.

[4]Bruno Schulz, "The Age of Genius," in *Sanatorium under the Sign of the Hourglass,* trans. Celina Wieniewska (Harmondsworth: Penguin Books, 1977), p. 23. Future quotations from this book are cited in the text using the abbreviation *S.*

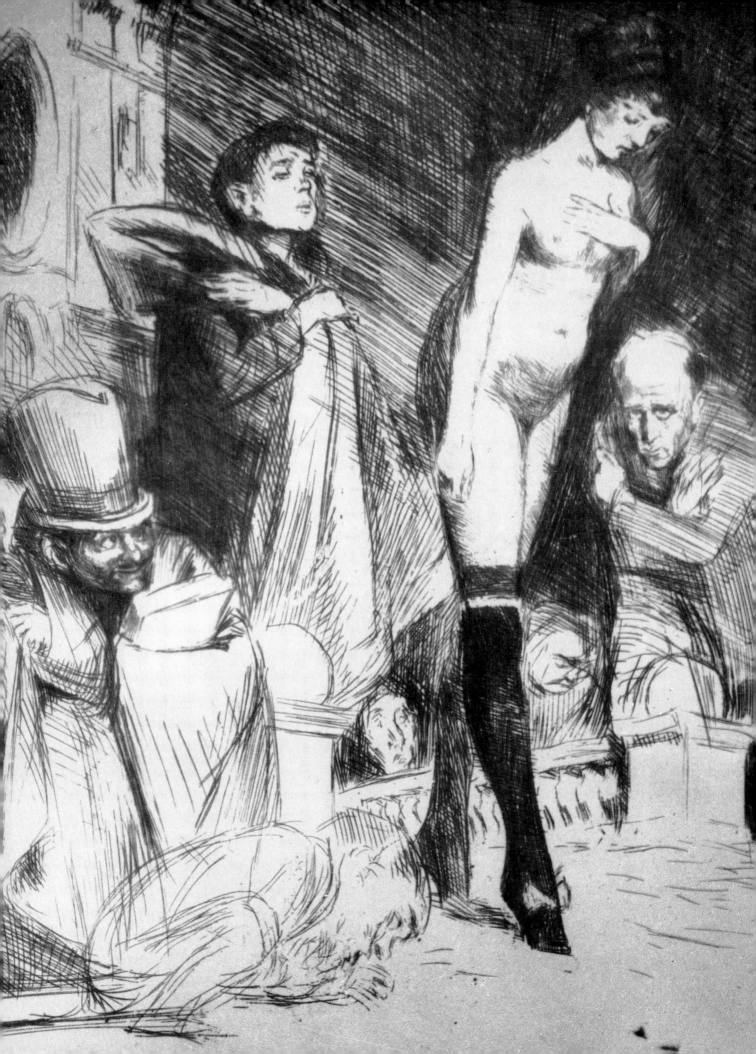

The Caterpillar Car,

or

Bruno Schulz's Drive into the

Future of the Past

In 1870 Leopold von Sacher-Masoch, whose sexual fantasies and habits led the psychoanalyst Krafft-Ebing to coin the term *masochism,* published his best-known book, the novel *Venus in Fur.* Some fifty years later Bruno Schulz, a drawing and crafts teacher at a secondary school in Drohobycz, a small town in Galicia, started to scratch into gelatin-covered glass plates compositions clearly indebted to masochist iconography. They show big women towering over street corners, stretching on huge, altarlike beds, reclining on monumental couches, or occupying thronelike chairs, and dwarfish skinny men creeping at their feet. The females, naked or dressed in ostentatious dishabille, have the depraved look of prostitutes. The males, either naked or in cheap dark suits or clown costumes, combine the appearance of modest clerks or stand-up comedians with the features of fantastic fauna: broken-down horses and crippled mongrels, cats, rats, bats, birds, and roaches. The scenes are shown against a background of petit bourgeois salons and bedrooms, provincial brothels, or the vistas of Drohobycz; they smell of suspect sex and often include the artist's self-portrait.

Schulz glued the finished prints to cardboard sheets and put them into cloth-bound portfolios that he called *Xiega Bałwochwalcza* (The Book of Idolatry). This wish to codify his ongoing fantasy of men's adoration of women and the title, even more provocative in Polish because of *Xiega,* an archaic and sacred-sounding word for book, suggest the creation of an *à rebours* bible. After

class Schulz worked on it in the crafts room. But he told his pupils that he had been illustrating *Venus in Fur*. This explanation was meant to mislead the school authorities, but there was more to it. Sacher-Masoch's novel is indeed a "book of idolatry"—and the bible of masochism. Its autobiographical hero, Severin von Kusiemski, a Russian-Polish-Austrian aristocrat, dedicates his life to the worship of cruel femininity. As a child he kneels in his father's library in front of a plaster Venus to whom he addresses the only prayers he knows: the Pater Noster, Ave Maria, and Credo. As a young man he falls in love, like Pygmalion, with a marble Venus, is plagued by hallucinations of her coming alive, and finally establishes an identity between the statue and a real woman, Wanda von Dunajew, to whom he transfers his feelings.

The Severin-Wanda love affair, the story of a man's total enslavement by a woman, begins in a Galician spa situated, like Drohobycz or Truskawiec, a health resort where Schulz used to spend his vacations, at the foot of the Carpathian Mountains. This wild landscape, a piece of untamed nature where primitive people and bears dwell, is contrasted by Sacher-Masoch with civilization—the provincial nest from whose boredom Severin tries to escape by means of fantasy. A shy dilettante dabbling in painting, poetry, and music and a student of chemistry, alchemy, history, astronomy, philosophy, law, anatomy, and literature, he shares a house with two widows: an elderly housewife, Madame Tartakowska from Lemberg, and Wanda, an attractive, rich, and provocatively dressed aristocrat in her early forties. Wanda occupies the second floor, while Severin lives on the first, and, no less bored than himself, starts to prepare herself for the role of a ruthless mistress that he wants her to play. The day she declares herself ready to enact Severin's masochist drama, the two leave for Italy. Their journey to the south evokes and parodies the traditional *Bildungsreise* of northern poets and their protagonists, a Goethe and a Faust, a stereotyped return to the bosom of nature and culture.

Bruno Schulz was not a Galician landowner with the leisure and means for staging his reveries. He was the youngest son of a Jewish textile merchant whose early death had left the family in less than modest conditions. He lived in his mother's house, which, after the suicide of his brother-in-law, he shared with his widowed sister and her two sickly children. Thus real escape was probed not *in vivo* but *in vitro*—on glass plates transporting the distressed male head of a sad household to a mythical space and time: the isles of love, eternal spring, and death. There in the "thirteenth month," added by Schulz to the ordinary calendar, men were stripped of their civilized breadwinner's skins and reborn as infants, animals, and playthings of an Aphrodite or Circe.

Schulz's women, evocative of powerful pagan goddesses, seem to be superior. But their superiority is also a form of degradation. The erotic prominence of femaleness is associated with the all-encompassing but inferior quality of womb, mother, and earth and connected, like in the Old Testament and in Platonic philosophy, to matter, ignorance, and immorality. This archaic vision of femininity as omnipotent nature and low culture prevails in Schulz's texts and pictures, where women represent a physical threat and an irresistible temptation. Each of them is a potential Eve and whore—a medium of debasement men want to use in order to escape from the law and order of the public world into a private and primitive state of existence.

Masochism begins with emotion, longs for motion, and requires locomotion. It's a trip, up for one partner, down for the other, for which Sacher-Masoch and Schulz choose the same bio-mechanical type of transportation: a horse carriage. As it drives the *Venus in Fur* lovers out of Galicia, Severin dreams about being a horse, while Wanda, who meanwhile has employed him as her servant and renamed him Gregor, treats her man like a baby or lapdog. Thus the rolling car serves as a vehicle of degradation in whose dark depths the process of debasement is initiated. A servant begins to metamorphose into a slave, a slave into a domestic animal, an animal into a corpse. Wanda orders Gregor to sign a document saying that Severin von Kusiemski has committed suicide. This gives her the freedom to kill him any time she wants. Severin does not hesitate to enter into the Mephistophelian pact, since for him only the most radical approach guarantees the complete attainment of pleasure.

The metaphor of a horse carriage is placed by Schulz at the origin and center of his entire graphic work. "Before I could even talk," he writes,

> I was already covering every scrap of paper and the margins of newspapers with
> scribbles that attracted the attention of those around me. At first they were
> all horses and wagons. The action of riding in a wagon seemed to me full of
> weight and arcane symbolism. From age six or seven there appeared and
> reappeared in my drawings the image of a cab, with a hood on top and lanterns
> blazing, emerging from a nocturnal forest. That image belongs to the basic
> material of my imagination; it is a kind of node to many receding series.
> To this day I have not exhausted its metaphysical content. To this day the
> sight of a carriage horse has lost none of its fascination and troubling power.
> Its schizoid anatomy, sprouting antlers, whorls, knotholes, outcroppings at
> every extremity, was arrested in its development, as it were, at a time when
> it still wanted to reproduce and branch into other forms. And the wagon
> is a schizoid structure, too, derived from the same anatomical principle—

multiarticulated, fantastic, made up of sheet metal warped into flipper shapes, of horse hides and huge clattering wheels.[1]

The journey's destination and the relationship between the carriage and the horse hinted at in this passage are made explicit in a print entitled *On Cythera* (cat. no. 17). It shows a fleshy woman, a whip in her hand, seated in a carriage pulled by naked men.

Who are the men in Schulz's prints? Modeled after Drohobyczan masculinity, they evoke, depending on their age, either fathers or sons and correspond to the mythical Father-Son doublet, a central motif of Schulz's prose. His stories are set in his childhood and deal with the horror and delight with which Son witnesses Father's degradation. Once Father was a mirror image of Jehovah as Logos and Demiurge, a personification of a Righteous Jewish Man and Good Emperor. His mind was focused on the Bible, and his life, deeply rooted in ritual and duty, had purpose, moral direction, and aesthetic quality. But after his faith crumbled, Father became vulnerable to the evil charm of primitive womanhood and fell under the thumb and toe of Adela, a simple servant girl. Under her bewitching gaze, Father retrogrades to a lower species, a bird or insect. Schulz's degradation outdoes the *Venus in Fur* scenario. His men do not behave like animals; they transform into beasts. Masochism ends in metamorphosis.

Masochism is commonly defined as a sexual aberration. But it also possesses, like every form of sexuality, a social, cultural, and historic dimension. The emergence of a collective desire for submission and regression signals a crisis of civilization. Sacher-Masoch's and Schulz's respective preoccupations with male degradation do not reflect merely their personal predilections. Both testify to the masochism of late nineteenth-century Europe. After the power of her monarchs and traditional male authority had withered, she perceived herself as decadent and, reveling in degradation and apocalypse, prepared herself for the iron fist and the mustached monstrosity of the Hitler-Stalin duo.

The erotic fantasies of Son, the protagonist and narrator of Schulz's stories, are embedded in a broader context of decline—of Father and the *Abendland*. In the tale "Spring" one emperor, the ancient Franz Joseph, fades away; another, his brother Maximilian of Mexico, fails and is first executed and then replicated as a wax cabinet doll. A whole generation of Fathers are exiled from their hometown to the "Sanatorium under the sign of the hourglass"—a ghetto, camp, and extermination site in one. Schulz sees the late nineteenth century in terms of Father's gradual deposition, the early twentieth century in terms of his absence. Father's place has been taken by Mother and Son or, more precisely, two depraved Sons.

One is a masochist and underdog, the other a sadist and "crocodile" whose every wink and gesture promises "to release the lowest instincts from their shackles," or a "Dr. Gotard," a superbureaucrat and the sinister director of the Sanatorium.[2] Schulz reworks the ancient myth of the twins, one passive and peaceful, the other a wicked aggressor, and the classic hammer-anvil metaphor on which Sacher-Masoch based his *Venus in Fur* and his philosophy.

Son-Underdog is still attached to the memory of his Father. But he is interested mainly in sex and fun and has completely abandoned The Book for Books of Idolatry: the illustrated magazines Adela leafs through, tears apart, and takes "to the butcher's for packing meat" or the Father's lunch.[3] While Father preserves dignity by holding onto his trade even in the satanic setting of the Sanatorium, Son embarrasses him by ordering a pornographic book and riding in a monstrous vehicle, a telescopic car that resembles a living creature. This science-fiction automobile, the single most visionary metaphor and picture of Schulz's entire oeuvre, represents a modern equivalent of the old horse carriage and suggests advanced pleasure and depravation.

To stimulate Son's expectation, the telescopic car arrives folded in a package and begins to rise under his fingers to "a kind of enormous bellows, a labyrinth of black chambers, a long complex of camera obscuras, one within another." After having reached its final form, that of a huge "arthropod with two imitation headlights on the front," the car starts moving and providing the passenger with distant images. "Sitting, as it were, in the rear chamber of the telescope as if in the back seat of a limousine," the Son can now see in his "field of vision the maid walking along the darkened corridor of the Sanatorium."[4]

Severin von Kusiemski was dominated by Wanda, Father by Adela. Son, the traveler in the telescopic car, is captivated by illusory femaleness. He is seduced and controlled by an image beamed at him from a distance. The new degradation, a simulation, is provided by a fantasy vehicle that needs neither a real woman nor a real man-horse. The tele-limousine foreshadows the future— an automatic car furnished with a TV—and suggests the spaced-out suspense of the electronic age. When existence is reduced to a passive reverie in front of a simulated reality, humanity becomes enslaved as if from within and loses, as in Schulz's sanatorium, the sense of time: "Whole chunks of time are casually lost somewhere; control over the continuity of the day is loosened until it finally ceases to matter; and the framework of the uninterrupted chronology that one has been disciplined to notice every day is given up without regret."[5]

Some thirty years later the imprisonment in an impenetrable mass-media bubble and the timeless character of a global-village humanity were observed by

Marshall McLuhan. Approximately at the same time, Oswald Wiener, an Austrian writer who had probably never read Schulz, described in his novel *Die Verbesserung von Mitteleuropa* (The Improvement of Central Europe, 1962–67) a fantastic bio-electronic apparatus called the "bio-adapter." Connected to a person's body and brain, the bio-adapter can simulate anything he or she desires and thus substitute for the world. "Even the ecstasy of annihilation can be induced and heightened by the adapter irrespective of whether annihilation is directed toward the world or toward the subject."[6]

The bio-adapter has fascinating implications. A wonderwork of modern technology, the instrument aims at reducing humanity, which has produced it, to an embryonic state of total dependence. The bio-adapter functions as an artificial womb and makes us realize that it won't be easy to get away from the archaic and uncomfortably misogynic metaphor of femininity as the matter and warp of life, because enclosures, particularly when they induce regression, sleep, and dream, are likely to be associated, even when they are totally man-made, with biology and womanhood. Paradoxically, nature can be completely replaced with artifice and still be experienced as *das ewig Weibliche*. Schulz's car, manufactured from "lightweight paper and stiff canvas imitating the bulkiness of reality," is "a theatrical prop," a piece of modern trash and a cheap simulation. But since it offers an adult man a female-animal feel and mesmerizes his mind with the "real" images of things he desires, it has the power of driving him into an embryonic state. In a contemporary piece of science fiction, "Chiprunner" by Robert Silverberg, an anorexic young man keeps shrinking and running out of the world until he reaches the size of an atomic embryo-skeleton—small enough to slip into a microchip.[7]

Civilized humanity longs to leap back to barbarity and nature. And the quicker the progress, the stronger the longing. However, true returns are rare. More often, they remain just a dream, and the result is an overproduction of junk imitative of the virgin jungle: "a rich but empty and colourless vegetation of pretentious vulgarity" which reproduces itself with an "almost self-propagating fertility."[8] Schulz's visual imagination was stimulated by the biological character of turn-of-the-century culture—the *belle époque* Europe that transformed itself as a whole into an artificial cave garden. Couches and desks, bedrooms and bathrooms, brothels and hotel lobbies, railroad stations and sanatoria assumed vegetal, animalistic, and feminine shapes, were saturated with Greco-Roman obscenities, and pretended to be temples and altars of a global femme fatale—Mother Earth and Planet Venus—a make-believe demon every high-class woman tried to be. Dresses trimmed with paillettes and pearls, shell-shaped

accessories with coral and mother-of-pearl inlays, shoes and bags manufactured from snake and crocodile skin, feathers, boas, tiger and cheetah furs, hats imitative of bird nests or fruit and flower baskets, and other fantastic outfits made women resemble exotic fauna and flora and blend with their environment.

This fusion of nature and artifice exuded devilish seductiveness. Reviewing the late-1800s style of Rupert Carabin, a popular and influential French furniture maker, Max Nordau wrote in his book *Dégénérescence* (1892): "These staircase banisters on which naked and possessed Furies parade tumultuously, these bookcases on which the decapitated heads of assassins form bases and pilasters—even this table which provides the vision of a gigantic opened book borne by gnomes—constitute a style of, and for, the feverish or damned. If the director-general of Dante's Inferno has a reception room, it must surely be similarly furnished."[9]

The *belle époque* is a textbook example of how the progress of civilization is accompanied by the psychological need for regression and degradation. But the phenomenon is probably as old as the world. Only in modern times it has been intensified and speeded up. As new technologies uproot existing traditions, feelings of nostalgia surface. People panic and dream about going underground or to the moon. They also become extremely susceptible to ideas of renewal: the arrival of a new Spring, a demigod or goddess. Suffering from contradictions and exaggerations, periods of transition oscillate between manic and depressive and produce a literature and art that, as we know from Bakhtin, prefer the grotesque.

The grotesque, a steady subcurrent of European culture dedicated to the exploration of the nightly and subterranean, the apocryphal and heretic, has been dominated by idiosyncratic outsiders and visionaries, people interested in retiring to primordial foundations and escaping into the future. Relatively few writers (Rabelais) and artists (Hieronymus Bosch, Giuseppe Arcimboldo, Aubrey Beardsley) focused exclusively on the grotesque. However, the importance of this fantastic dimension was acknowledged by all great masters. The luminous nobility of Dante's heaven is complemented by the ludicrous horrors of his hell; tragic scenes are followed by obscene jokes in Shakespeare's or Goethe's plays; the monumental simplicity of Giotto's saints is contrasted with his tail-and-horn diableries; craziness and evil creep around in the pictures of the Brueghels; some of Leonardo's sketches of human faces resemble animal heads; people turn into beasts in the novels of Victor Hugo or Balzac; Michelangelo portrays himself as flayed skin; Raphael surrounds his biblical Vatican frescoes with monstrous pagan arabesques; devils and witches slide in and out of Dürer's prints; Goya depicts Time as a terrible giant, Saturn, devouring one of

his children; Jacques Callot's illustrations of the *commedia dell'arte* and Hogarth's and Cruikshank's satirical sketches render the perversion, folly, and cruelty hiding in back of the civilized stage.

Bruno Schulz, a late heir of the grotesque tradition, is drawn to the fantastic landscapes, *fleurs du mal,* and caves of nineteenth-century literature and art. He keeps strolling in "these gardens . . . where, between old walls, poisonous plants are growing, where Poe's artificial Edens, full of hemlock, poppies, and convolvuli, glow under the grizzly sky of very old frescoes"; and he keeps waking up, like Severin von Kusiemski, "the white marble statue sleeping with empty eyes in that marginal world beyond the limits of a wilting afternoon."[10] But beyond the grottoes of the past Schulz catches a glimpse of the future caves. They extend in the back of "cheap jerrybuilt houses with grotesque façades, covered with a monstrous stucco of cracked plaster"—in "the Street of Crocodiles."[11]

As an artist Schulz was indebted to European art nouveau and early expressionism. As a writer he was fascinated by the exuberant and convoluted imagery of Young Poland, especially Bolesław Leśmian, and by the uncanny and apocalyptic literature of the Austro-Hungarian empire. Schulz's stories echo the prose and poetry of the young Hugo von Hofmannsthal, Leopold von Andrian, and Georg Trakl; and they reflect the preoccupation of those writers with infancy as time and space—the "age of innocence," the "cave of pre-existence," and the "garden of knowledge."[12] Schulz was also a close relative of the various turn-of-the-century author-artists describing and depicting the obscene, enchanting, and terrible territory situated "under the hill," in Aubrey Beardsley's unfinished novel of that title, or on the "other side," in Alfred Kubin's novel *Die andere Seite* (1909). In this paradise-hell of a paranoid masochist the beginning and end meet. During his stay in a psychiatric hospital, the painter Edvard Munch composed a horrible little story, "Alpha and Omega" (1909), which tells us how the monsters that have been engendered by the woman Omega in her extramarital copulations with beasts tear to pieces her husband, Alpha.

Bruno Schulz has often been compared to Franz Kafka, whom he translated into Polish and by whom he was certainly influenced. But in spite of similarities, the tone and climate of Schulz's work differ greatly from those of Kafka's writings. Kafka renders debasement in a dry, hard-edge German with a deliberately bureaucratic and rabbinic touch. Schulz tracks the sociobiologic leveling down in an overheated, poetic Polish of a grotesque visual artist inspired by the sensuality, irony, and wit of Hasidic storytelling. The metaphoric richness of his language ties Schulz to the past and makes him appear or, more precisely, made

him appear less modern than Kafka after World War II, when Kafka's books were read as unsurpassed visions of the totalitarian death machine. Nevertheless, Schulz has been internationally acclaimed as a great fiction writer of twentieth-century Poland. His graphic oeuvre, however, has often been considered a curious anachronism lagging behind his prose; in consequence, it has remained relatively unknown. Indeed, both Schulz's iconography and his form are likely to embarrass a conventional scholar of twentieth-century art. His idolatric fantasies resemble the satirical sketches young Félicien Rops (1835–98) published in "Le crocodile," a student magazine, under the influence of Honoré Daumier and Gavarni. Alas, Schulz's drawings were executed some seventy-five years later.

The artist Bruno Schulz does not fit into the traditional scheme of modernity, a hierarchy that was established in the thirties and put into textbooks in the fifties and sixties. Does it mean that he was a provincial epigone who was as stuck in Drohobycz as Drohobycz was stuck in the past? Or is there something wrong with our value system? I want to argue in favor of the second proposition and against the common belief in a main line in twentieth-century art progressing from realism to abstraction, from mythology to rationality, from hot subjectivity to cool objectivity, from illustration to autonomy, and from the flora and fauna of sadomasochist fantasy to the order and clarity of the Bauhaus. I also want to use Schulz's case to reexamine the common definition of the twentieth-century avant-garde.

At any given point in history, humanity defines as leading and central the art it wants to be visible, as retrogade the art it wants to hide. The assignment of top places to Malevich or Mondrian, the main representatives of the classical twentieth-century avant-garde, celebrates the spirituality and abstraction of a highly civilized humanity absorbed in measure and mathematics, the analysis of the color spectrum, and the most subtle permutations of form, rhythm, and tone. Their pursuits and pictures reflect the new ideals of objectivity, rationality, and science cherished by an enlightened elite, which believes that humanity has finally outgrown its primitive origins, vegetal, animalistic, and embryonic; that it has left behind—once and for all—the archaic swamps and shadow caves of the past and arrived at the luminous heights of pure intelligence. Indeed, that's how Malevich and Mondrian dream the twentieth century—and seduce us to dream it with them. But to do justice to the history of this century, their solar squares must be seen in the company of other, obscure, troubling, and archaic-looking images showing the lapse into barbarity, degradation, and irrationality that occurred in spite of the ambition to pursue light and reason.

Ours has been a time of totalitarianism. The totalitarian systems rose in reaction to modernity. But they were also fueled by progress. The fascist, nazi, and communist ideologies combined scientific or pseudoscientific tendencies with the religious duality of good and evil and a millennia-old messianism: prophecies of an apocalyptic struggle that would purge all bad humanity (inferior races or classes) from the surface of the earth and end in paradise. The implementation of this new Revelation resulted in an unprecedented debasement. Millions were enslaved or exterminated like roaches; entire countries were dragged down to the level of kindergarten-camps. The new despotism reduced the quality of everything, infantilized people, and brought out the beastly within individuals and societies. Complexity and moderation were replaced with polarity and antagonism. And as the victim-master bond began to dominate all other relations, reality was degraded to a sadomasochist farce.

This development went very much against the expectations of the mainstream international academia, whose opinion was summarized by a former lecturer at the Hartford School of Sociology in the eleventh (1910) edition of the *Encyclopaedia Britannica*. There "civilization" is divided into three stages: the first terminates with the introduction of gunpowder; the second ends with the invention of the steam engine; and the third, "the Upper Period of Civilization," is nearing its termination. Soon, we are told, the last traces of barbarism will be erased by the final victory of cosmopolitanism and humanitarianism. Peace will descend onto the earth, and a new, enlightened humanity will "doubtless marvel that their ancestors of the third period of civilization should have risen up as nations and slaughtered one another by thousands to settle a dispute about a geographical boundary. Such a procedure will appear to have been quite as barbarous as the cannibalistic practices of their yet more remote ancestors, and distinctly less rational, since cannibalism might sometimes save its practiser from starvation, whereas warfare of the civilized type was a purely destructive agency."[13]

This proclamation of optimism delivered only four years before the outbreak of World War I shows that reasoning which does not take into account the contradictory character of human nature amounts to little more than wishful thinking. Obviously, the future cannot be grasped when civilization is seen as a one-way street and the obscure archaism of civilized humanity, something grotesque artists have studied for ages, is ignored. Everyone, Freud observes in *The Future of an Illusion,* is an enemy of law and order and thus dreams, not about becoming more civilized, but about getting out of civilization.

The problem of escape lies at the core of Schulz's entire work. In his short story "Spring" the wish to jump out of one's civilized skin is tied to the awaken-

ing of a boy's sexuality and presented as an irresistible seduction. The story is narrated by Joseph (a name evocative of both the biblical Joseph and the Hapsburg emperors), a schoolboy who flees from his fatherland ruled by the emperor Franz Joseph, who "rested on top of everything," to "the dark foundations" of being: the world of "the Mothers," with its "movement and traffic, pulp and rot, tribes and generations."[14] Joseph's new motherland is personified by Bianca, an aristocratic girl dressed in white. Riding in her "shining, open landau as broad and shallow as a conch," Bianca resembles a young Aphrodite and allegorizes Spring rising from the depths of the earth. But she also acts, being an illegitimate daughter of Maximilian, the emperor of Mexico and the exotic and doomed brother of the mediocre Franz Joseph, as an emissary from the eroticized and degraded twilight territory of the empire. There adventure and intrigue mix, revolution and war originate, and the defeat of civilization is hatched.

But the wish to escape represents only one side of humanity's paradoxical relationship with civilization. On the other side, Schulz tells us in "The Street of Crocodiles," we love civilization for the pleasures it offers us; and even more because it promises ultimately to free us from civilization by "breaking down the barriers of hierarchy" and returning us to the primordial "shallow mud of companionship, of easy intimacy, of dirty intermingling."[15] Schulz perceives civilization as an immanent absurdity. The more humanity tries to better itself through the enforcement of moral norms and the rules of reason, science, and technology, the more it has to repress primitive instincts and passions. In turn, the stronger becomes everyone's desire to grow the fur and claws of beasts and dive into "voluntary degradation."

The Street of Crocodiles is a product of civilization—and a threat to civilization. The dubious district is a huge shopping mall stuffed with mass-produced rubbish and populated with the scum "of the lowest orders," with "creatures without character, without background, moral dregs" whose only goal is to consume and make others consume. Therefore they multiply enticements, devise new sales strategies, and tempt clients with tricks and fantastic transformations. What begins as a shopping spree ends in a fata morgana of confusion and depravation: "It then appeared that the outfitter's shop was only a façade behind which there was an antique shop with a collection of highly questionable books and private editions. The servile salesman opened further store rooms, filled to the ceiling with books, drawings, and photographs. These engravings and etchings were beyond our boldest expectations: not even in our dreams had we anticipated such depths of corruption, such varieties of licentiousness."[16]

But this is neither the climax nor the end. The tailor's store in the Street of Crocodiles keeps metamorphosing. It changes from an antique store into a vaudeville theater or peep show, with salesgirls and boys assuming the roles of cheap entertainers. First they demonstrate to one another the obscene "poses and postures of the drawings on the book jackets"; then, turning their backs on the client, "they adopted arrogant poses, shifting their weight from foot to foot, making play with their frivolous footwear, abandoning their slim bodies to the serpentine movements of their limbs and thus laid siege to the excited onlooker whom they pretended to ignore behind a show of assumed indifference. This retreat was calculated to involve the guest more deeply, while appearing to leave him a free hand for his own initiative."[17]

This visionary passage rings many bells. It brings to mind the endless simulation and sexualization provided by today's advertising, the hallucinating effects of TV spots stimulating childish appetites, and the achievement of a universal involvement by means of covering everything with a new reality "as thin as paper," or "a screen ironically placed to hide the true meaning of things."[18]

Kafka's sensibility picked the menace of degradation through totalitarian bureaucracy from the air of his day. Schulz, on the other hand, had an eye for detecting threats to human integrity in escapist and sadomasochist tendencies. This exit from civilization, he predicted, will end under the trash heap of a Disneyland: in an artificial marsh with a bio-touch. This low world, thriving on the aggressivity of salesmen and the passivity of clients, resembles either a "sanatorium," where dreadful conditions make humans mutate to dogs, or commercial districts quickly rising and even more rapidly disintegrating "into the geometry of emptiness, into the timbers of a void."[19]

The scope of Schulz's art is not as broad as that of his fiction. But in his prints and sketches degradation is even closer at hand, even more intimately palpable than in his texts. Taking off from Sacher-Masoch, the bulk of nineteenth-century masochist art and literature, and the central metaphor of a suicidal Tannhäuser, an infant-frog groping in the dark and drinking the cup of oblivion at the bottom of a humid Venus grotto, Schulz proceeds to depict her cave, which can also serve as a crocodile's or wolf's hideout (Hitler's bunker beneath a Polish forest was called the *Wolfsschanze*).

Schulz's visual power is derived from the grotesque tradition. What appeared old-fashioned earlier in this century, when abstraction and formal innovation were given the highest marks, now strikes us as very much to the point. *Tempora mutantur, et nos mutamur in illis.* In the course of this century we have become tired of art divorced from reality and fed up with the perfec-

tion of empty gestures. Today pictorial narration fascinates us again, and we prefer it to be casual rather than saturated with style. Thus we appreciate Schulz's nonchalance. Moreover, we realize that if his dream of degradation were more stylized, it would be a vain exercise in pathos and kitsch. Schulz's depiction of himself as this century's exemplary underdog—a Central European Jew and provincial schoolteacher offering gold-paper crowns to queens who are either maids or tailor's dummies—succeeds because of his self-deprecating intensity and modesty.

The art of Bruno Schulz is an example of how the anachronism of yesterday can become the avant-garde of tomorrow; how the disregard for style can infuse the immediacy of a snapshot into a sketch; and how in our age of photography too little form may be more effective than too much of it. In his small, dark plates swarming with masochist masculinity, Schulz gives himself away more than in his texts. Pointing to himself and letting us see it all, he uses his art to dwell on his own debasement. This makes contact with his work embarrassing and painful. It's like listening to a confession one does not want to hear. Thus it takes time to appreciate Schulz's art, which at first glance almost everyone dislikes. But as repulsion is followed by a lasting desire to return to his pictures, to scrutinize the agony of his protagonists, to penetrate the corners of his plates, each of them pregnant with monstrosity, one begins to admire Schulz's multiple self-portraits of degradation. Imperceptibly, his reveries and nightmares become part of our own suffering, reminding us that hell is situated not without, but within.

Behind Kazimir Malevich's white square a long tunnel extends. In its darkness a dwarf drives a black caterpillar. To grasp the complexity of twentieth-century humanity, I recommend complementing the well-known facade of modern art, an absolute of abstraction, with the ignored backstage: the grotesque realism of Bruno Schulz, whose escape into the past has ended in the future.

Ewa Kuryluk

Notes

[1]Bruno Schulz, "An Essay for S. I. Witkiewicz," in *Letters and Drawings of Bruno Schulz,* ed. Jerzy Ficowski, trans. Walter Arndt (New York: Harper & Row, 1988), p. 110.

[2]Bruno Schulz, "The Street of Crocodiles," in *The Street of Crocodiles,* trans. Celina Wieniewska (Harmondsworth: Penguin Books, 1977), p. 102.

[3]Bruno Schulz, "The Book," in *Sanatorium under the Sign of the Hourglass,* trans. Celina Wieniewska (Harmondsworth: Penguin Books, 1979), p. 5.

[4]"Sanatorium under the Sign of the Hourglass," ibid., p. 124.

[5]Ibid., p. 125.

[6]Oswald Wiener, "The Bio-adapter," trans. Patrick O'Brien, *Formations* 4, no. 2 (Fall 1987): 91.

[7]Robert Silverberg, "Chiprunner," *Isaac Asimov's Science Fiction Magazine,* November 1989, pp. 84–98.

[8]Bruno Schulz, "The Street of Crocodiles" and "August," in *The Street of Crocodiles,* pp. 101 and 32.

[9]English translation after John Loring, "Belle Epoque," in *Fantasy Furniture,* ed. Bruce M. Newman (New York: Rizzoli, 1989), p. 135.

[10]"August," p. 53.

[11]"Street of Crocodiles," p. 101.

[12]*Der Garten der Erkenntnis,* 1895, a compendium of early intuitions published by Leopold von Andrian at the age of twenty. See Ewa Kuryluk, *Wiedeńska Apokalipsa* (Krakow: Wydawnictwo Literackie, 1974), pp. 121–61.

[13]Henry Smith Williams, "Civilization," *Encyclopaedia Britannica,* 11th ed., 6:408.

[14]Bruno Schulz, "Spring," in *Sanatorium,* pp. 33 and 43.

[15]"Street of Crocodiles," p. 101.

[16]Ibid.

[17]Ibid., p. 104.

[18]Ibid., pp. 105 and 103.

[19]Ibid., p. 102.

The Drawings of BRUNO SCHULZ

The Book
of Idolatry

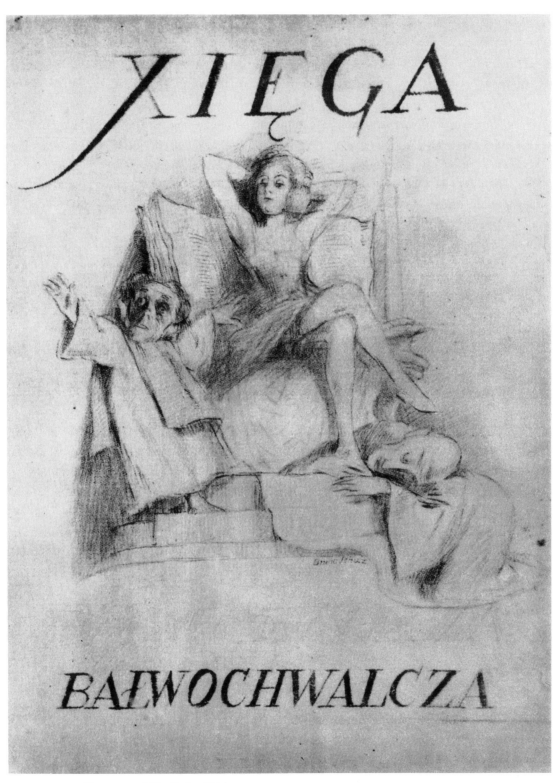

1. The cover of *The Book of Idolatry*

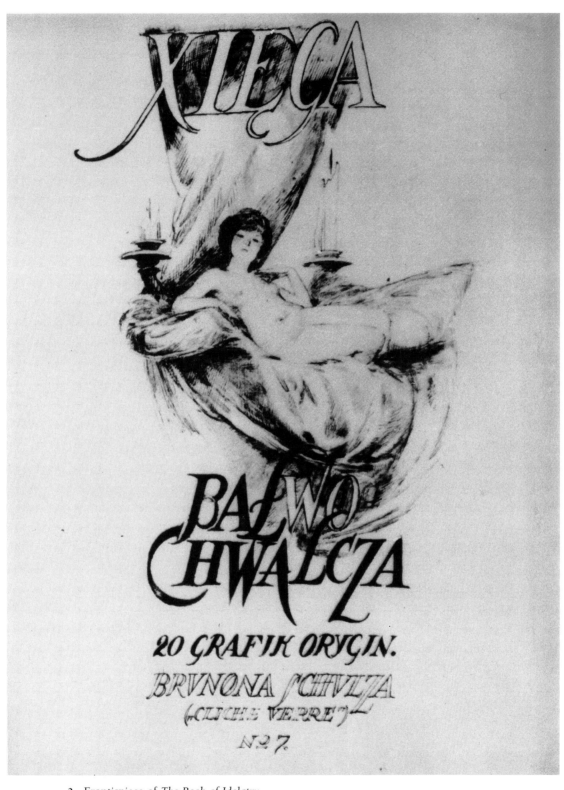

2. Frontispiece of *The Book of Idolatry*

XIĘCA
BAŁWOCHWALCZA
GRAFIKI ORYGINALNE
BRUNONA SCHULZA

TREŚĆ:

DEDYKACIA – ODWIECZNA BAŚN – INFANTKA I JEJ KARLY –
JEJ GARDEROBIANA – UNDULA, ODWIECZNY IDEAŁ –
UNDULA U ARTYSTÓW – UNDULA IDZIE W NOC – ŁAWKA –
PLEMIĘ PARIASÓW – ZACZAROWANE MIASTO – NA CYTERZE –
ZUZANNA PRZY TUALECIE – MADEMOISELLE CIRCE I JEJ TRUPA –
BESTJE – ZACZAROWANE MIASTO II – ŚWIĘTO WIOSNY – OGIERY
I EUNUCHY – ŚWIĘTO BAŁWOCHWALCÓW – XIĘGA BAŁWOCHWALCZA

3. Frontispiece of *The Book of Idolatry*

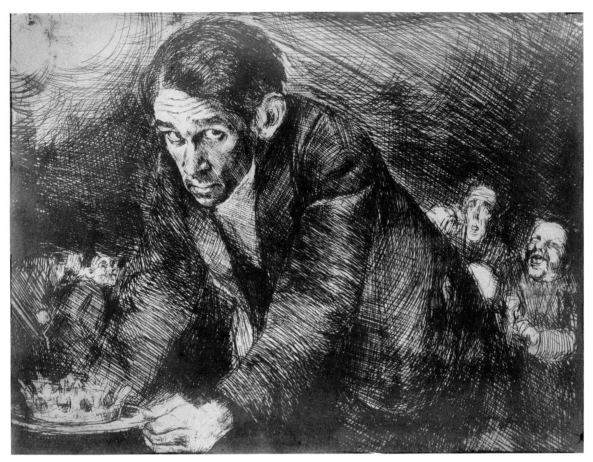

4. *Dedication* (*Introduction*)

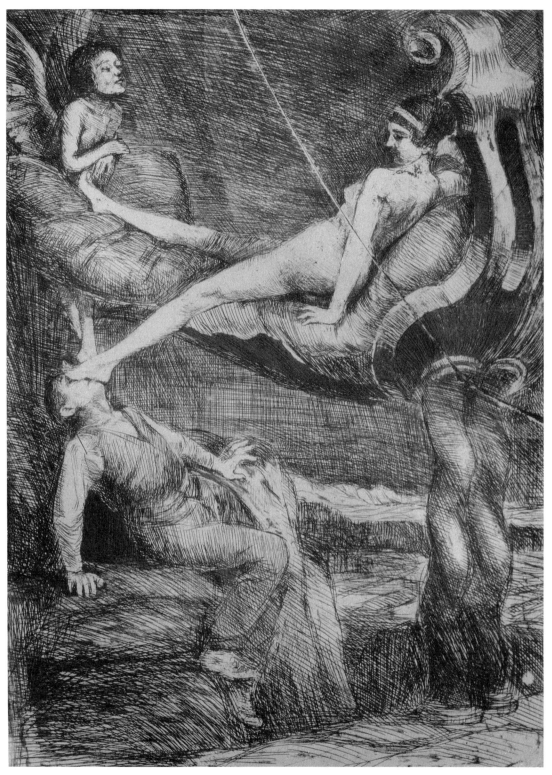

5. *The Eternal Tale*

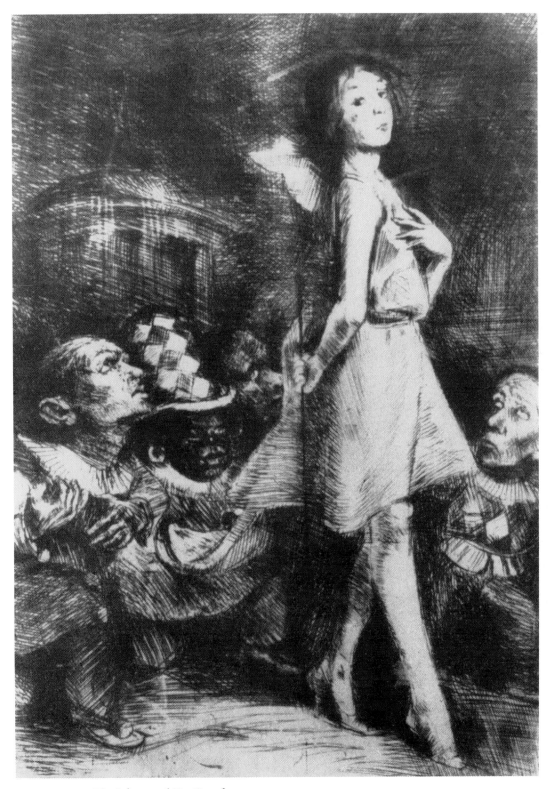

6. *The Infanta and Her Dwarfs*

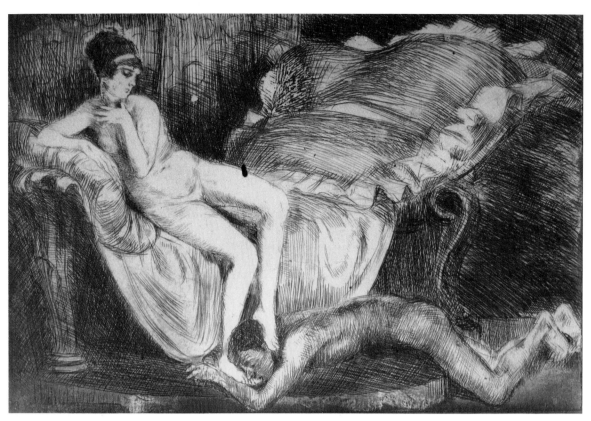

7. *Undula, the Eternal Ideal*

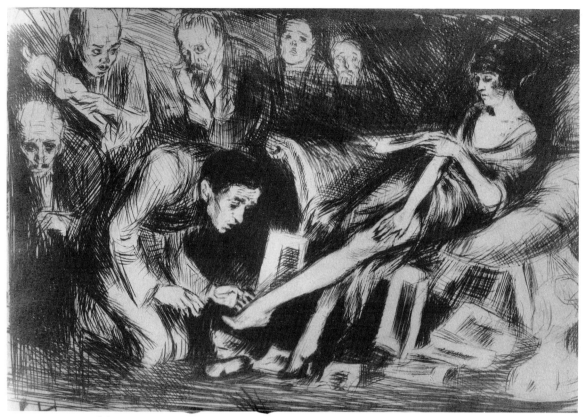

8. *Undula with the Artists*

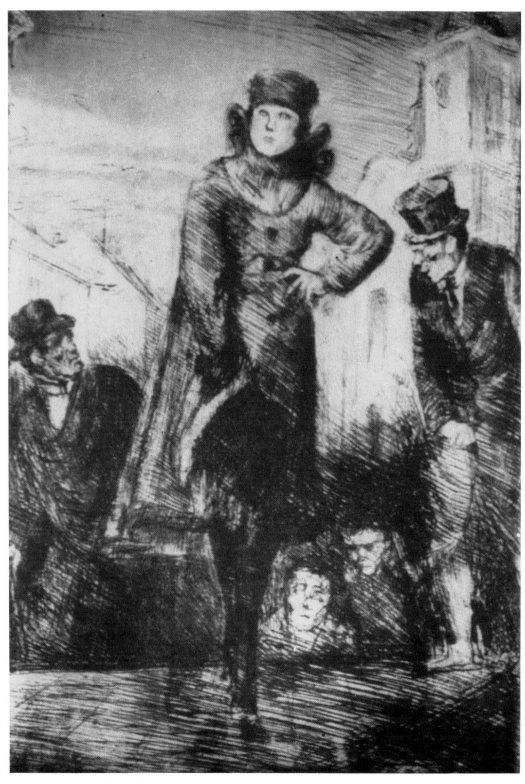

9. *Undula Walks into the Night*

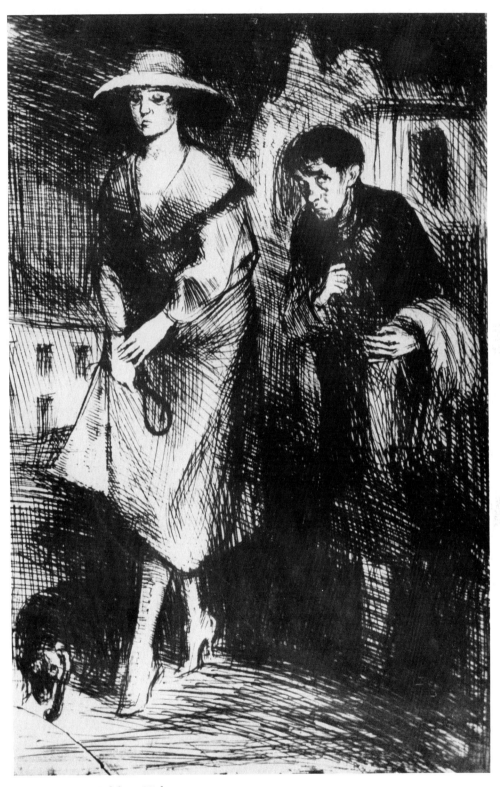

10. *Undula at Night*

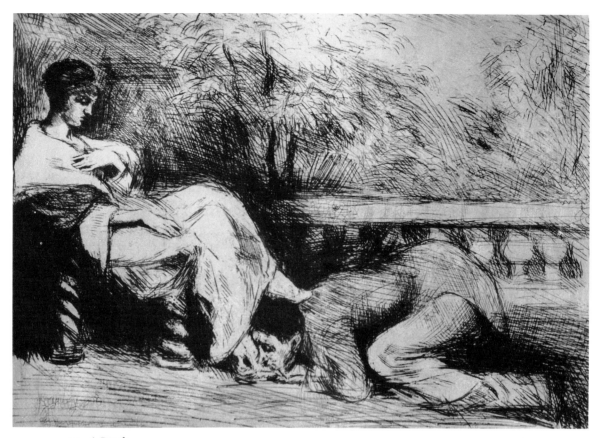

11. *A Bench*

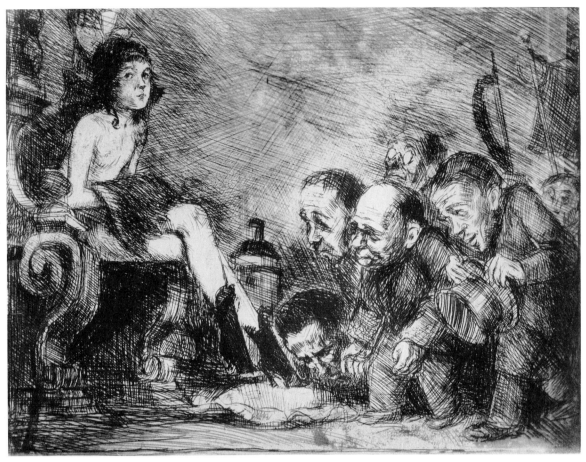

12. *Tribe of Pariahs*

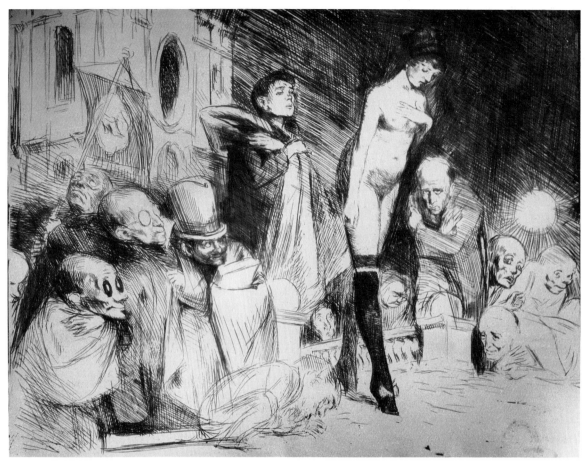

13. *Procession*

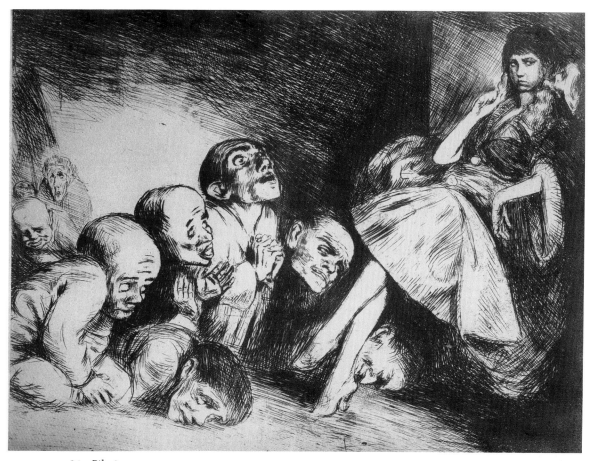

14. *Pilgrims*

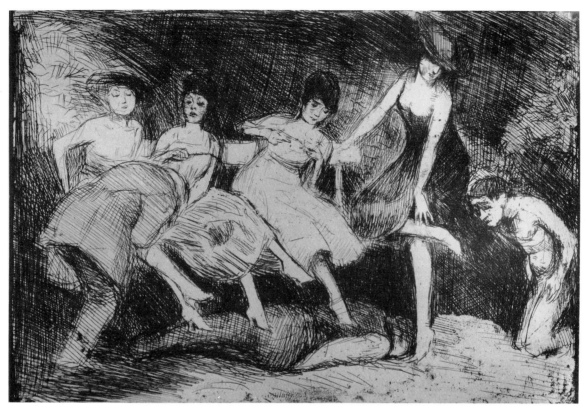

15. *Garden Games*

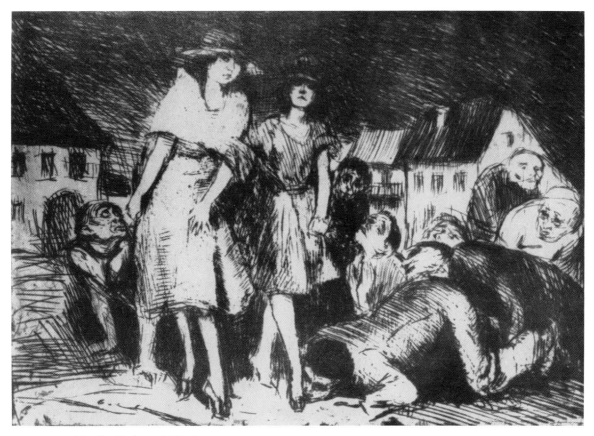

16. *The Enchanted City I*

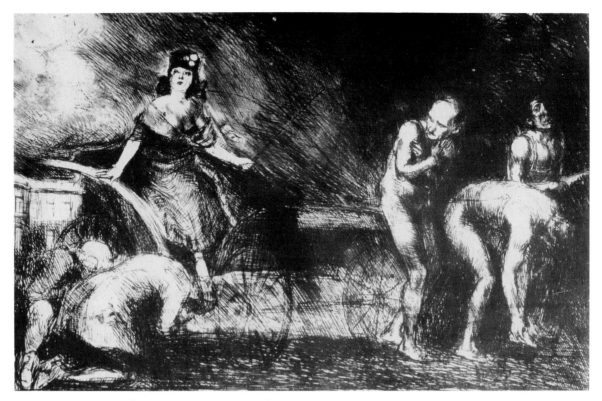

17. *On Cythera*

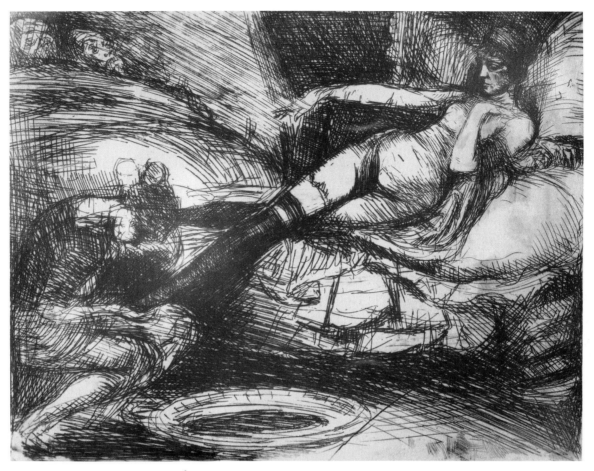

18. *Susanna at Her Toilet*

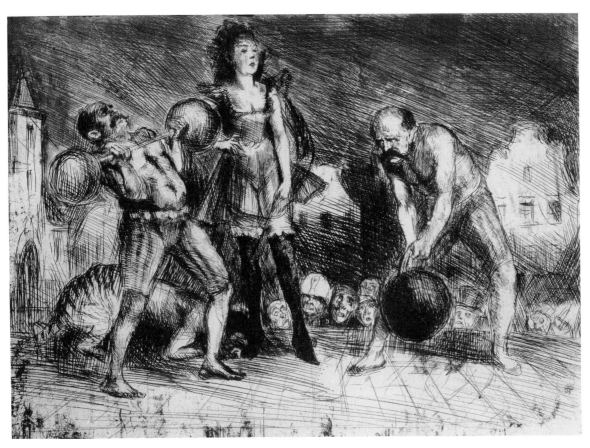

19. *Mademoiselle Circe and Her Troupe (Circus)*

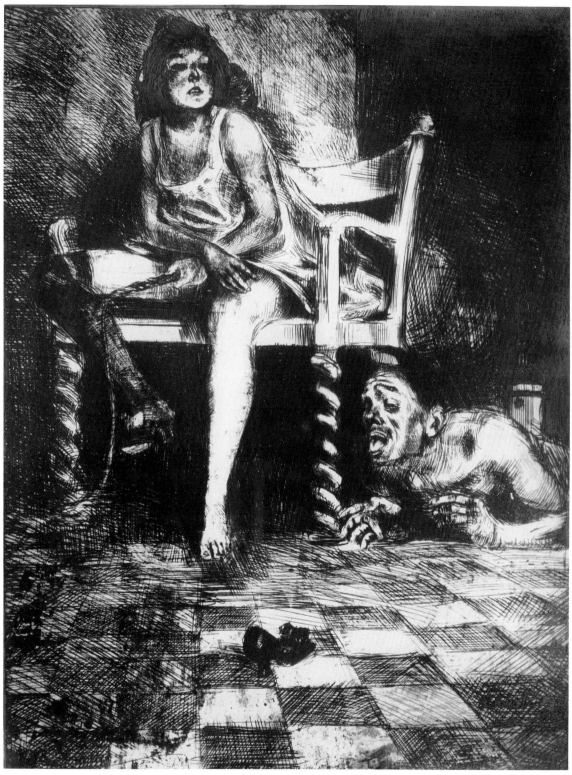

20. *The Beasts*

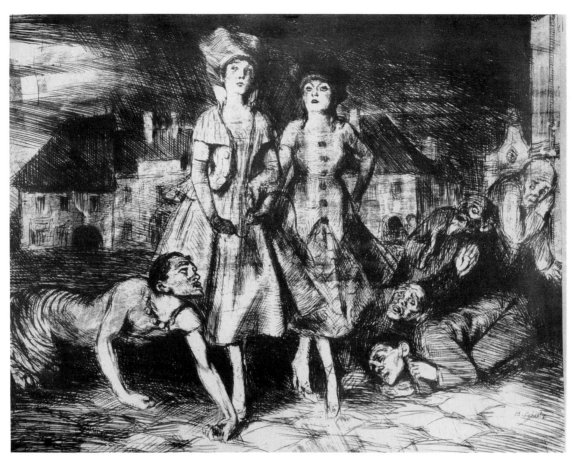

21. *The Enchanted City II*

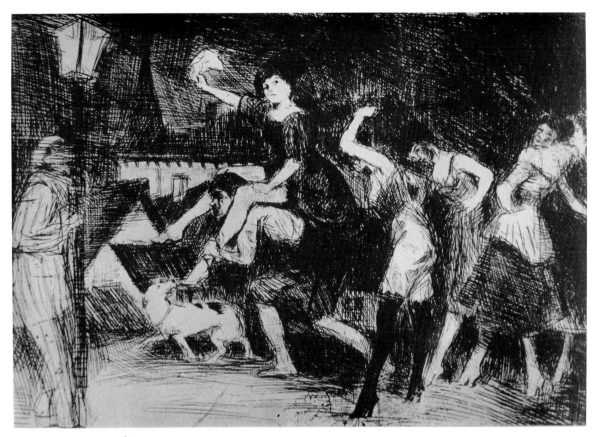

22. *Rites of Spring*

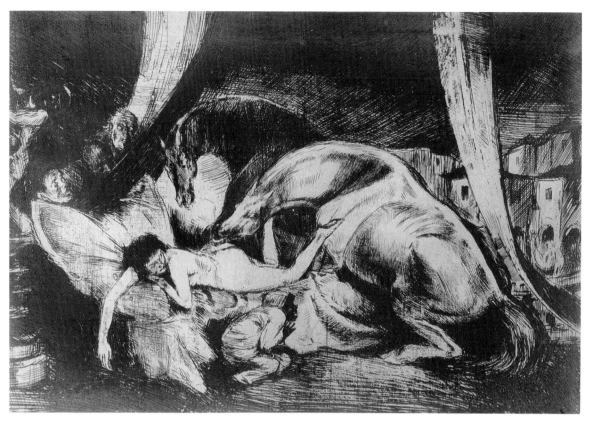

23. *Eunuch with Stallions*

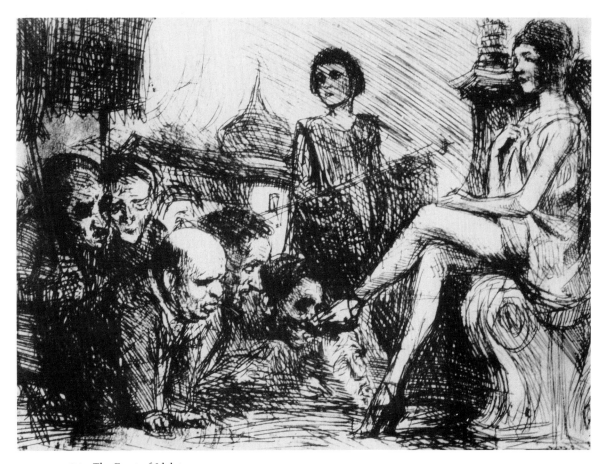

24. *The Feast of Idolaters*

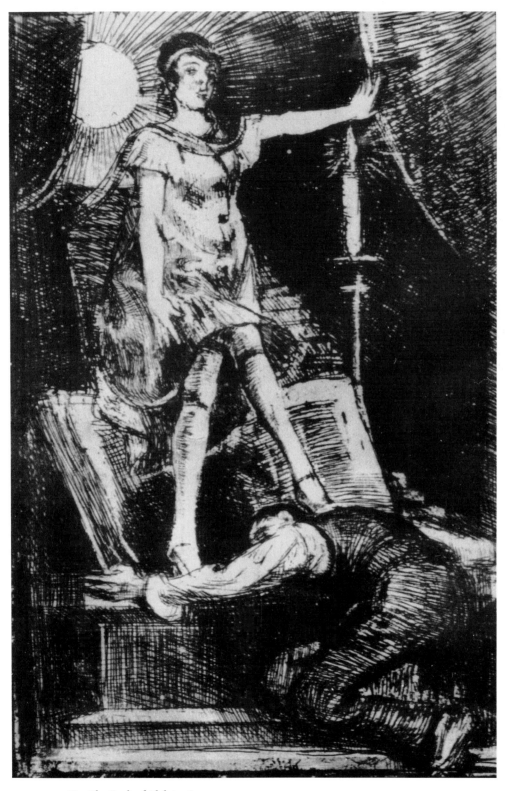

25. *The Book of Idolatry I*

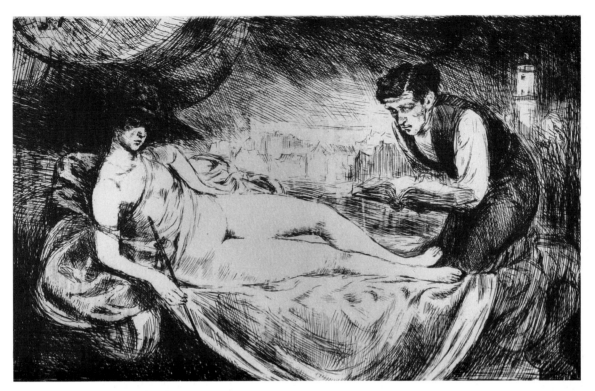

26. *The Book of Idolatry II*

Masochistic Scenes

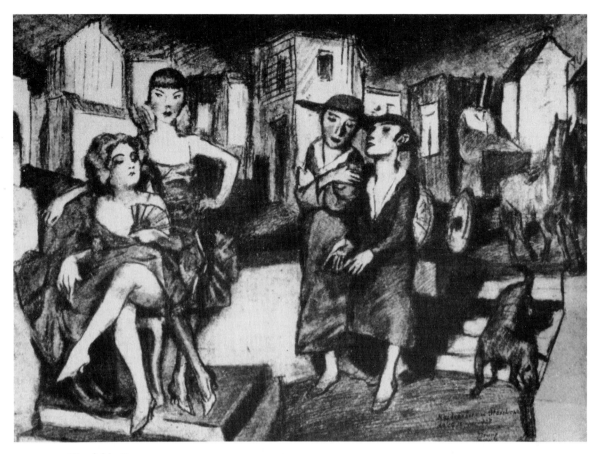

27. *A Meeting*

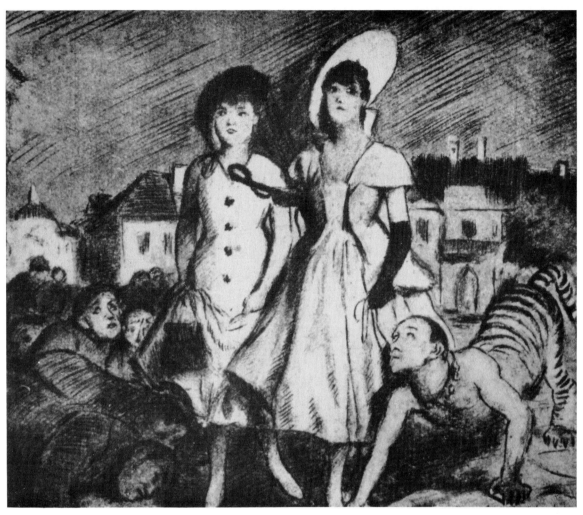

28. *Undula Takes a Walk*

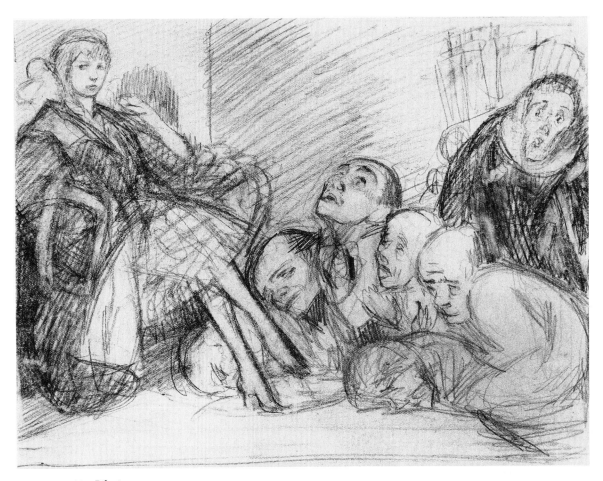

29. *Pilgrims*

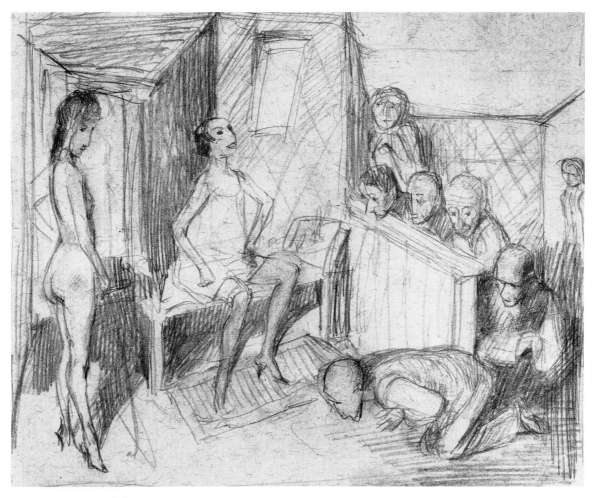

30. Untitled

31. Untitled

32. Untitled

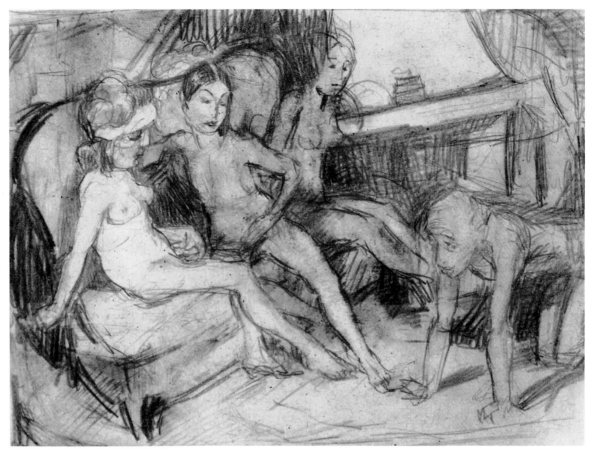

33. Untitled

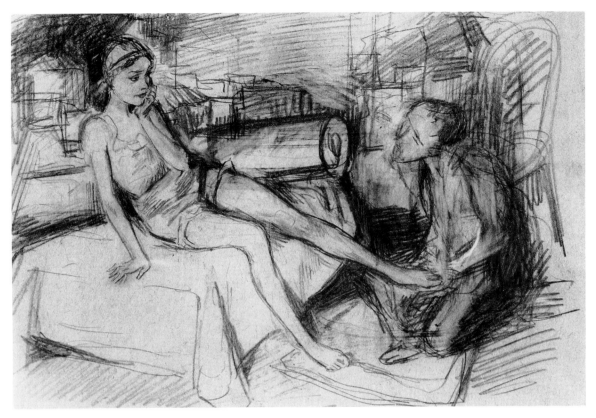

34. Untitled

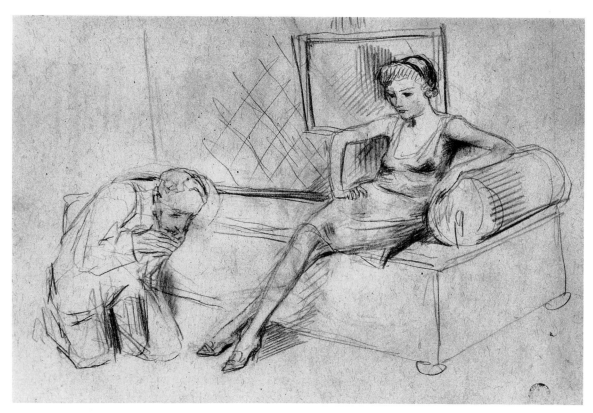

35. Untitled

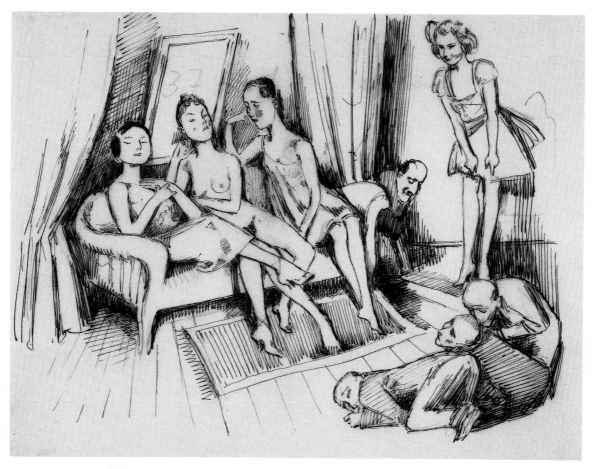

36. Untitled

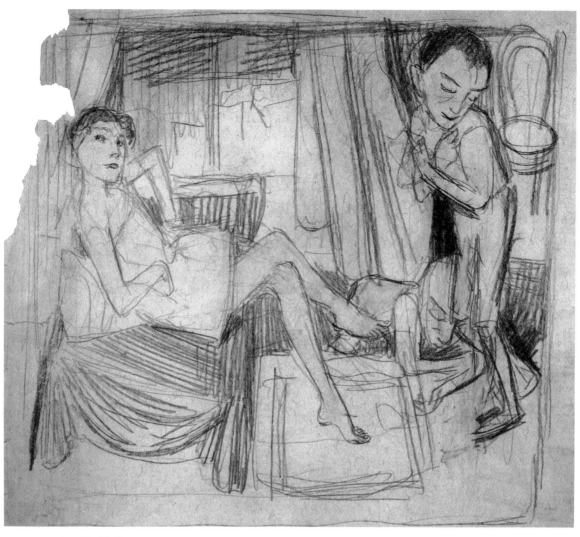

37. Untitled

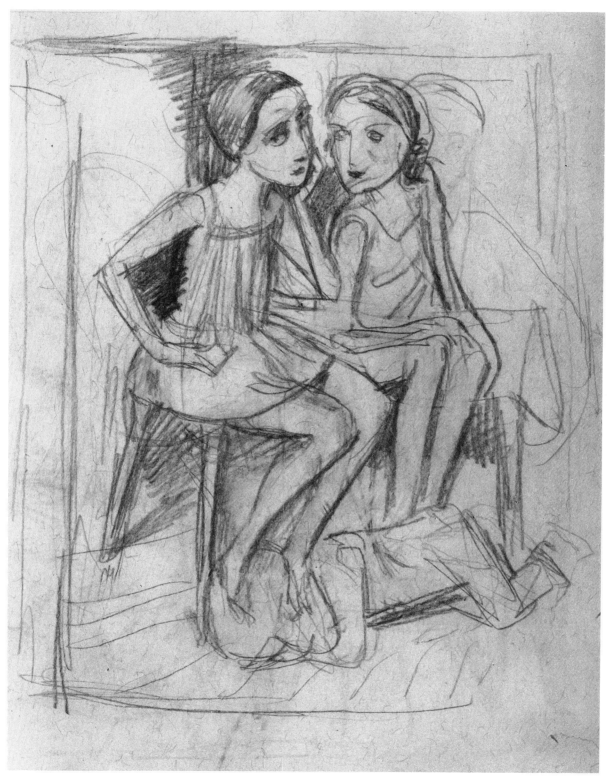

38. Untitled

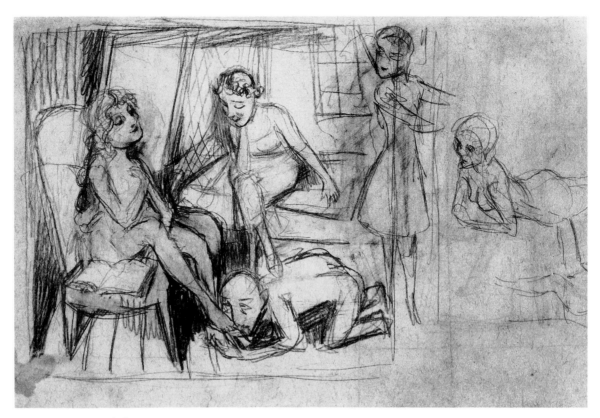

39. Untitled

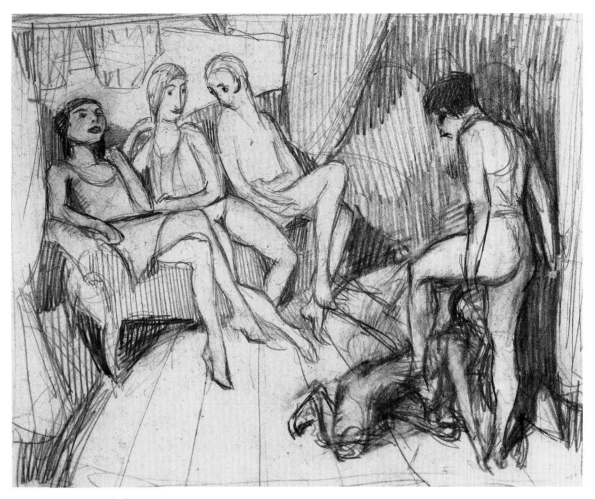

40. Untitled

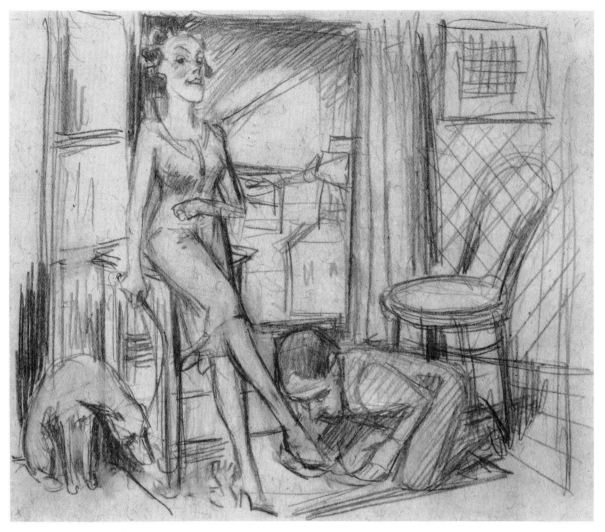

41. Untitled

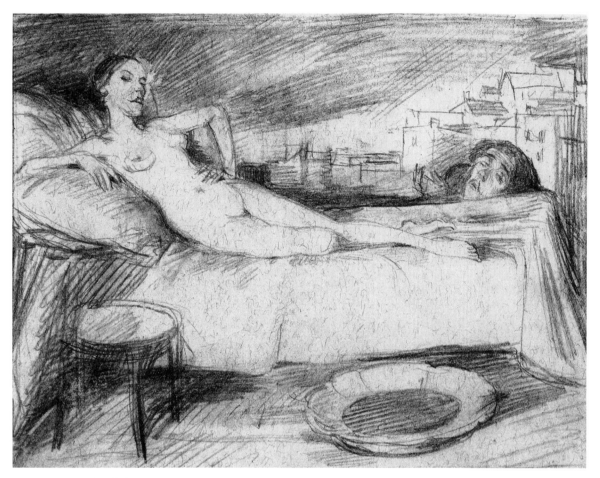

42. Untitled

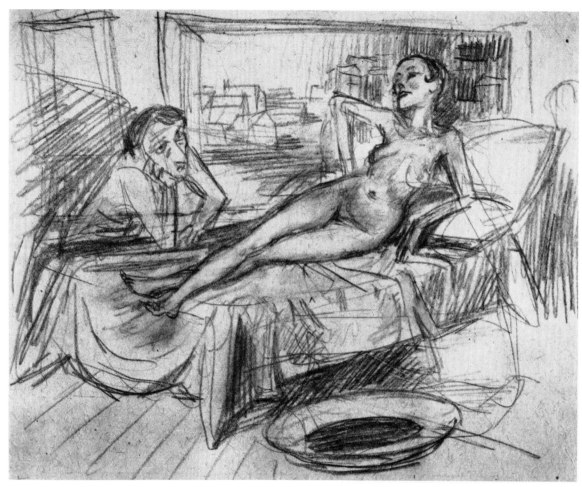

43. Untitled

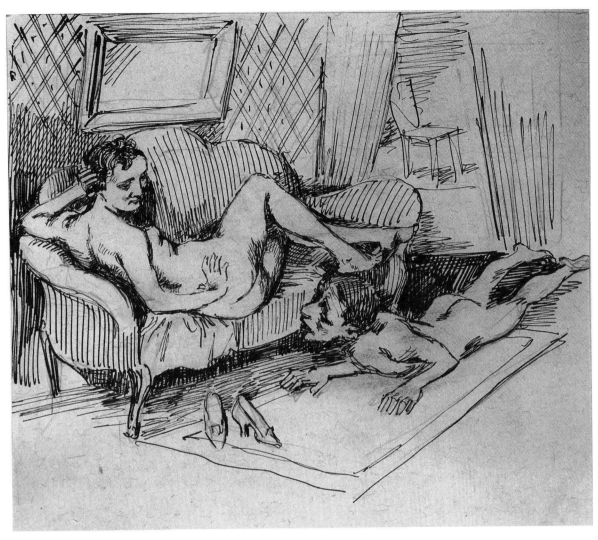

44. Untitled

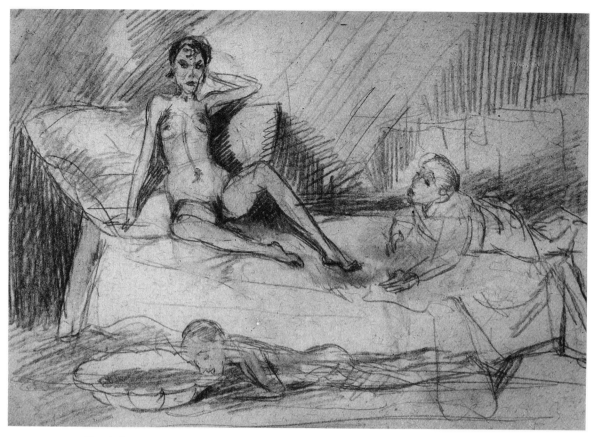

45. Untitled

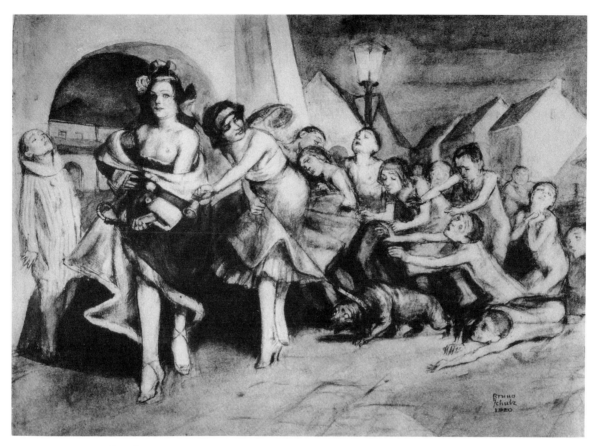

46. *Bacchanalia*

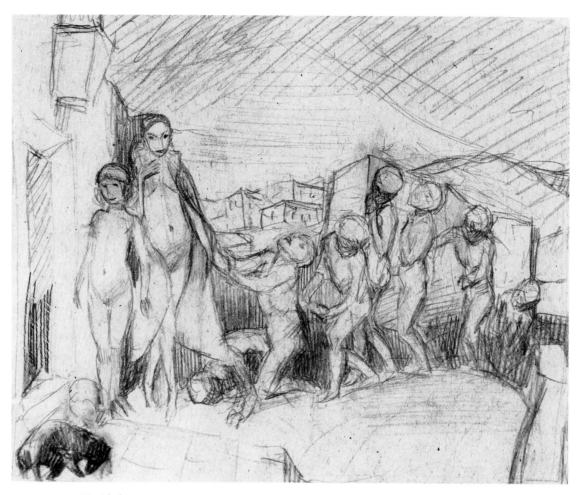

47. Untitled

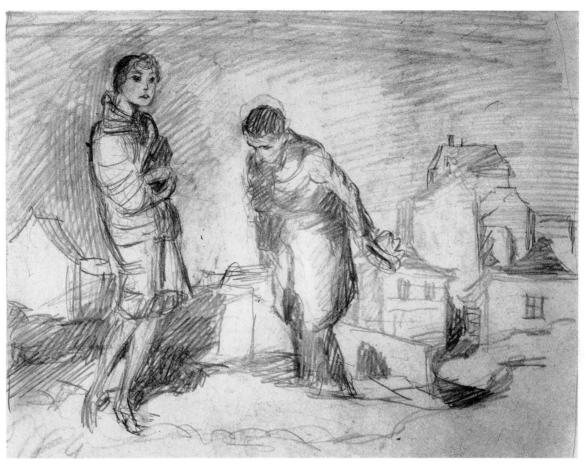

48. Untitled

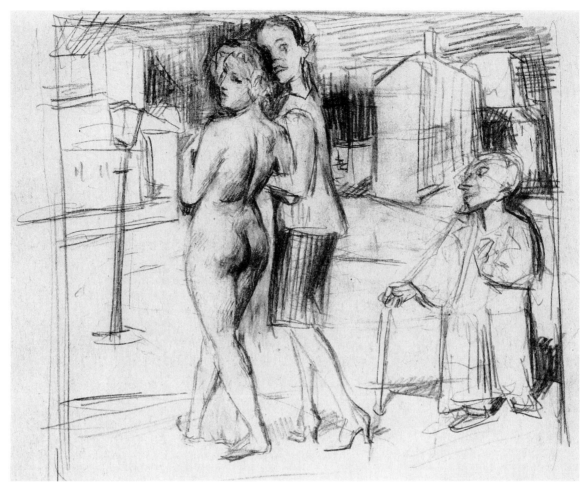

49. Untitled

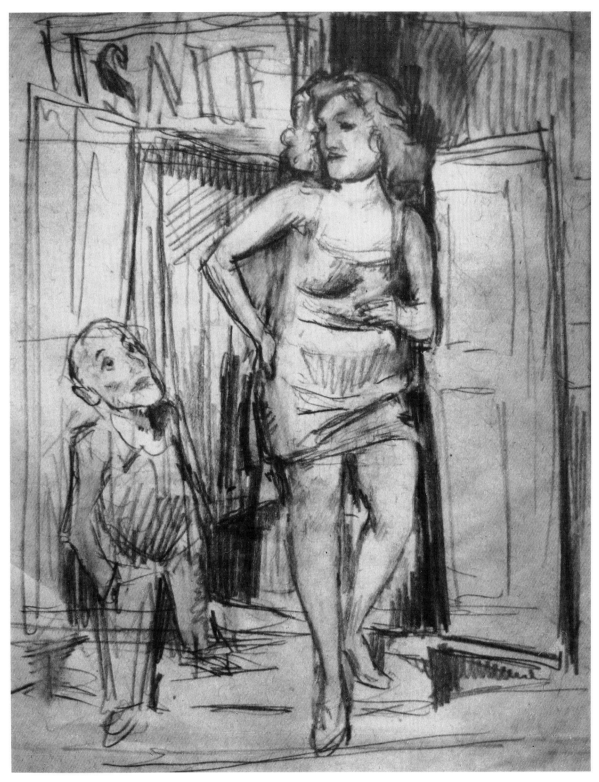

50. Untitled

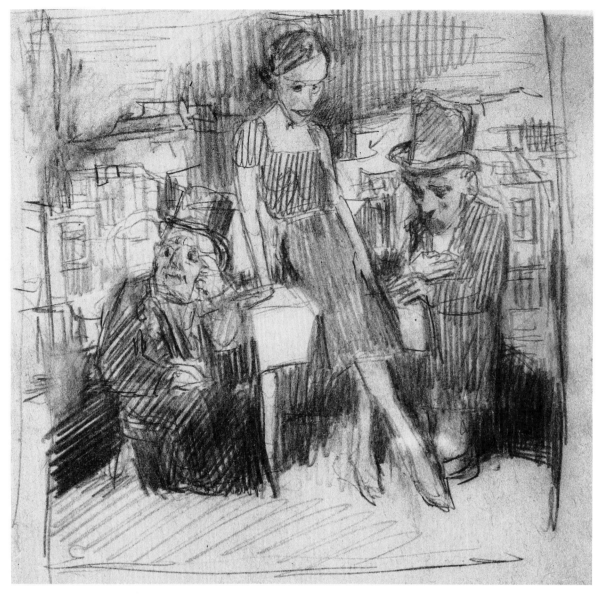

51. Untitled

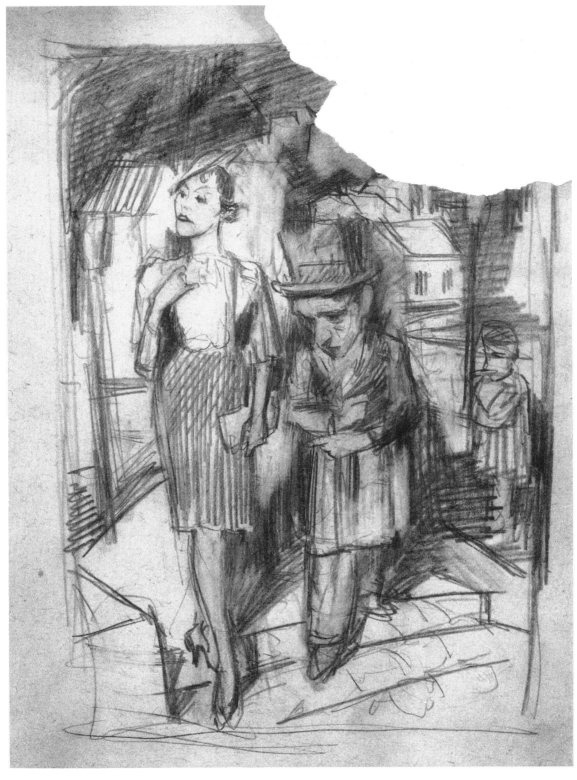

52. Untitled

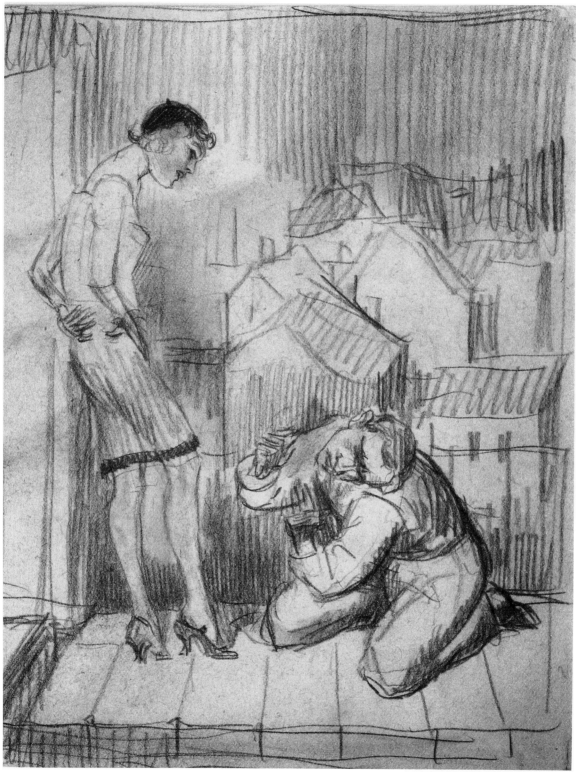

53. Untitled

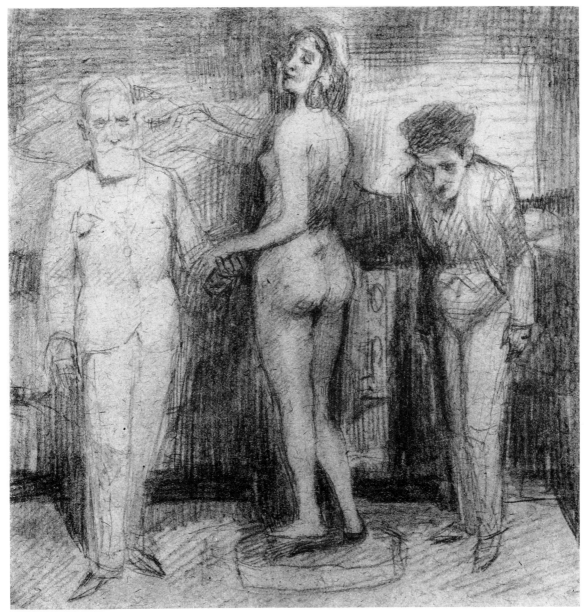

54. Untitled

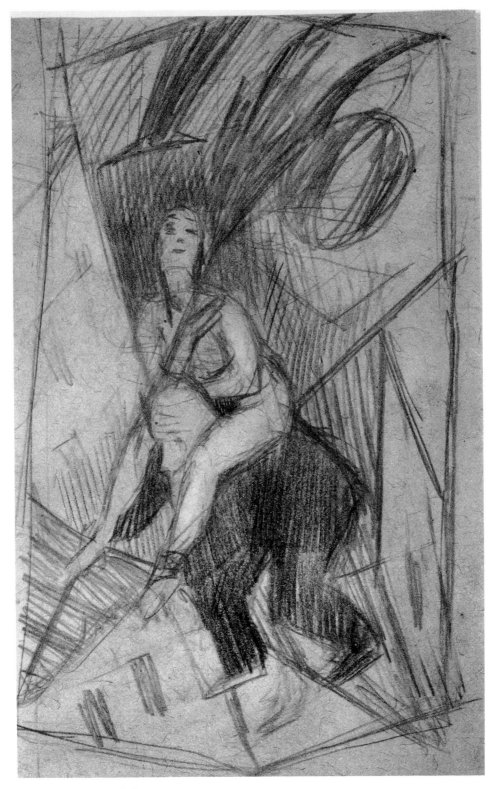

55. Untitled

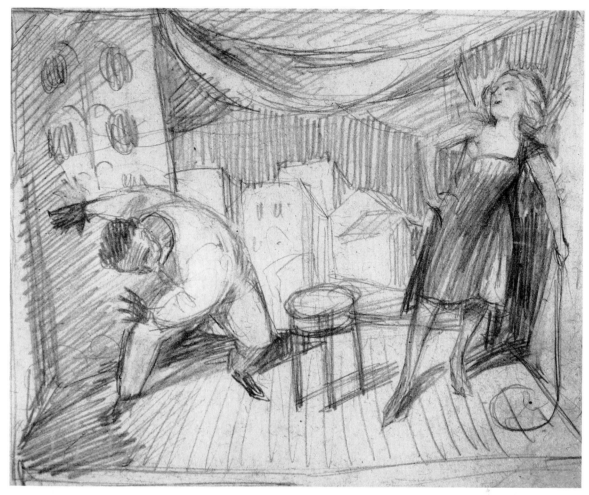

56. Untitled

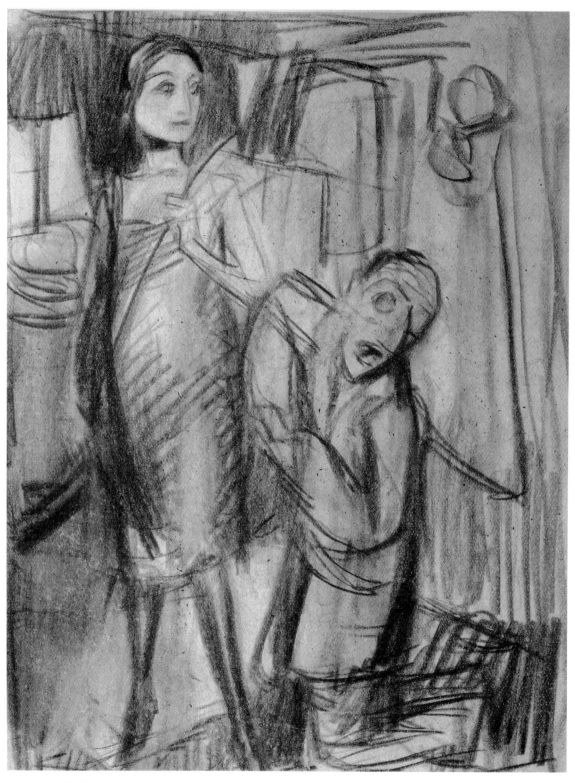

57. Untitled

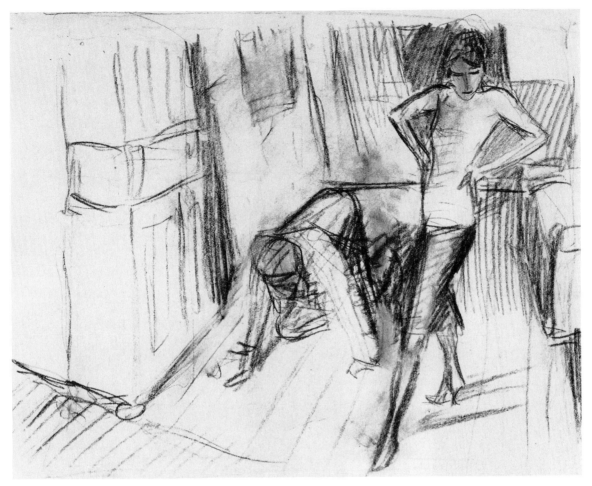

58. Untitled

Nudes

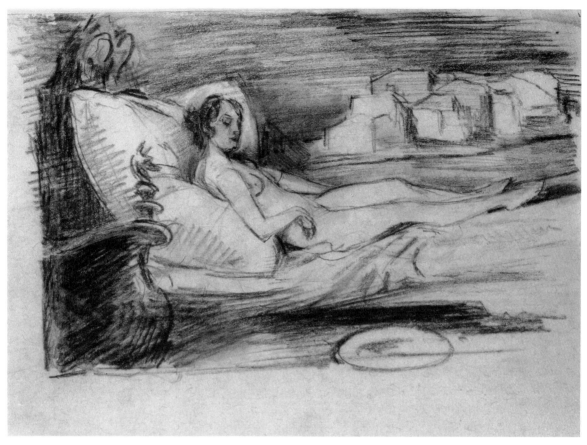

59. Untitled

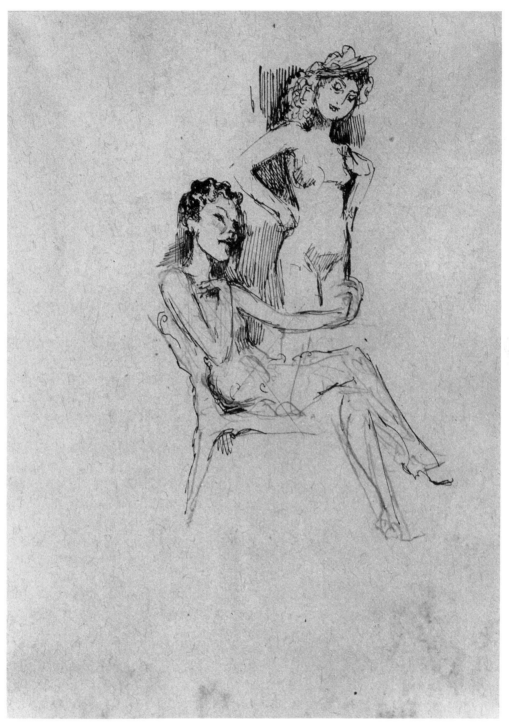

60. Untitled

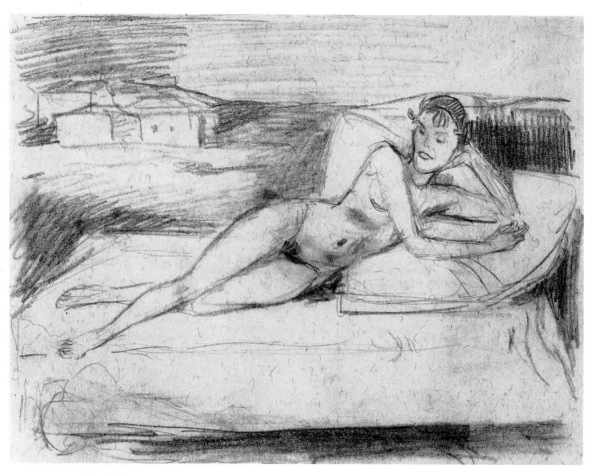

61. Untitled

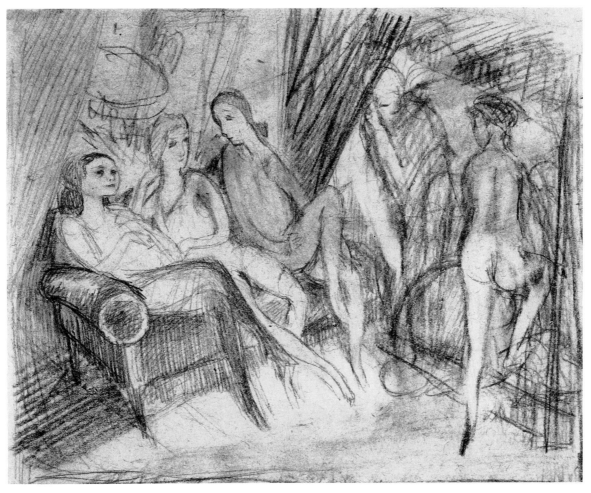

62. Untitled

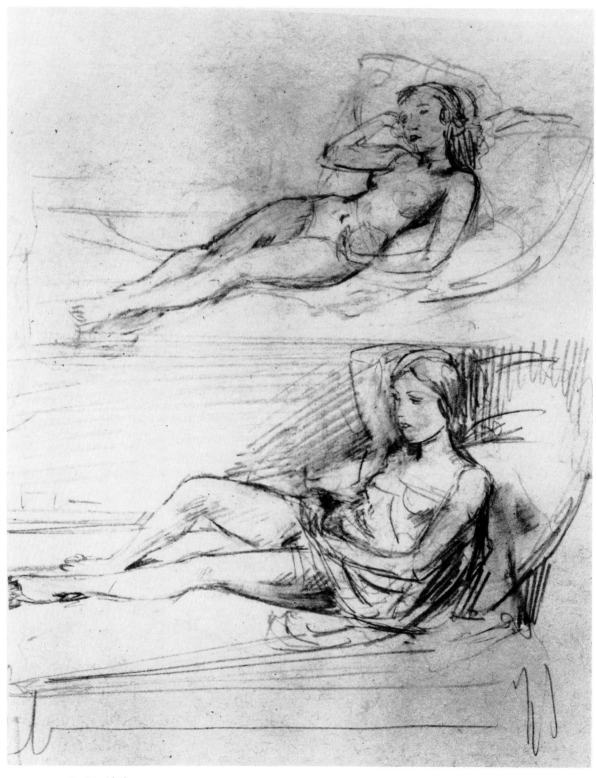

63. Untitled

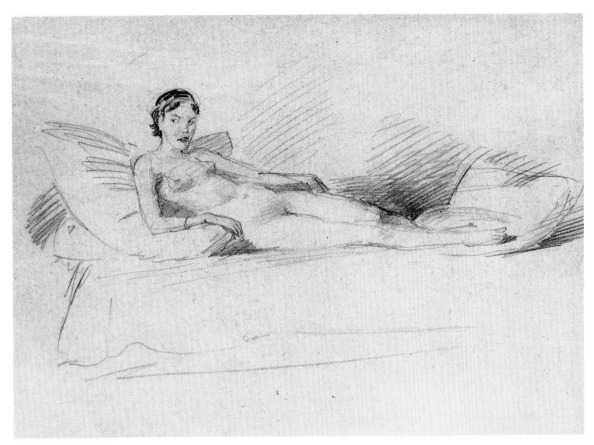

64. Untitled

At the Table

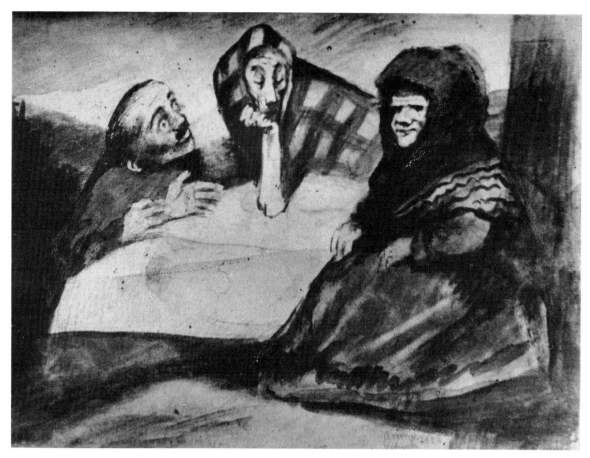

65. Untitled

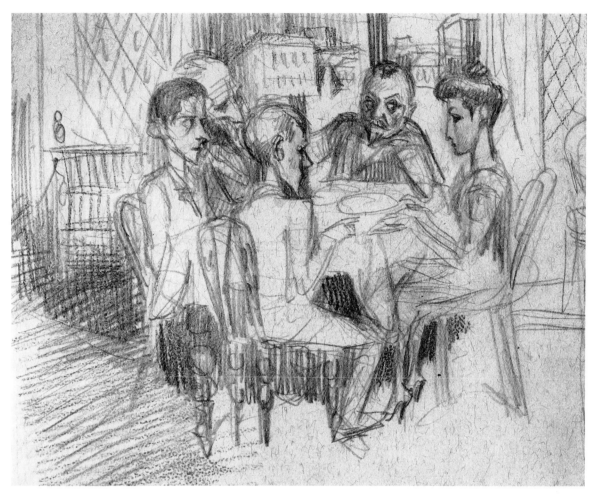

66. Untitled

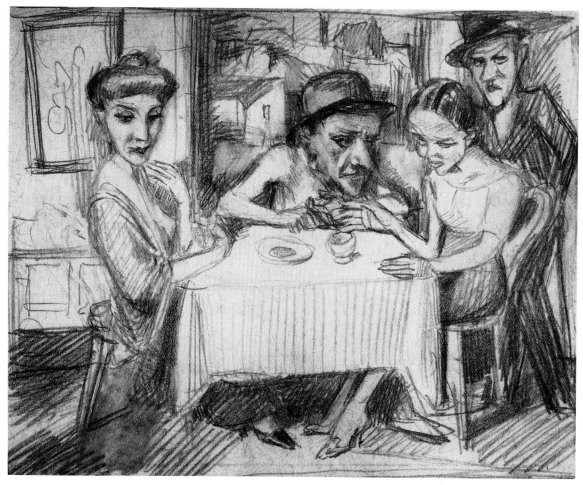

67. Untitled

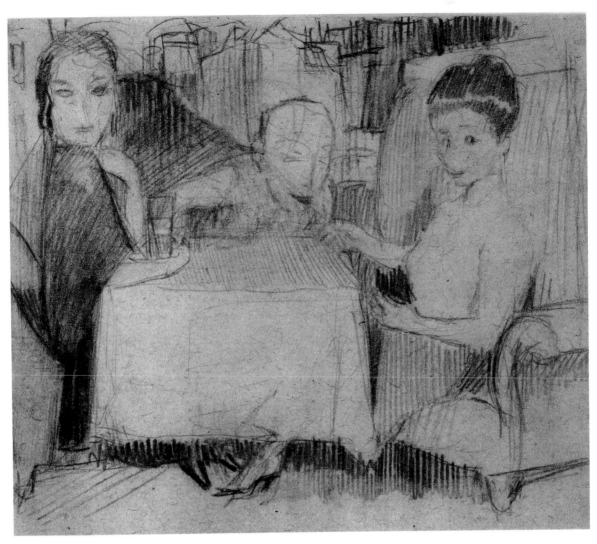

68. Untitled

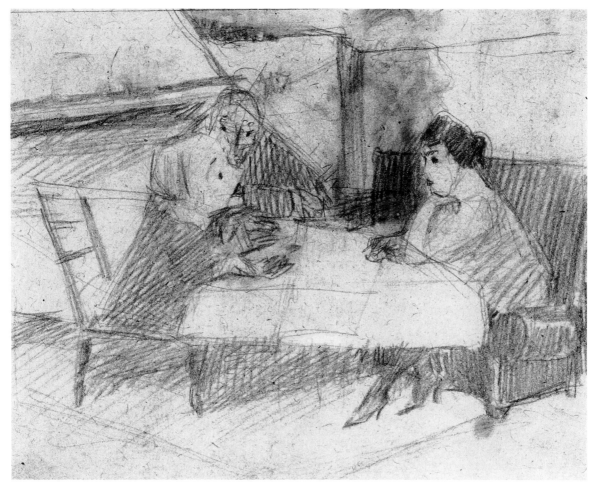

69. Untitled

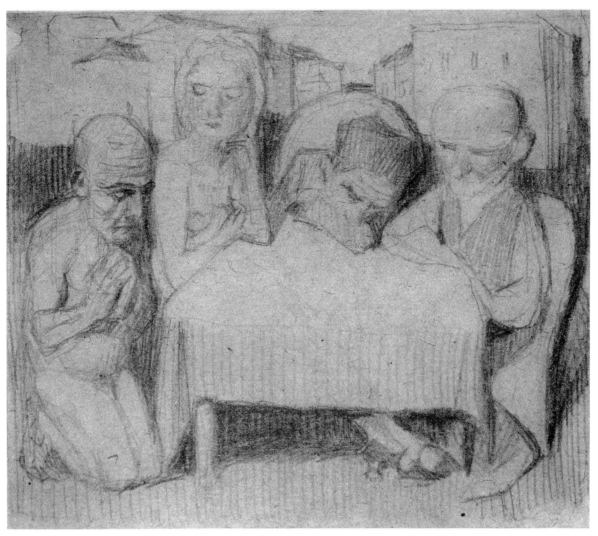

70. Untitled

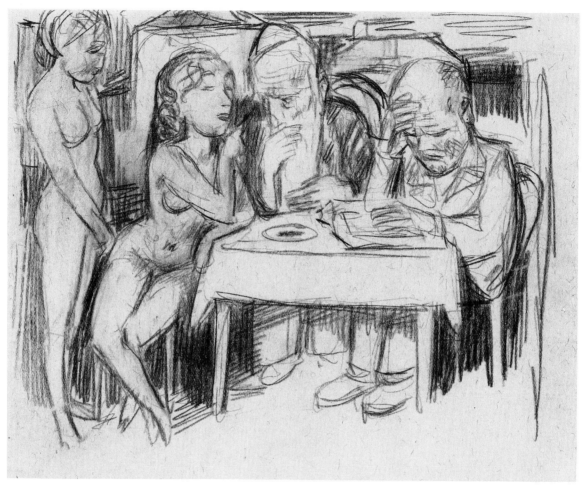

71. Untitled

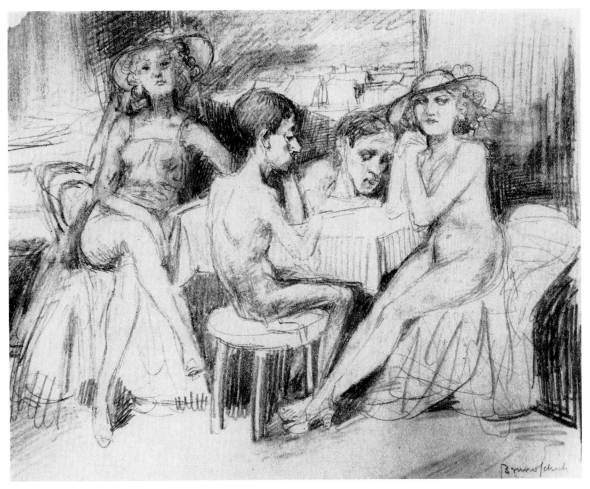

72. Untitled

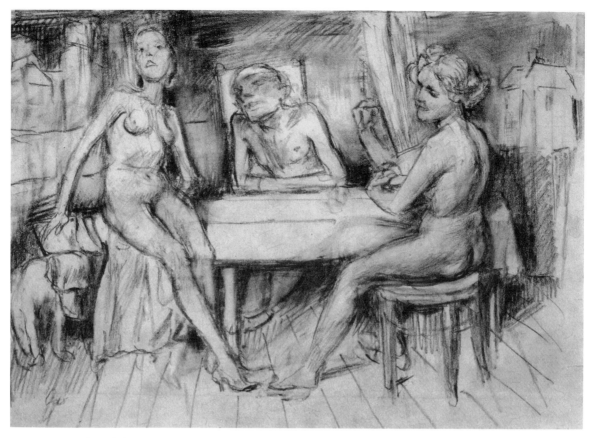

73. Untitled

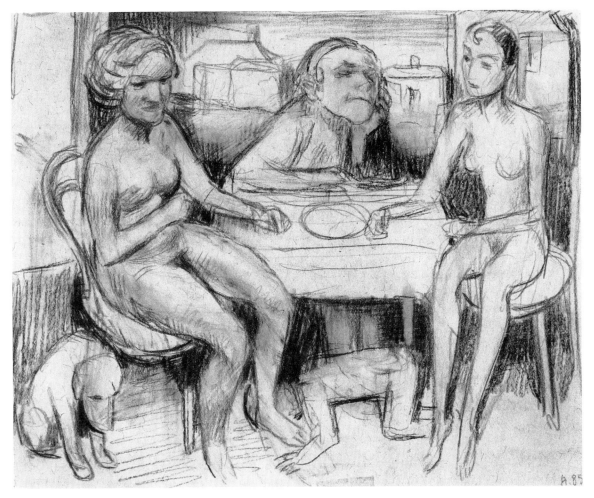

74. Untitled

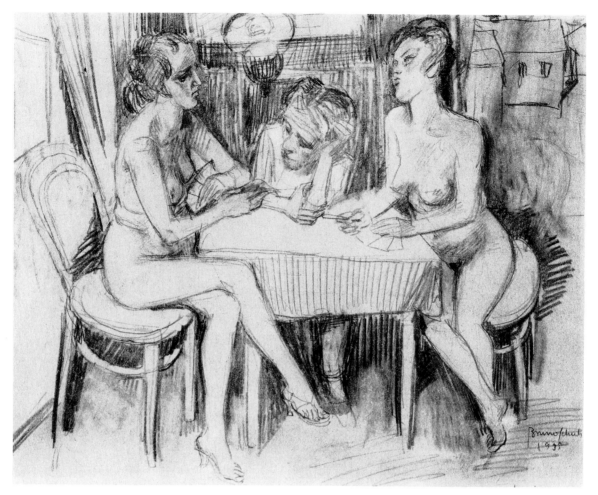

75. Untitled

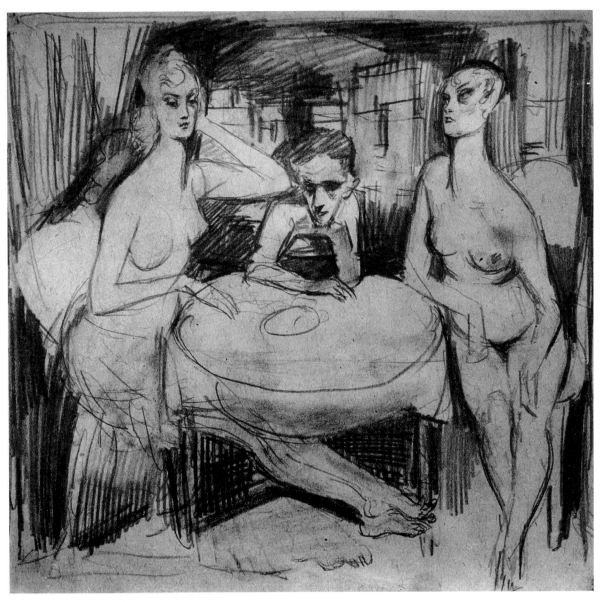

76. Untitled

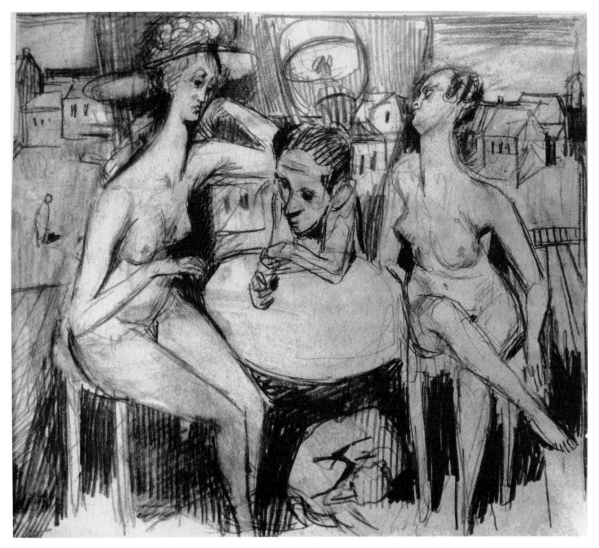

77. Untitled

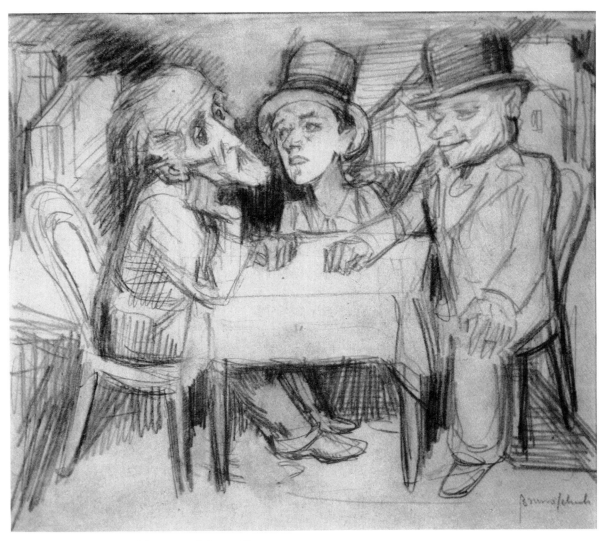

78. Portrait of the artist's father, self-portrait,
and portrait of Emanuel Pilpel

Jews

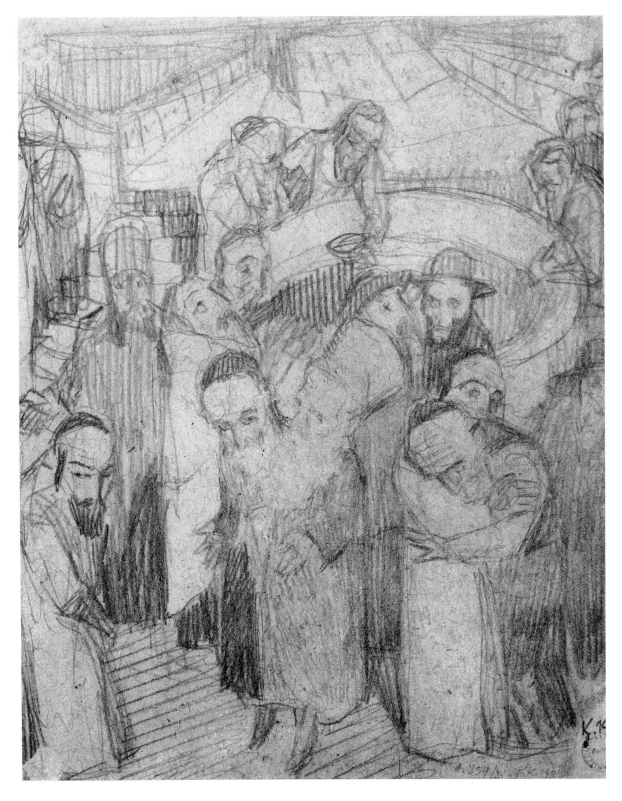

79. Untitled

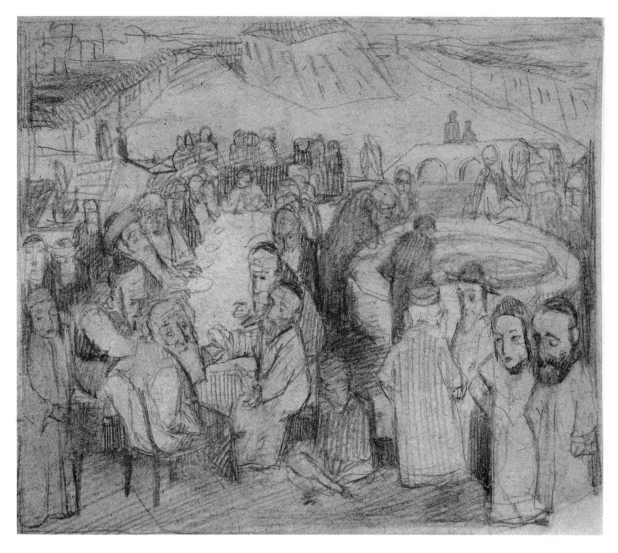

80. Untitled

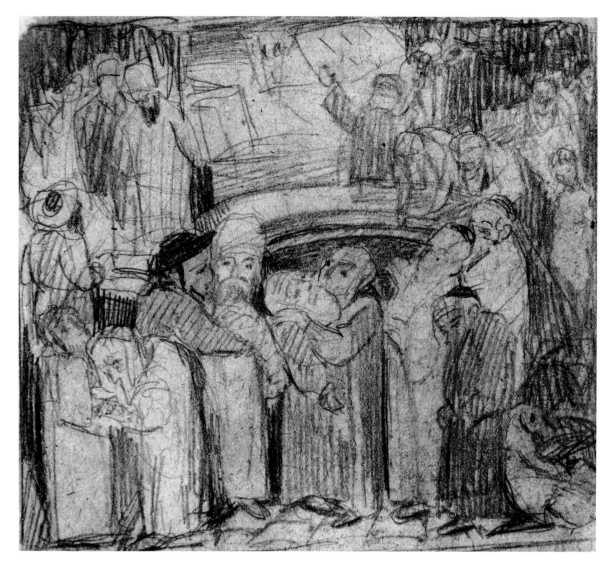

81. Untitled

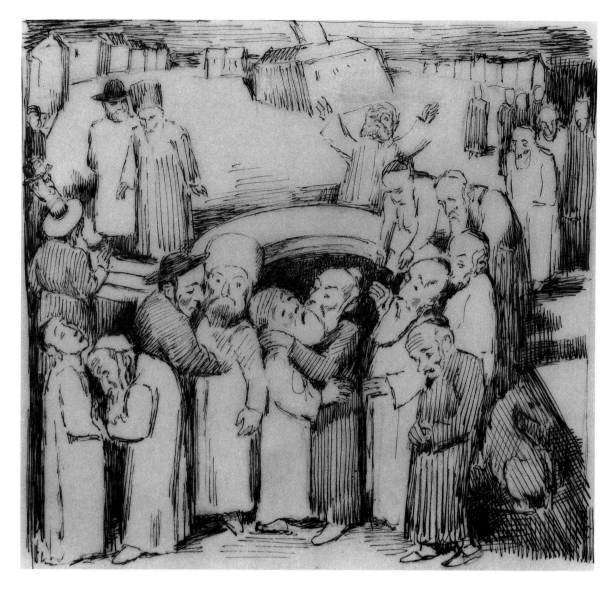

82. Untitled

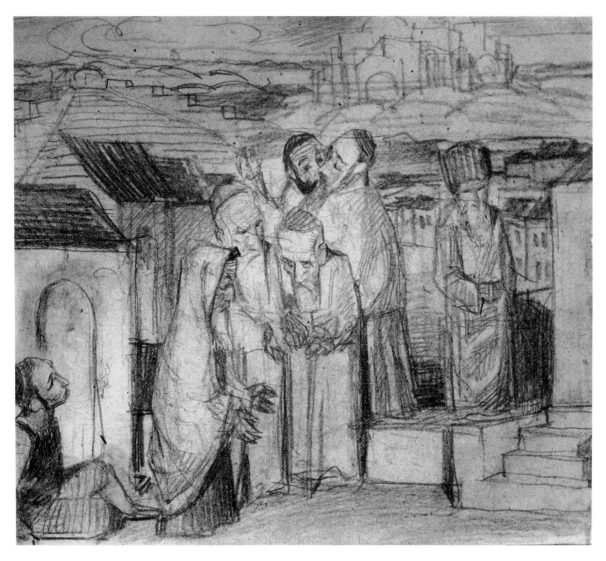

83. Untitled

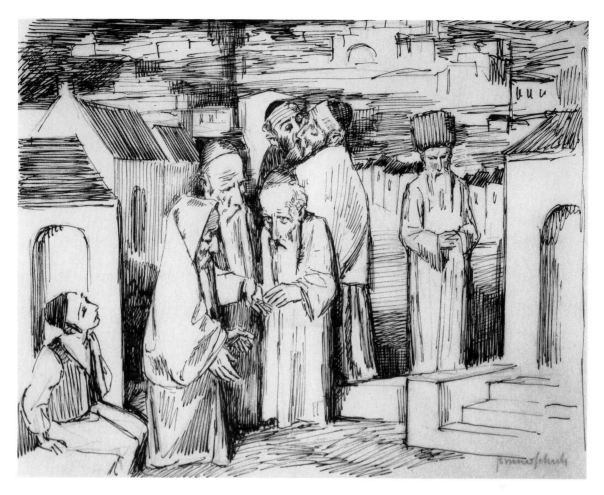

84. Untitled

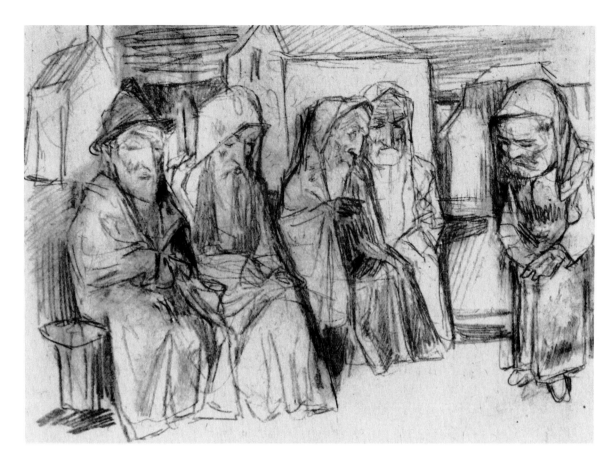

85. Untitled

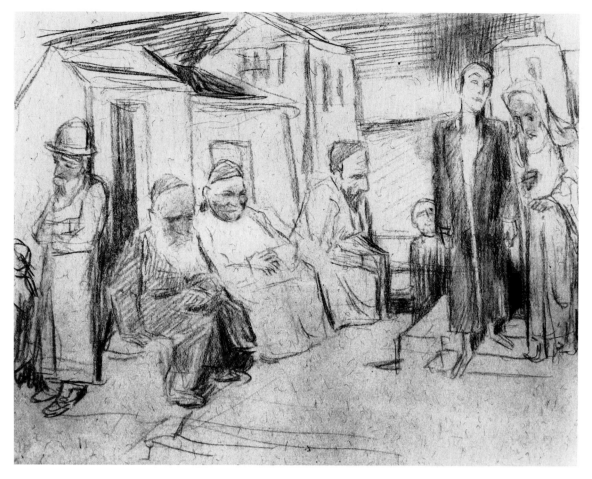

86. Untitled

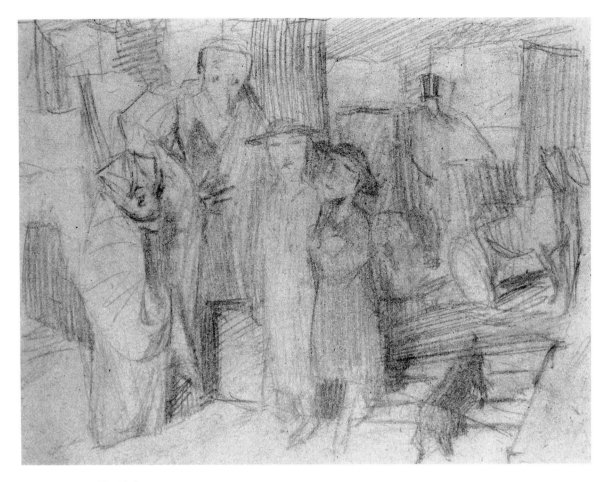

87. Untitled

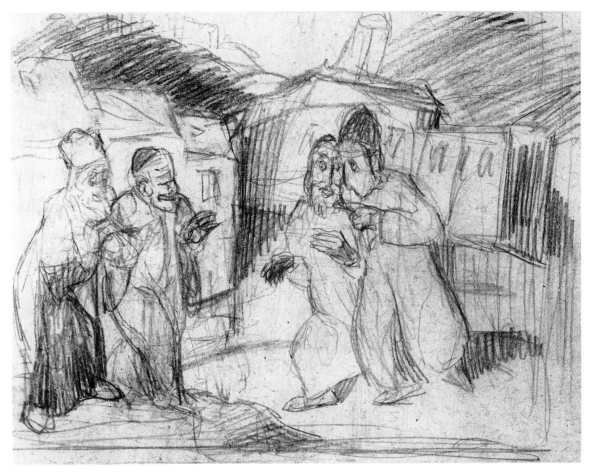

88. Untitled

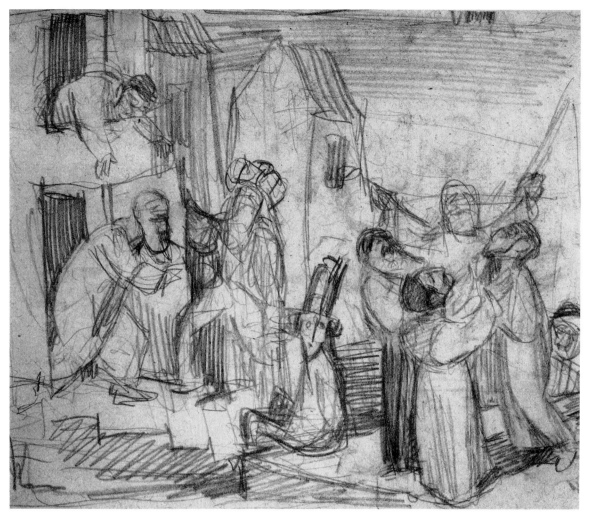

89. Untitled

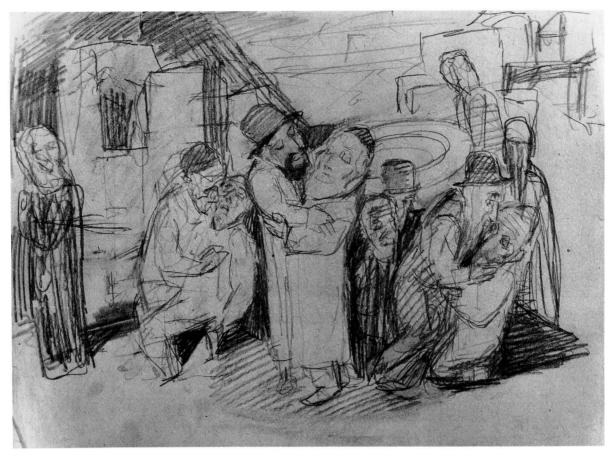

90. Untitled

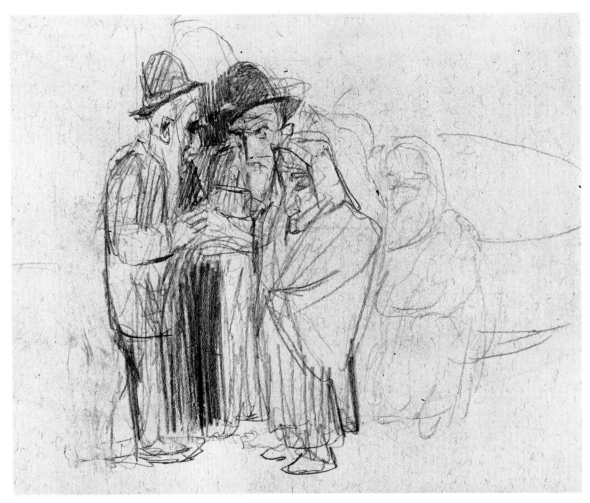

91. Untitled

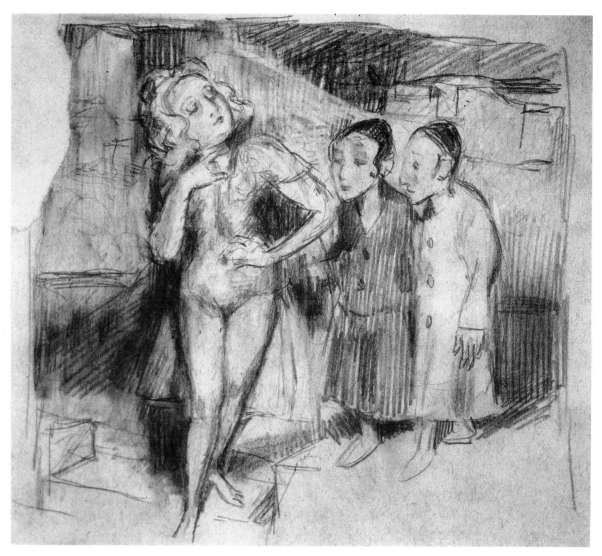

92. Untitled

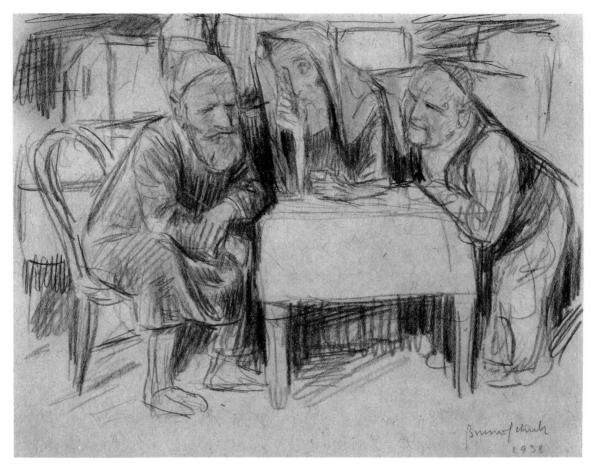

93. Untitled

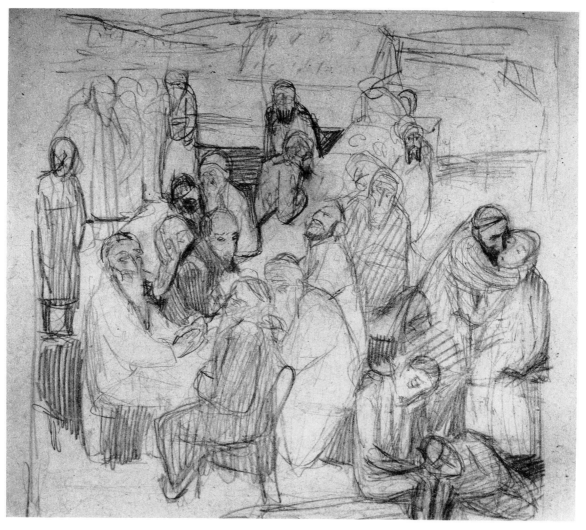

94. Untitled

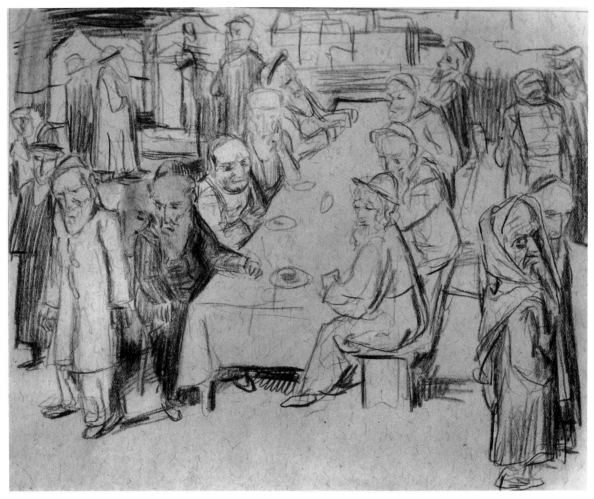

95. Untitled

Self-Portraits

96. Untitled

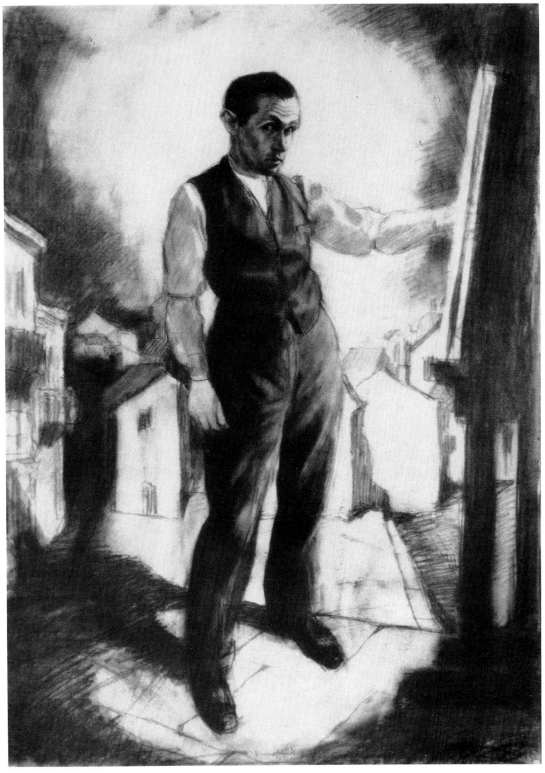

97. Untitled

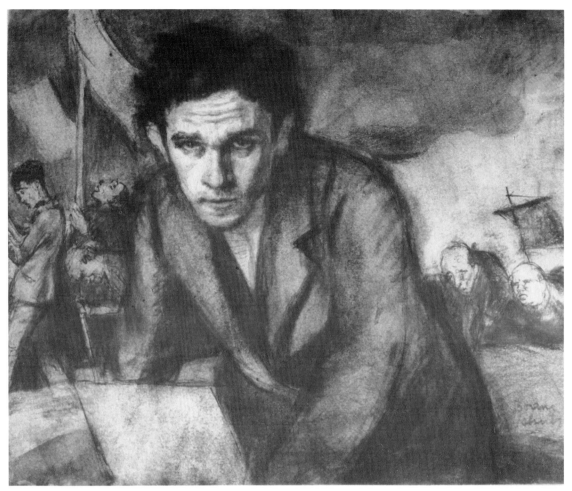

98. Untitled

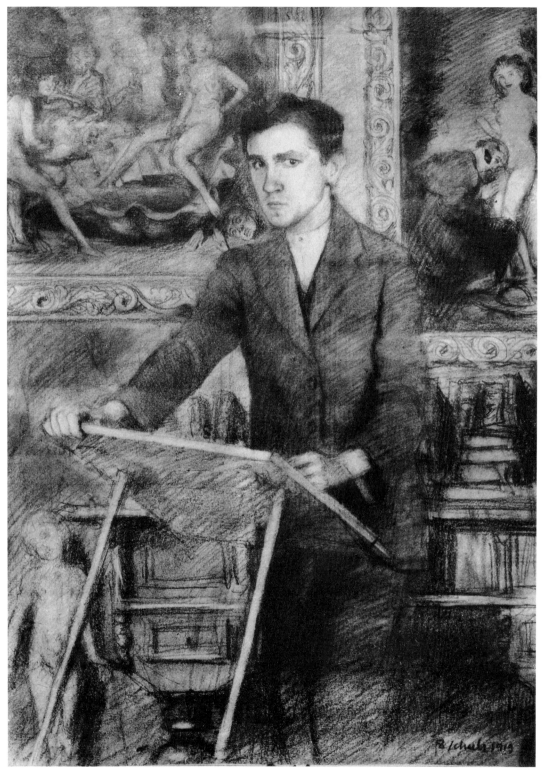

99. Untitled

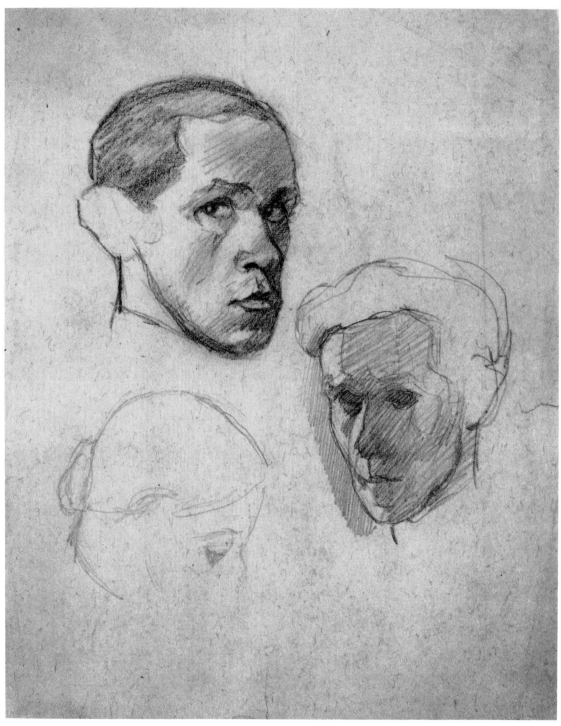

100. Untitled

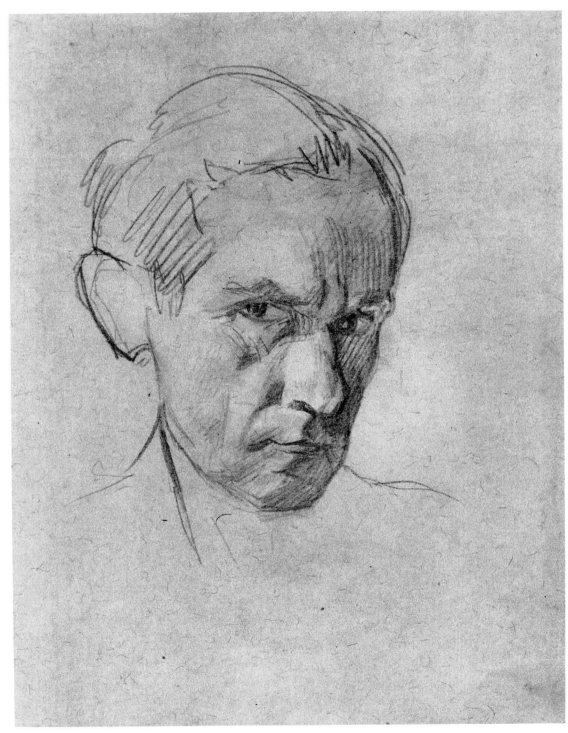

101. Untitled

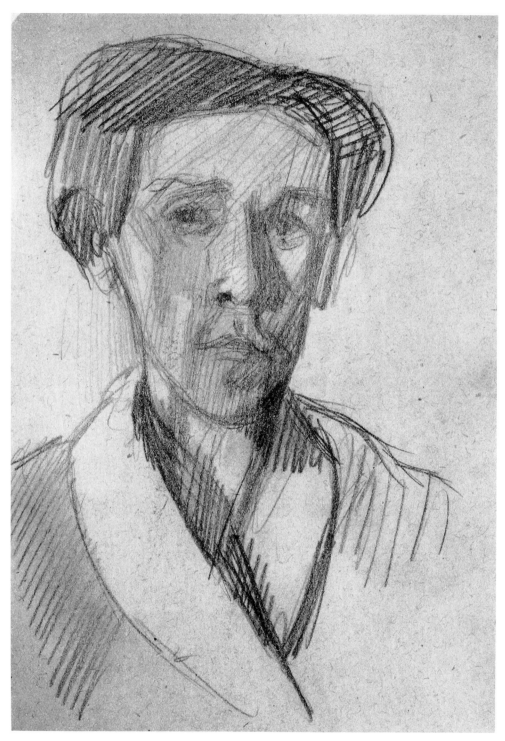

102. Untitled

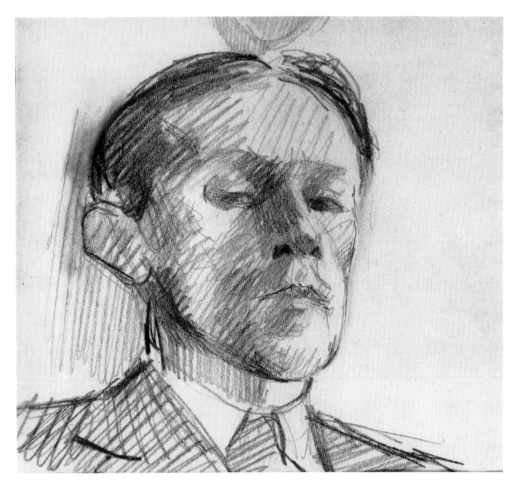

103. Untitled

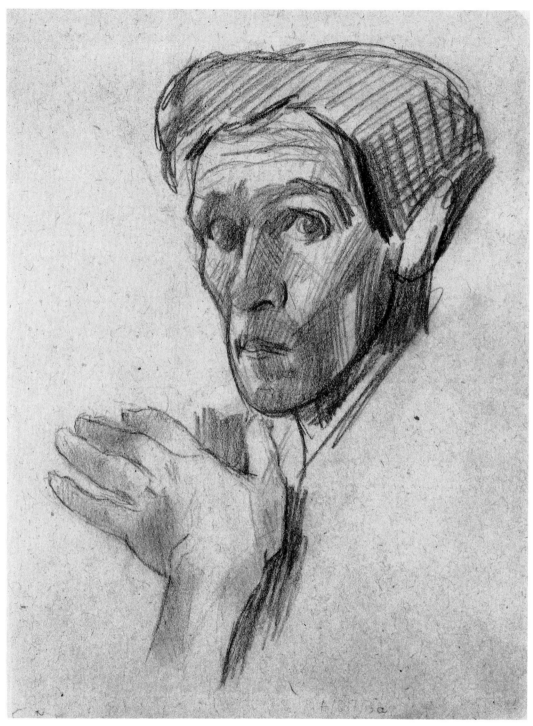

104. Untitled

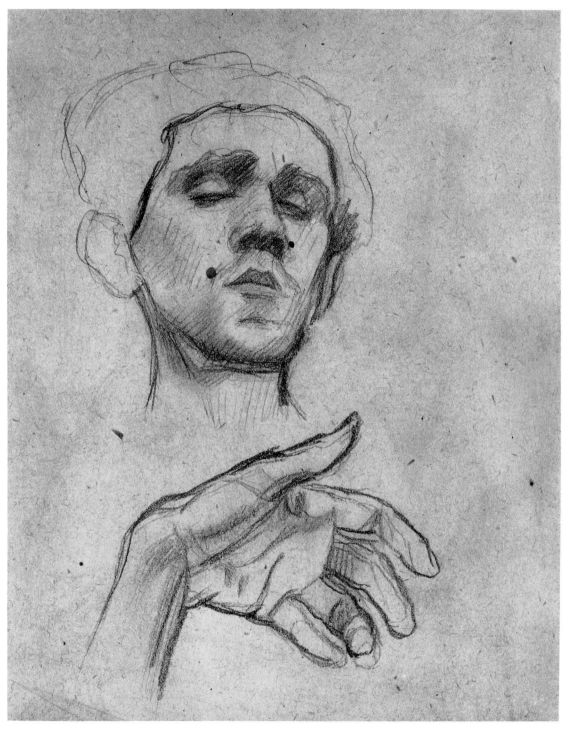

105. Untitled

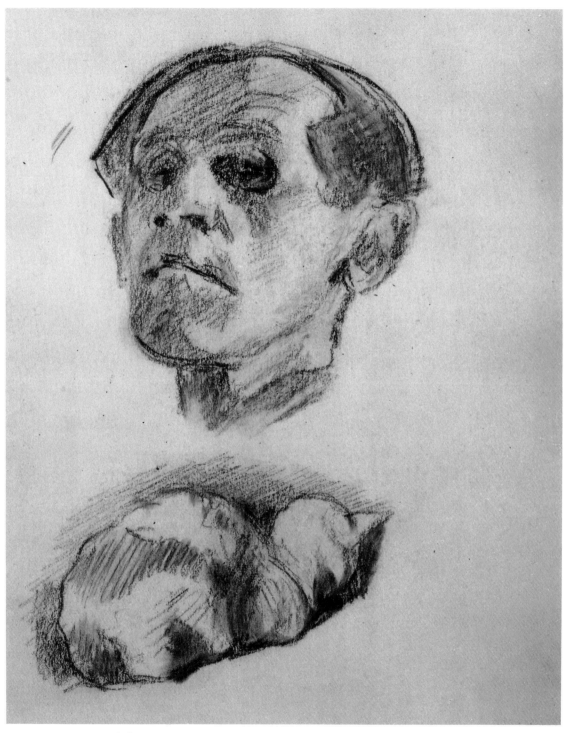

106. Untitled

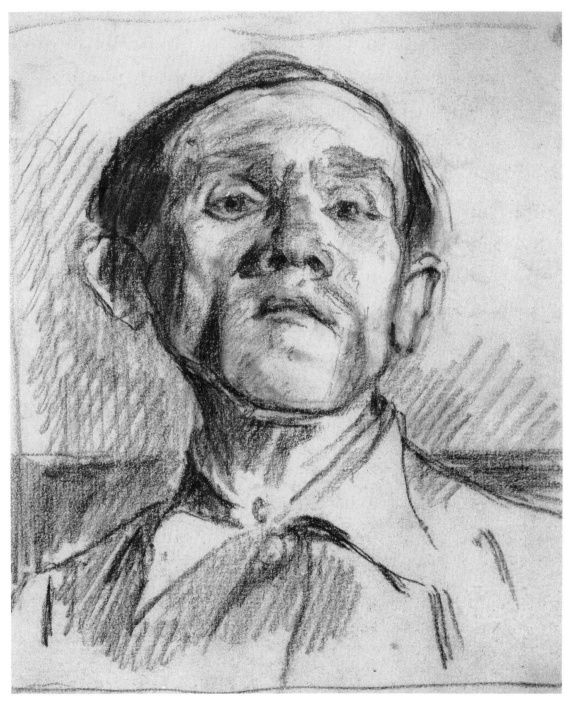

107. Untitled

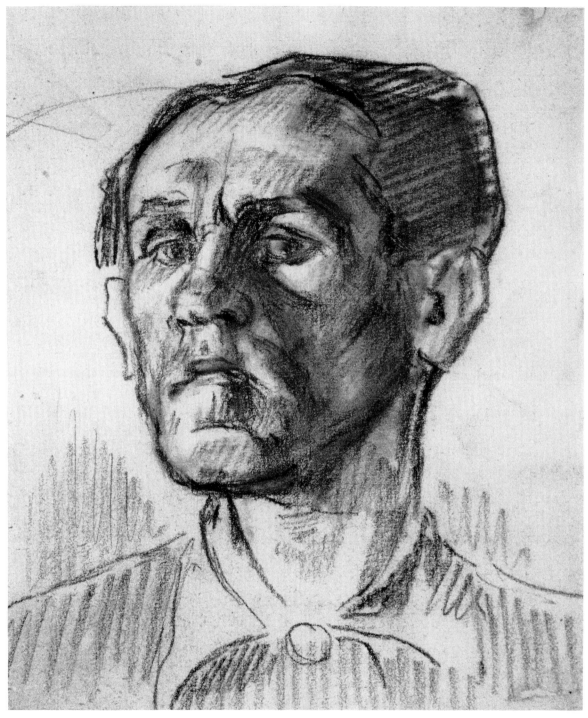

108. Untitled

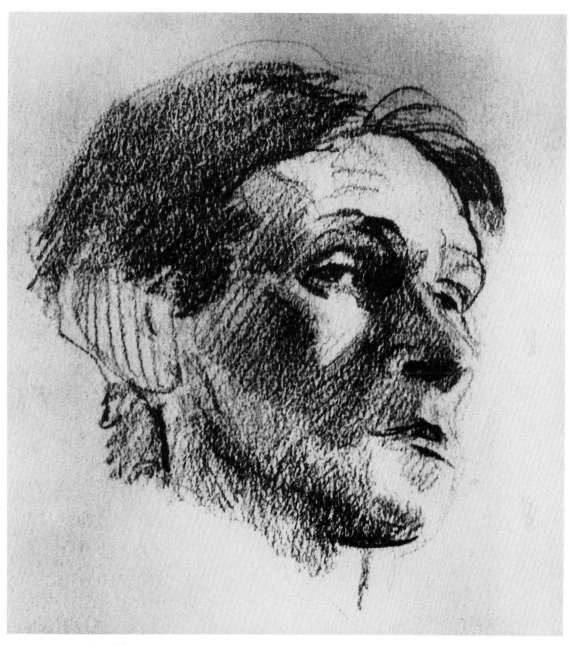

109. Untitled

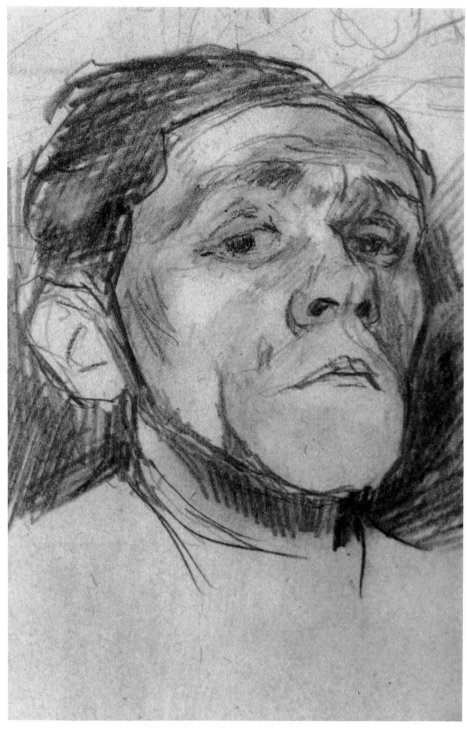

110. Untitled

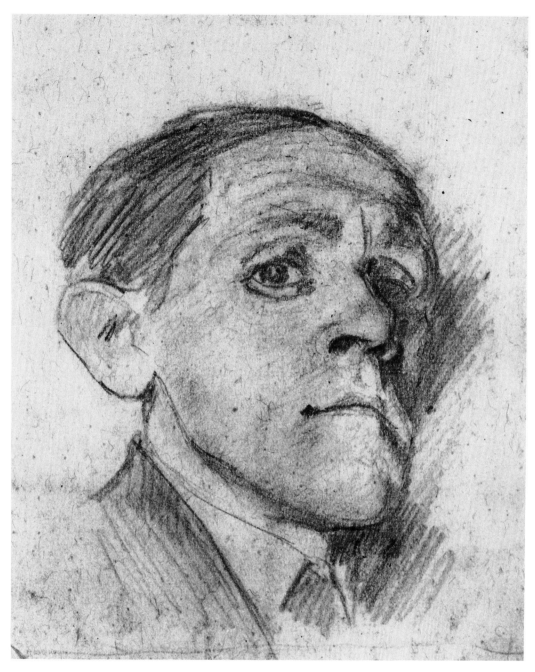

111. Untitled

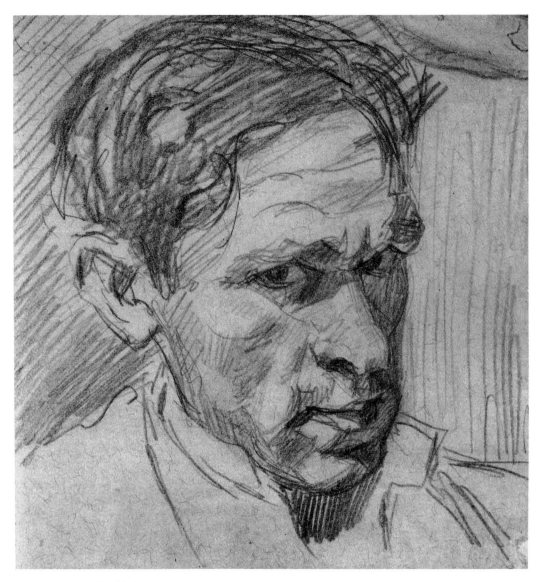

112. Untitled

Portraits

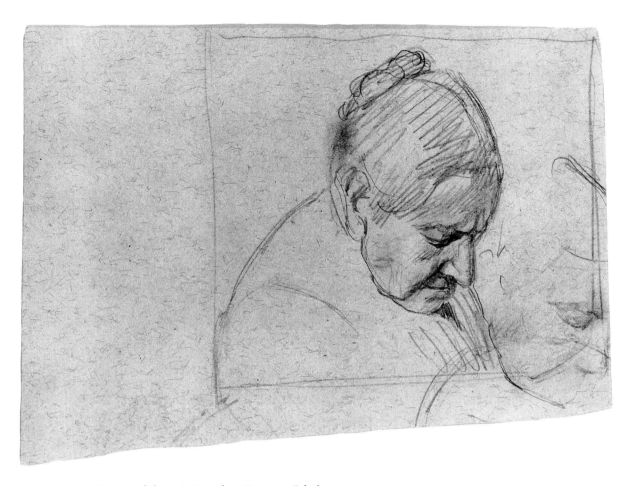

113. Portrait of the artist's mother, Henrietta Schulz

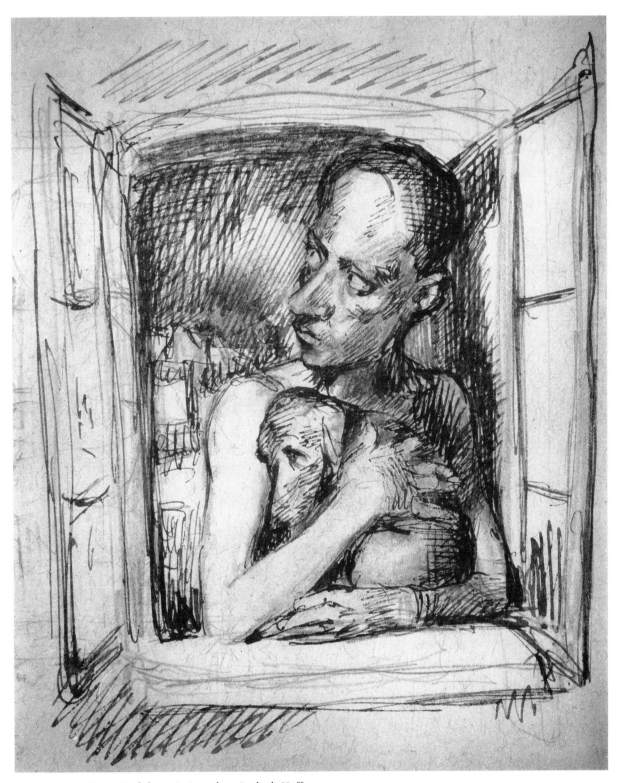

114. Portrait of the artist's nephew Ludwik Hoffman

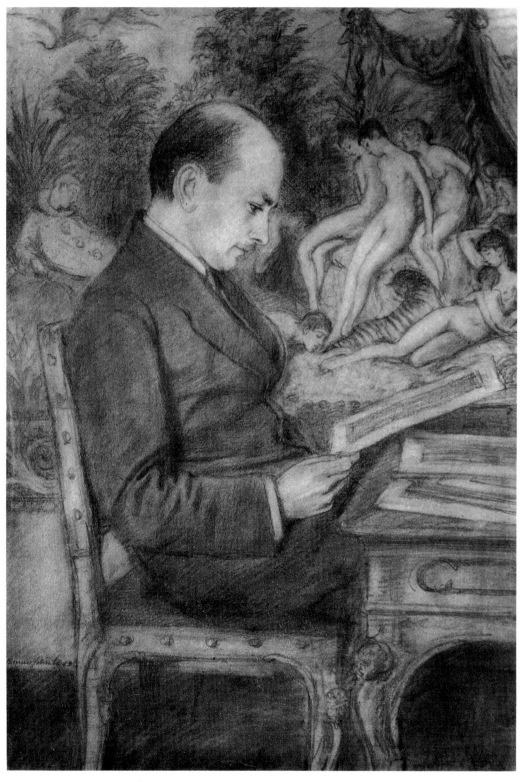

115. Portrait of the artist's friend Stanisław Weingarten

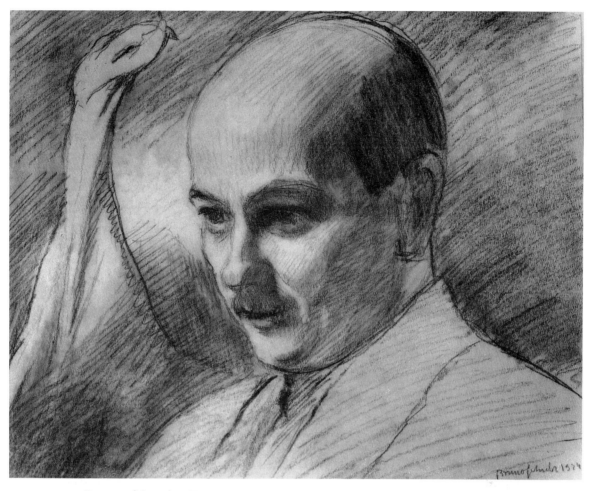

116. Portrait of Stanisław Weingarten

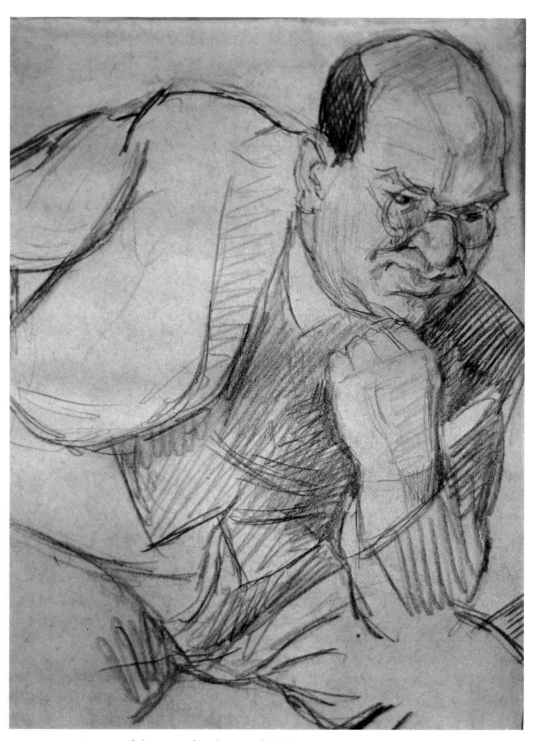

117. Portrait of the artist's friend Emanuel Pilpel

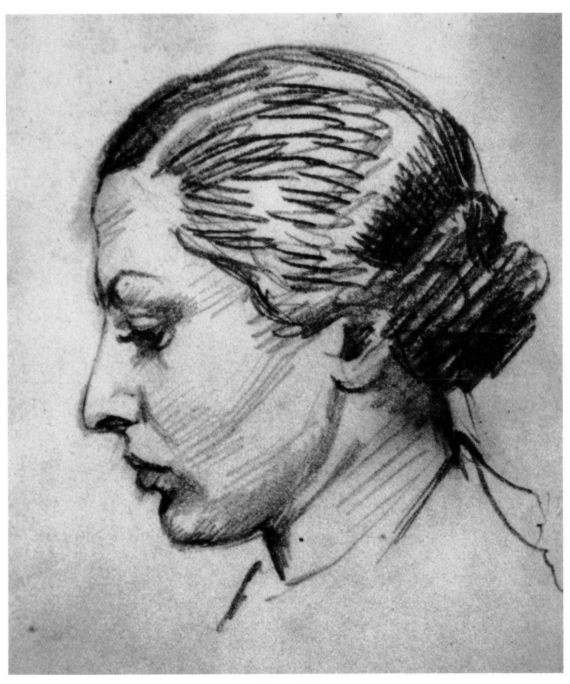

118. Portrait of the artist's fiancée, Josephina Szelinka

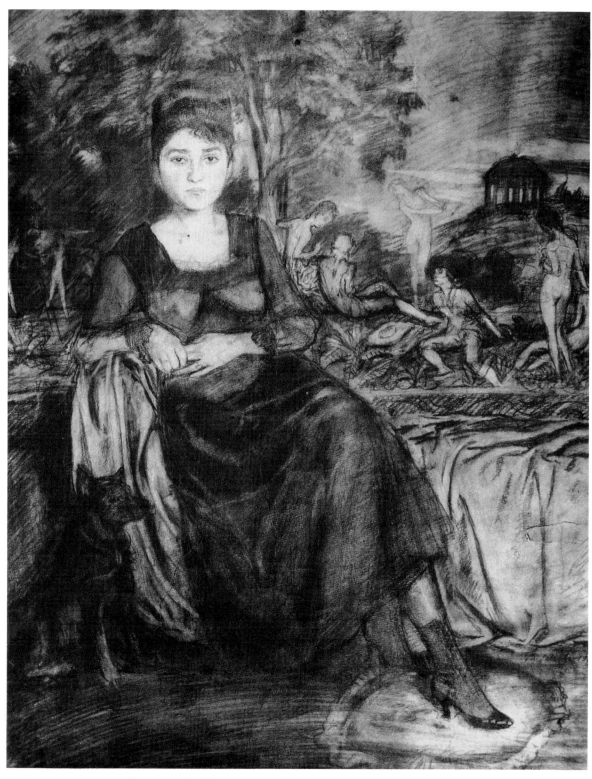

119. Portrait of Maria Budratzka

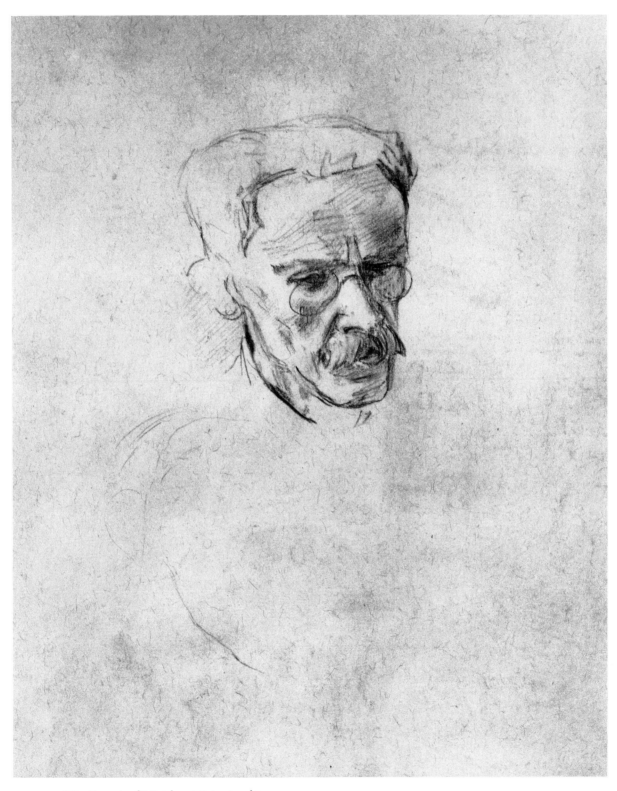

120. Portrait of Mścisław Mściwujewski

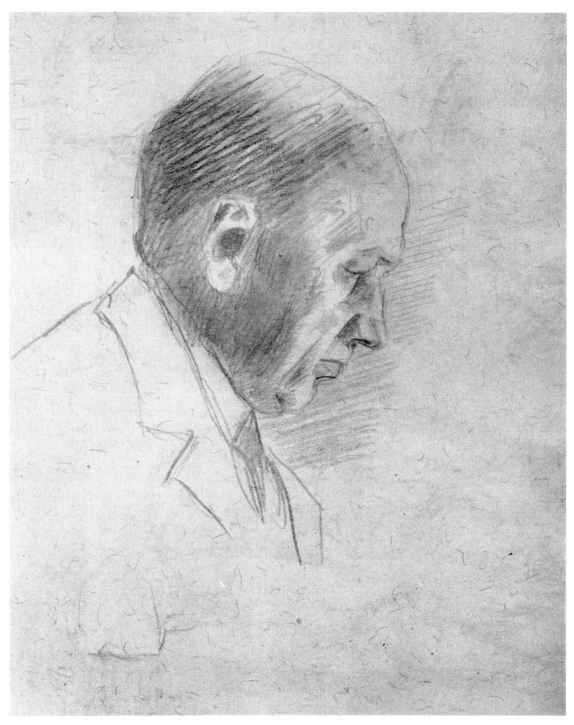

121. Portrait of XY

Book Covers

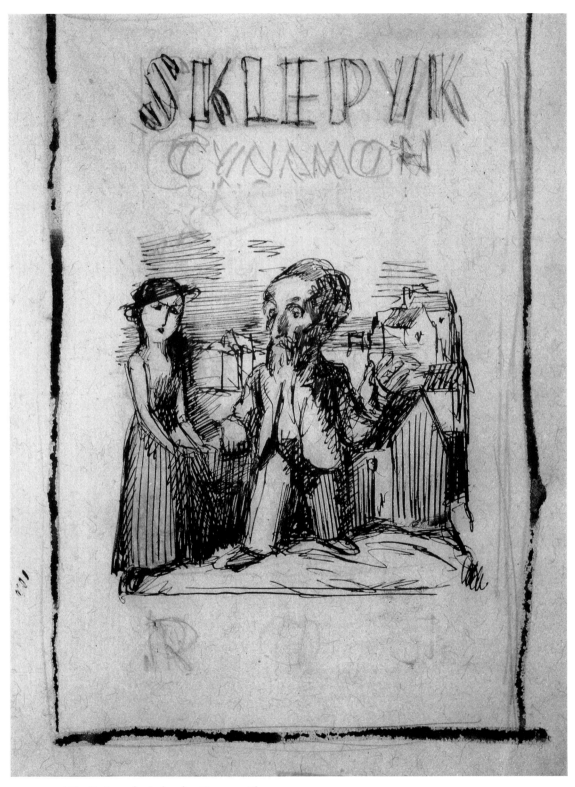

122. Project of a jacket for *Cinnamon Shops*

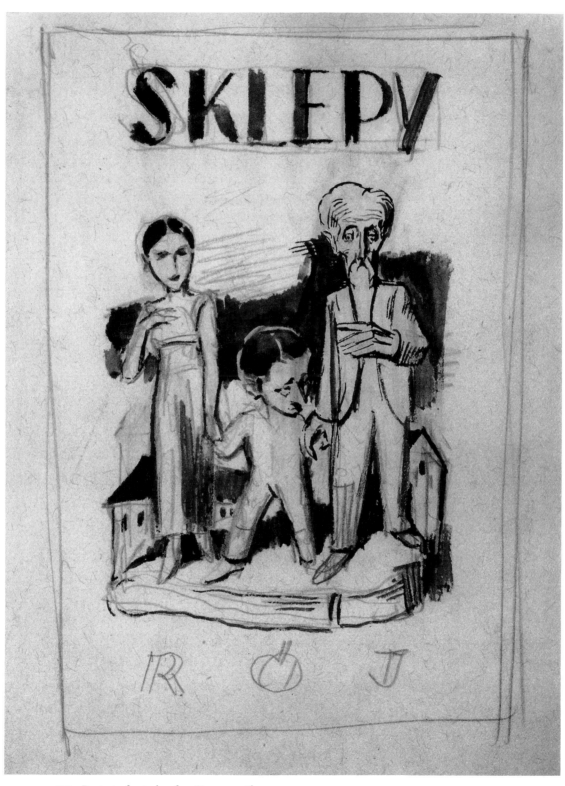

123. Project of a jacket for *Cinnamon Shops*

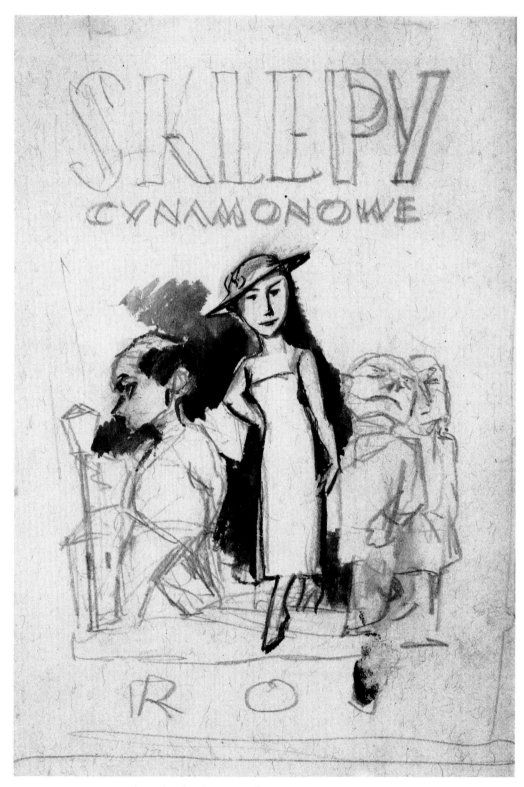

124. Project of a jacket for *Cinnamon Shops*

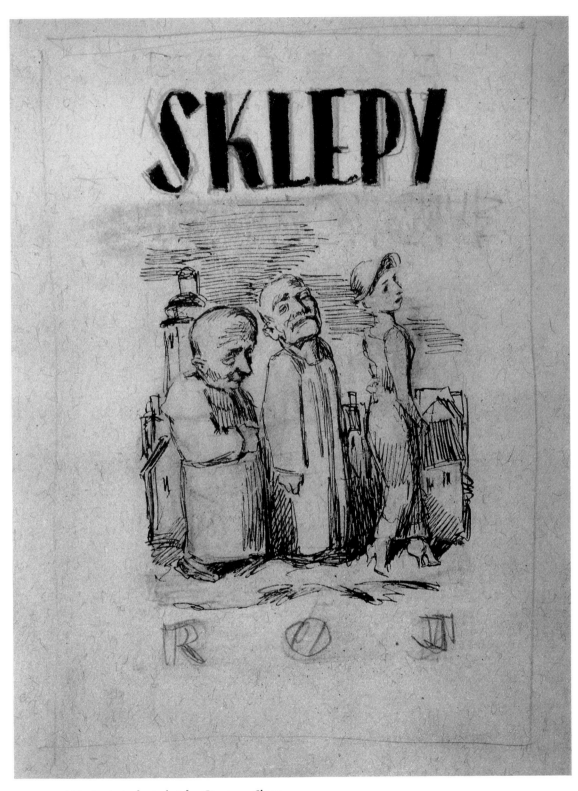

125. Project of a jacket for *Cinnamon Shops*

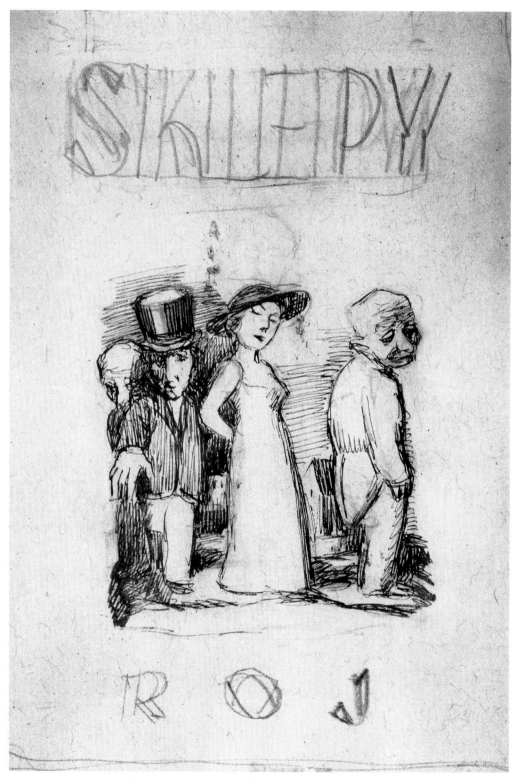

126. Project of a jacket for *Cinnamon Shops*

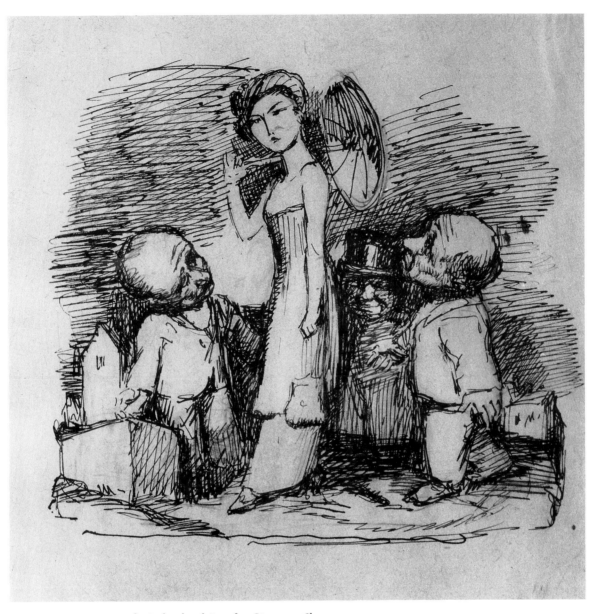

127. Project of a jacket headpiece for *Cinnamon Shops*

128. Jacket of *Cinnamon Shops*

129. Jacket of *Sanatorium under the Sign of the Hourglass*

Illustrations

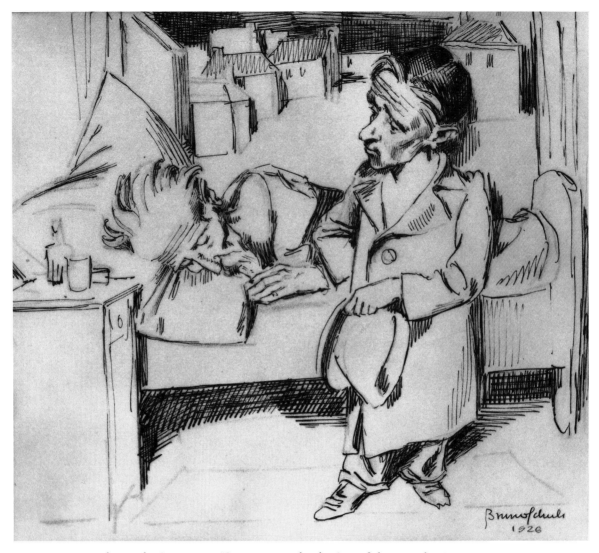

130. Father in the Sanatorium, "Sanatorium under the Sign of the Hourglass"

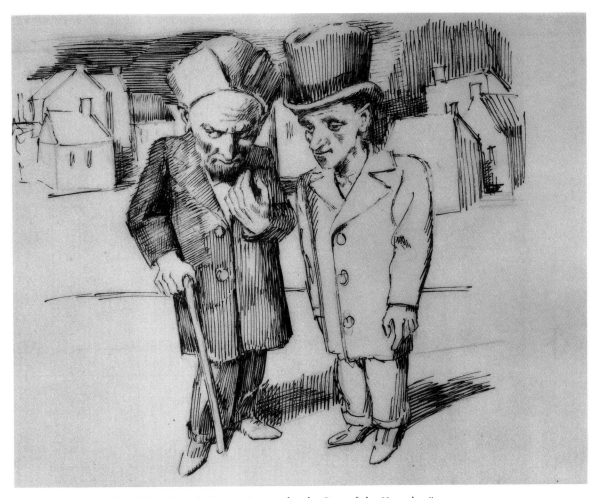

131. Joseph and Dr. Gotard, "Sanatorium under the Sign of the Hourglass"

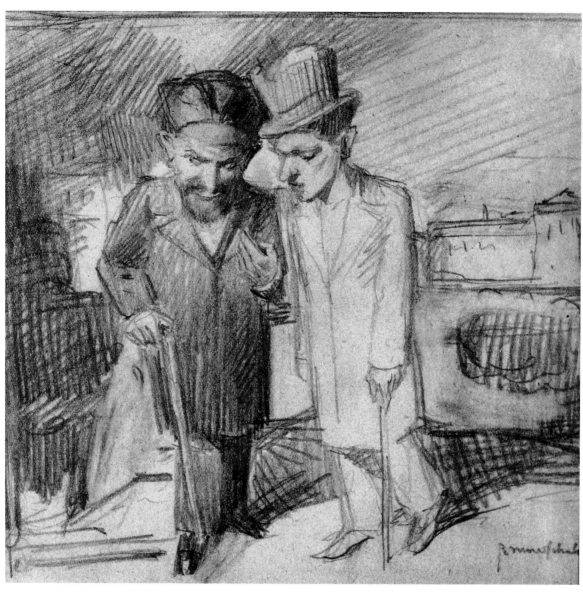

132. Joseph and Dr. Gotard, "Sanatorium under the Sign of the Hourglass"

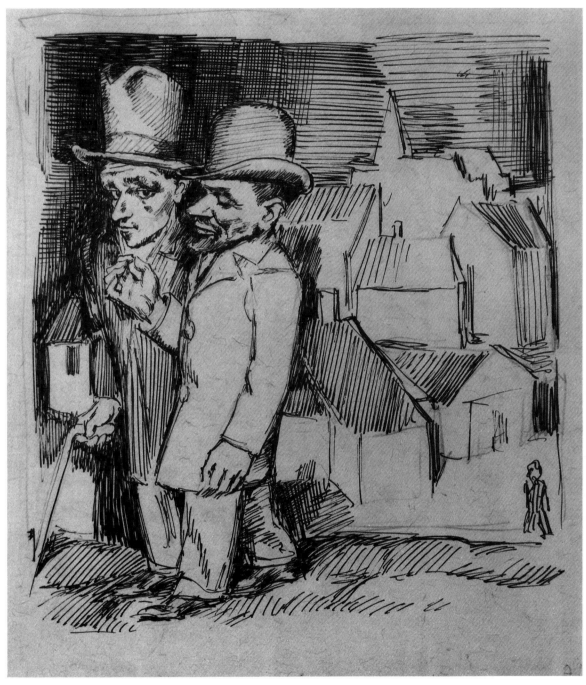

133. Joseph and the dog-man before metamorphosis, "Sanatorium under the
Sign of the Hourglass"

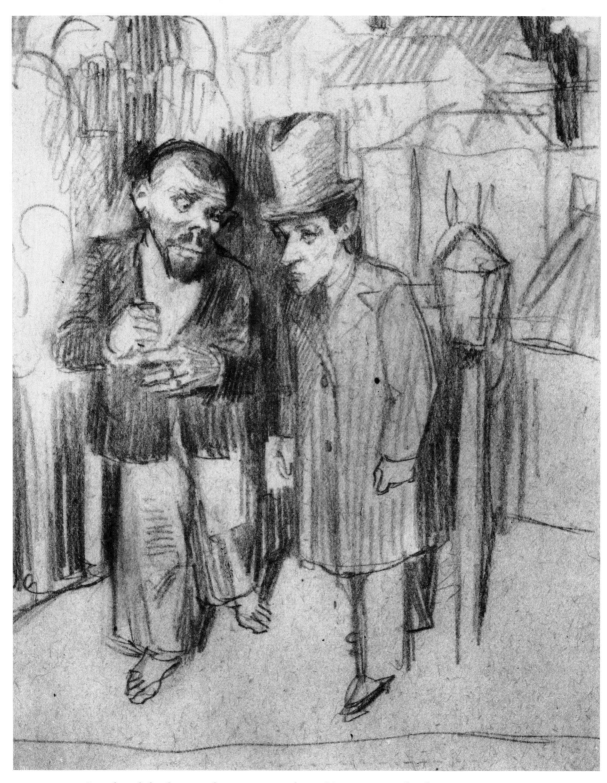

134. Joseph and the dog-man during metamorphosis, "Sanatorium under the
Sign of the Hourglass"

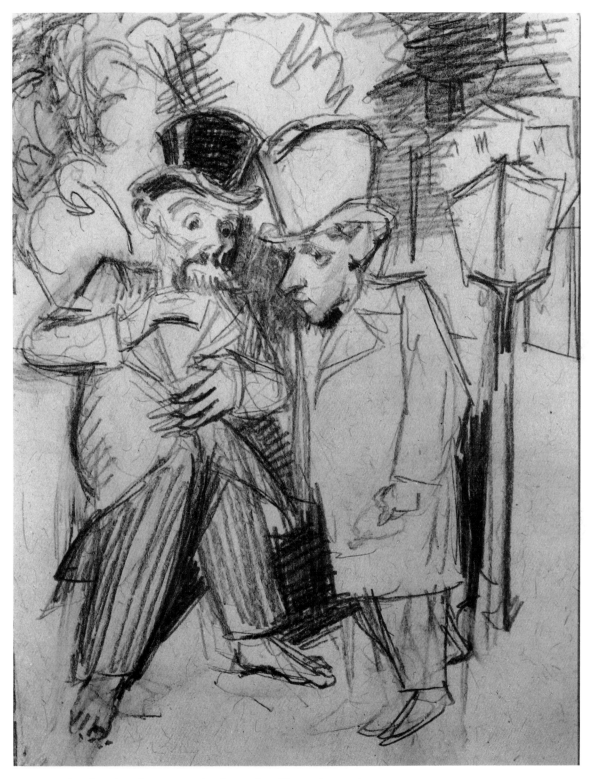

135. Joseph and a man turning into a dog, "Sanatorium under
the Sign of the Hourglass"

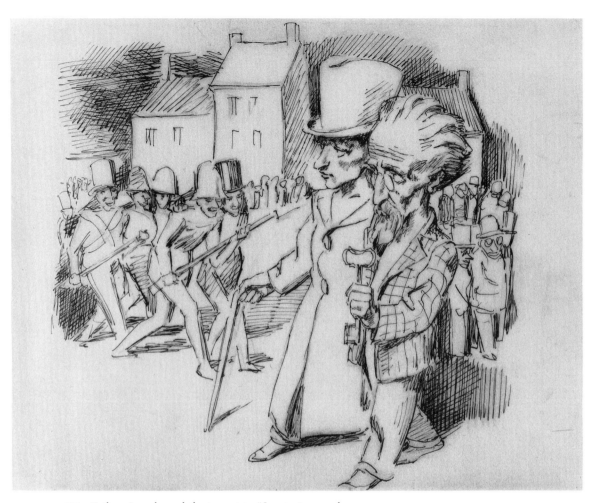

136. Father, Joseph, and the terrorists, "Sanatorium under
the Sign of the Hourglass"

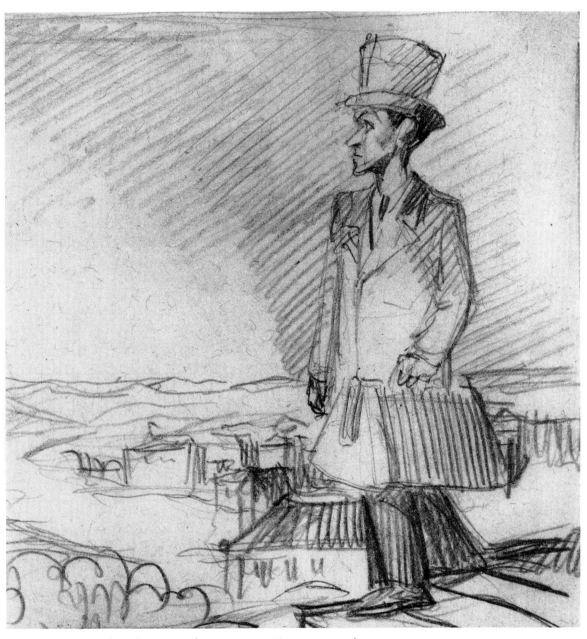

137. Joseph on his way to the Sanatorium, "Sanatorium under
the Sign of the Hourglass"

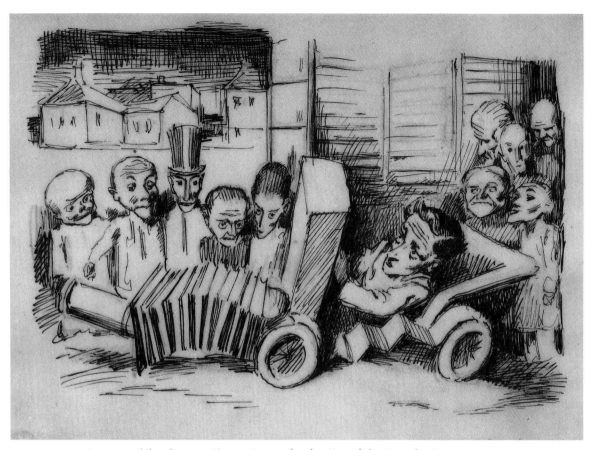

138. An automobile-telescope, "Sanatorium under the Sign of the Hourglass"

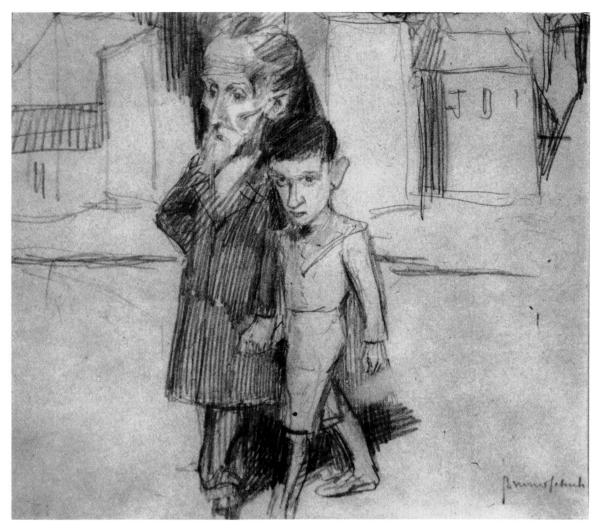

139. Father and Joseph, "Spring"

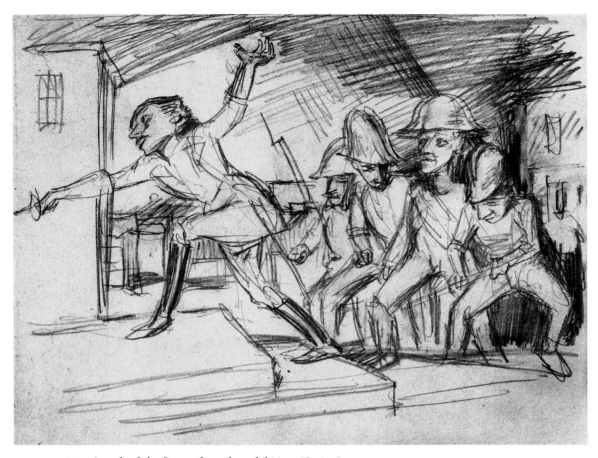

140. Assault of the figures from the exhibition, "Spring"

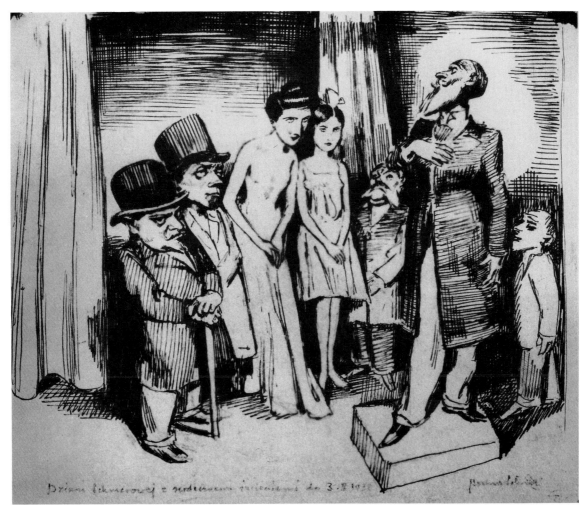

141. Wax figure exhibition, "Spring"

142. Joseph, Rudolph, and others, "Spring"

143. Bianca with her nurse and two boys, "Spring"

144. Bianca with her nurse and two boys, "Spring"

145. Bianca with her nurse, Joseph, and Rudolph, "Spring"

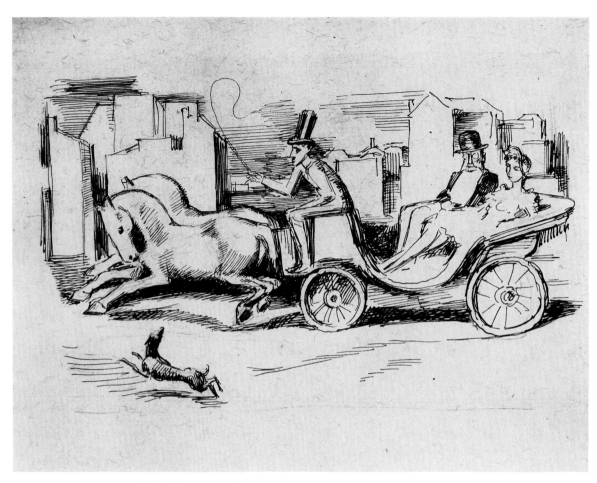

146. Bianca with her father in a cab, "Spring"

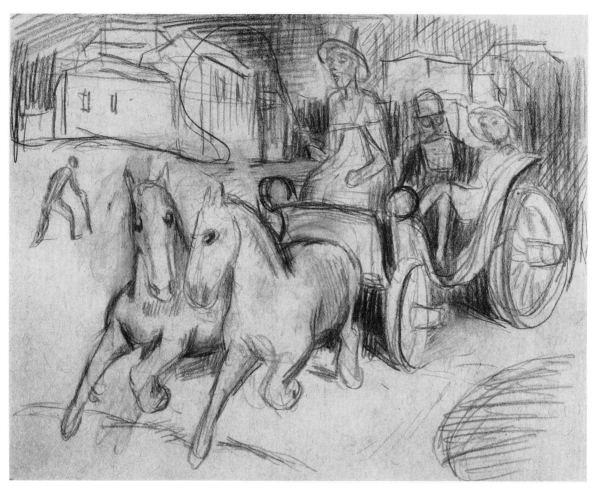

147. Bianca with her father in a cab, "Spring"

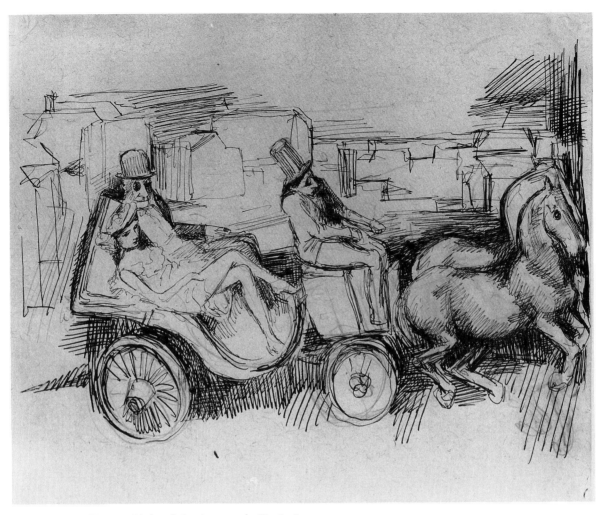

148. Bianca with her father in a coach, "Spring"

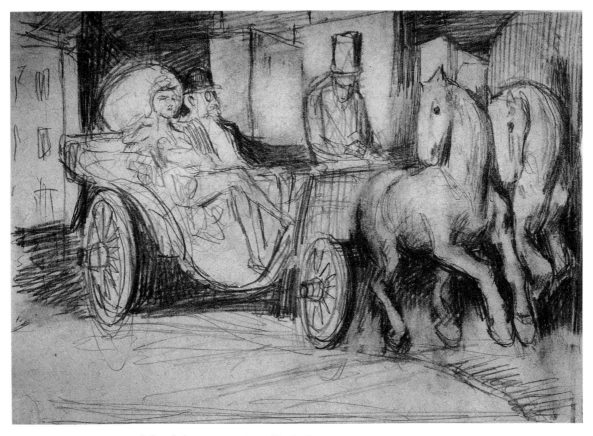

149. Bianca with her father in a carriage, "Spring"

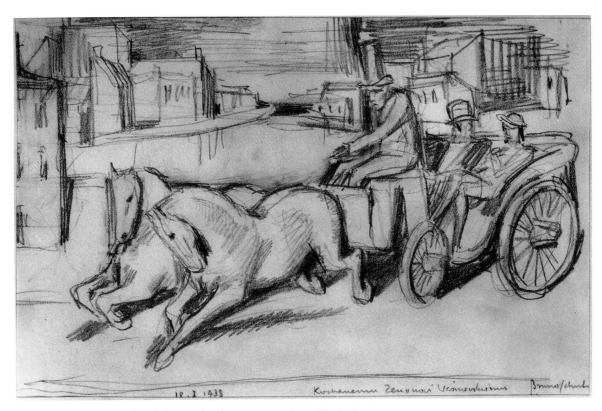

150. Bianca, her father, and a driver in a carriage, "Spring"

Book Covers

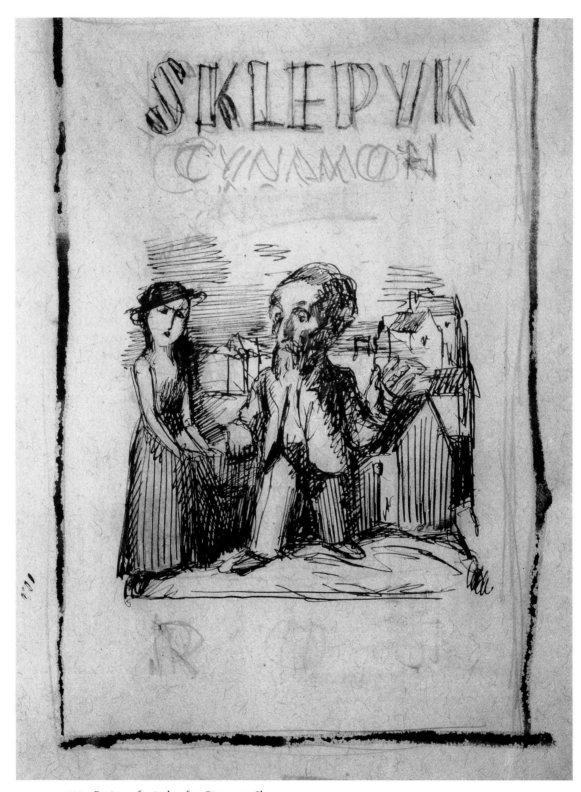

122. Project of a jacket for *Cinnamon Shops*

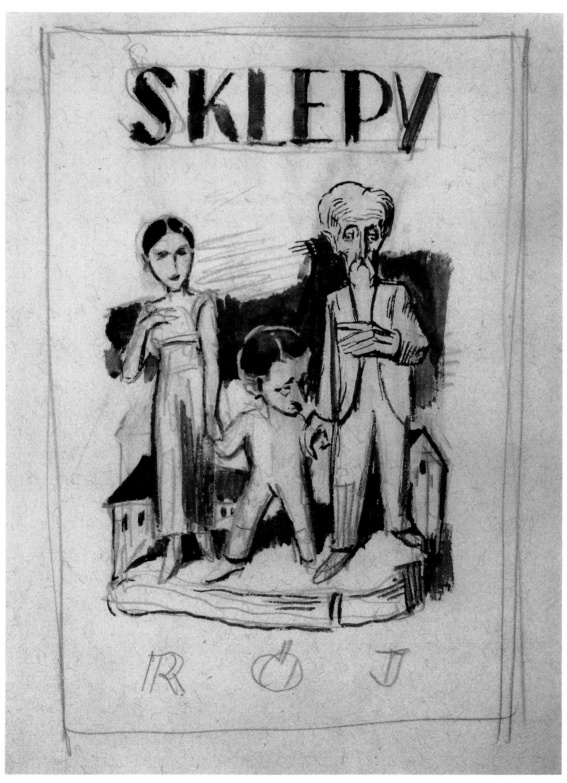

123. Project of a jacket for *Cinnamon Shops*

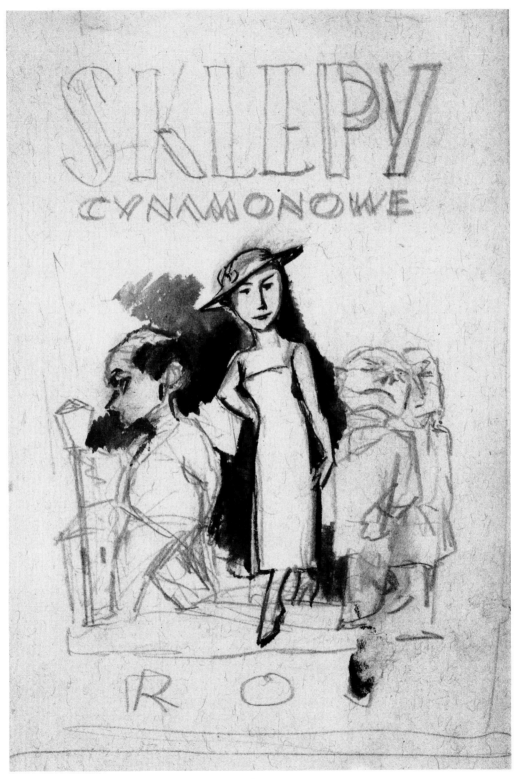

124. Project of a jacket for *Cinnamon Shops*

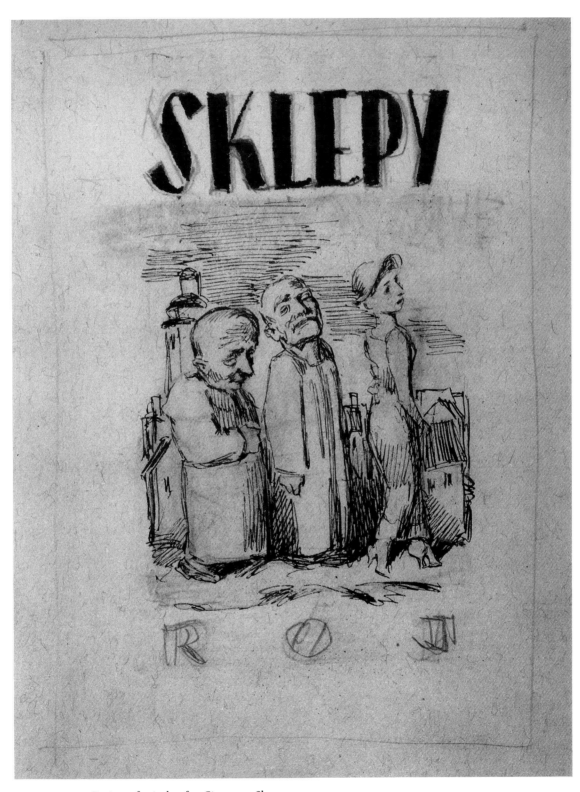

125. Project of a jacket for *Cinnamon Shops*

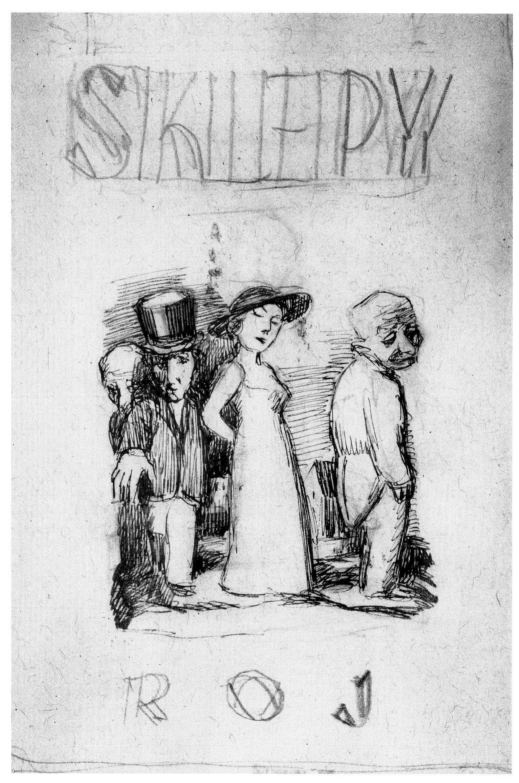

126. Project of a jacket for *Cinnamon Shops*

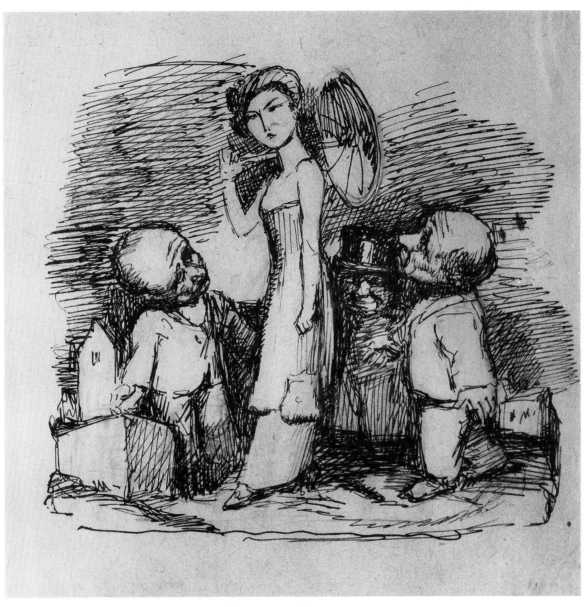

127. Project of a jacket headpiece for *Cinnamon Shops*

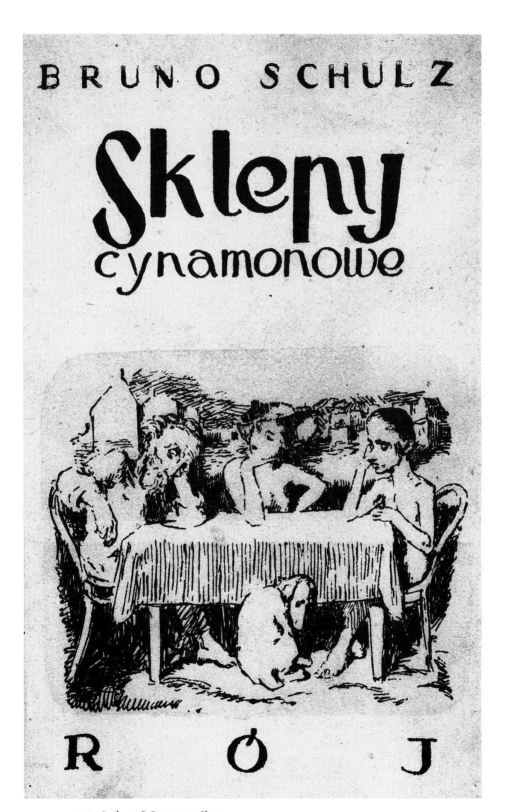

128. Jacket of *Cinnamon Shops*

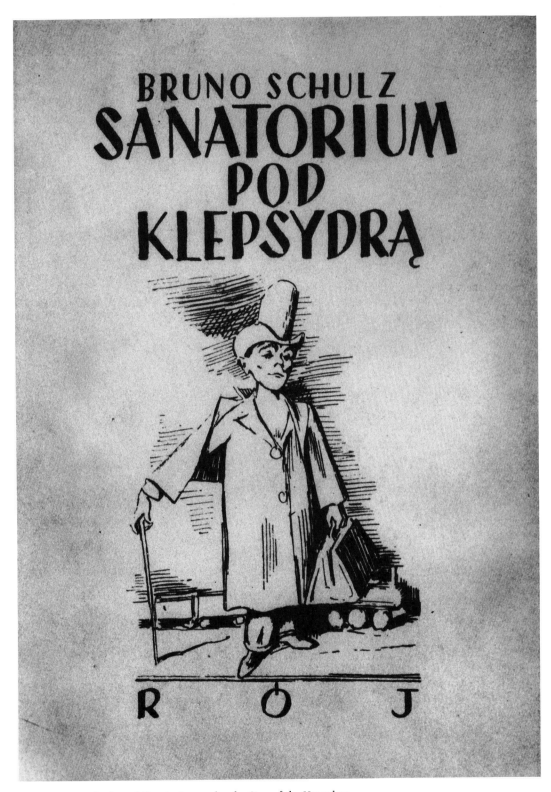

129. Jacket of *Sanatorium under the Sign of the Hourglass*

Illustrations

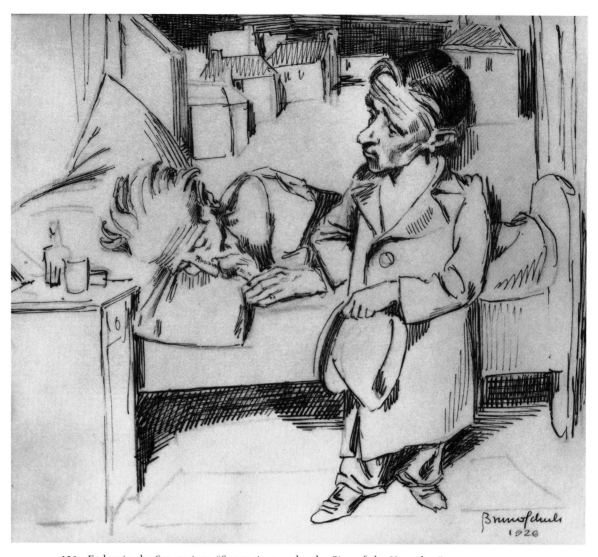

130. Father in the Sanatorium, "Sanatorium under the Sign of the Hourglass"

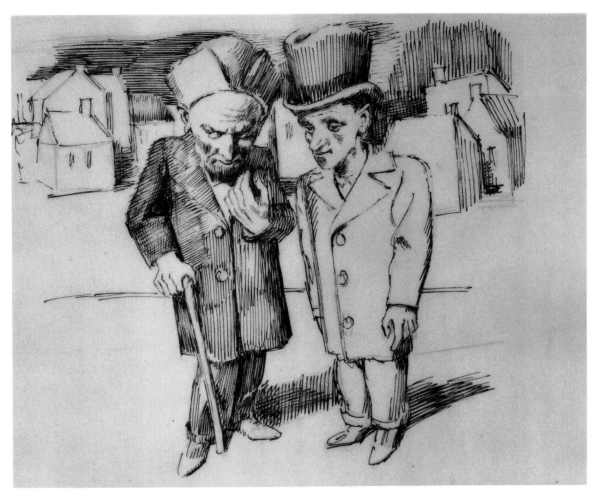

131. Joseph and Dr. Gotard, "Sanatorium under the Sign of the Hourglass"

132. Joseph and Dr. Gotard, "Sanatorium under the Sign of the Hourglass"

133. Joseph and the dog-man before metamorphosis, "Sanatorium under the
Sign of the Hourglass"

134. Joseph and the dog-man during metamorphosis, "Sanatorium under the Sign of the Hourglass"

135. Joseph and a man turning into a dog, "Sanatorium under
the Sign of the Hourglass"

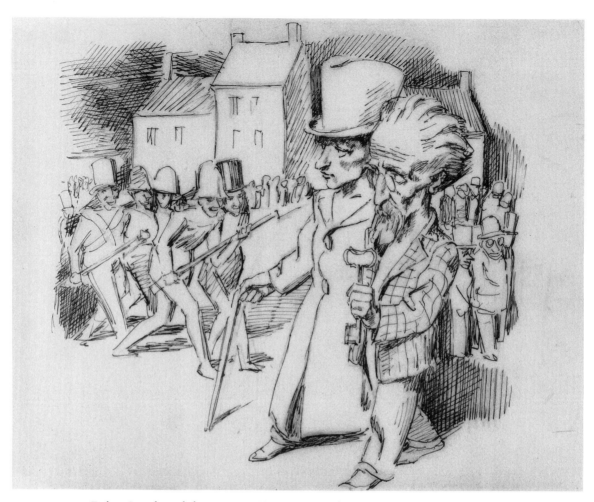

136. Father, Joseph, and the terrorists, "Sanatorium under
the Sign of the Hourglass"

137. Joseph on his way to the Sanatorium, "Sanatorium under
the Sign of the Hourglass"

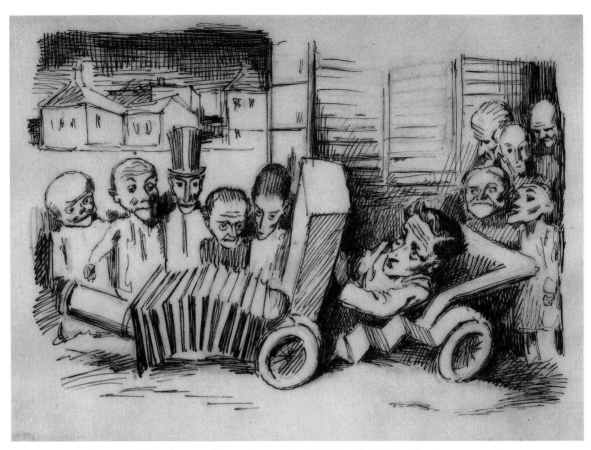

138. An automobile-telescope, "Sanatorium under the Sign of the Hourglass"

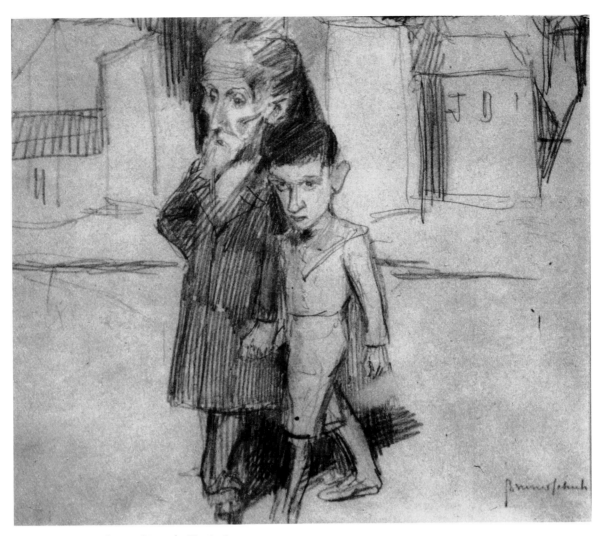

139. Father and Joseph, "Spring"

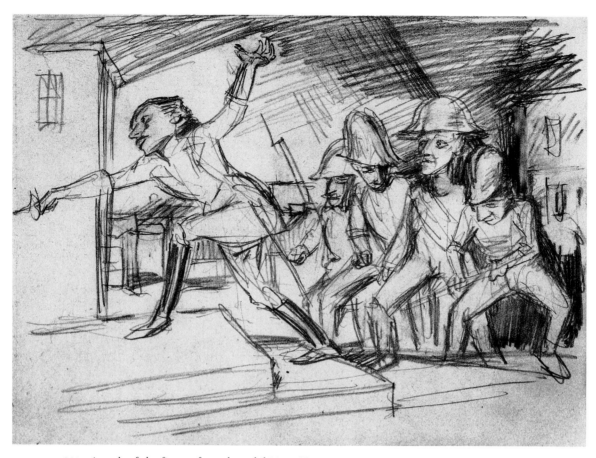

140. Assault of the figures from the exhibition, "Spring"

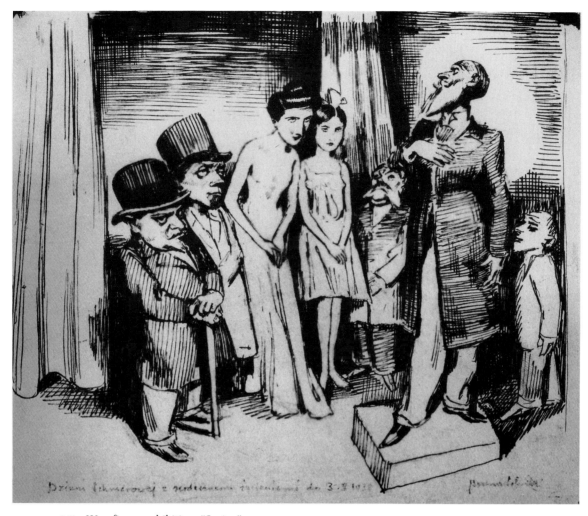

141. Wax figure exhibition, "Spring"

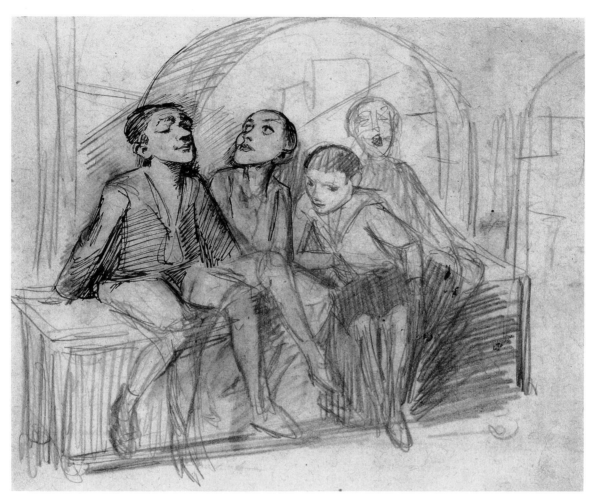

142. Joseph, Rudolph, and others, "Spring"

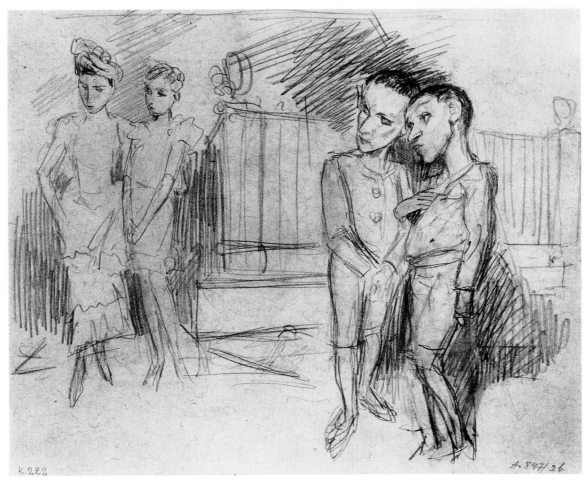

143. Bianca with her nurse and two boys, "Spring"

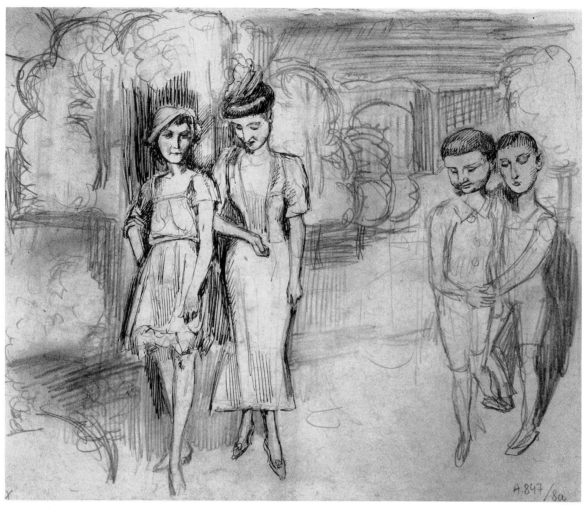

144. Bianca with her nurse and two boys, "Spring"

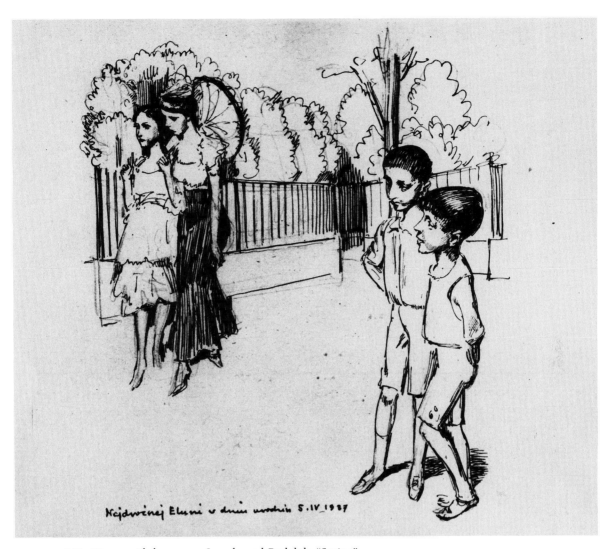

145. Bianca with her nurse, Joseph, and Rudolph, "Spring"

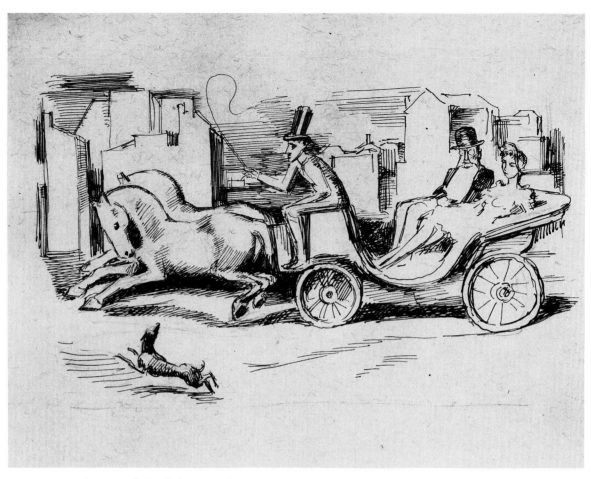

146. Bianca with her father in a cab, "Spring"

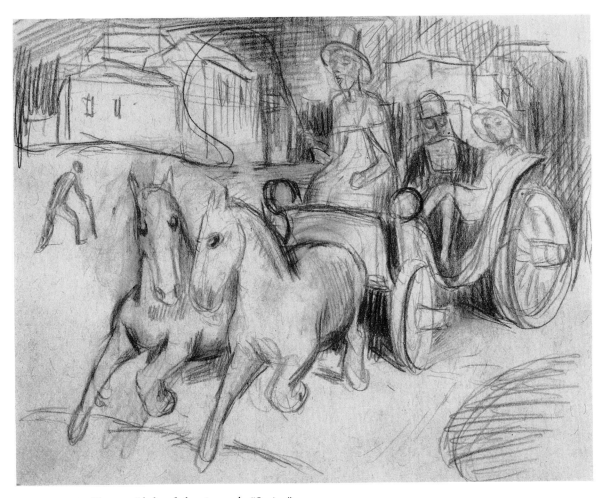

147. Bianca with her father in a cab, "Spring"

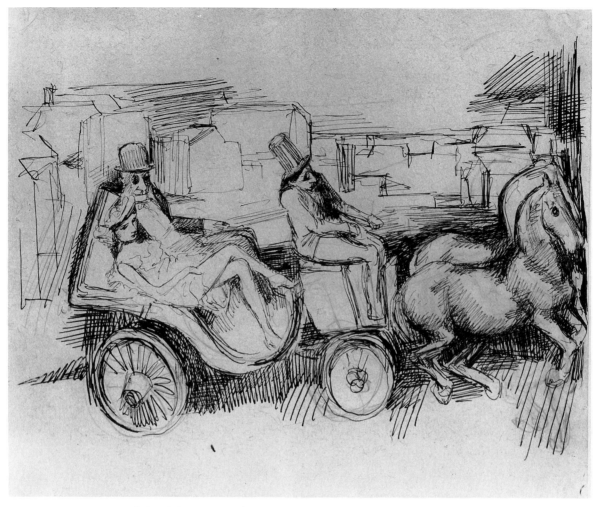

148. Bianca with her father in a coach, "Spring"

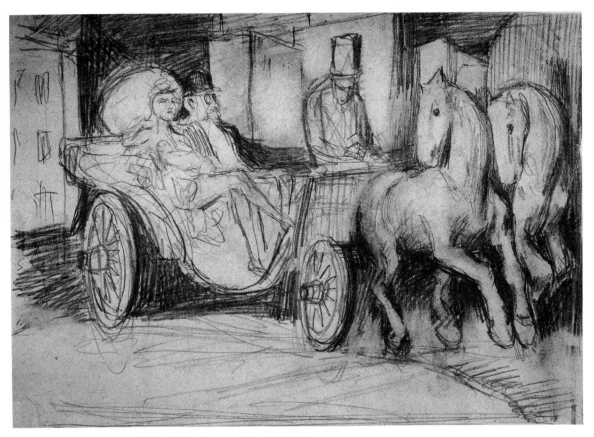

149. Bianca with her father in a carriage, "Spring"

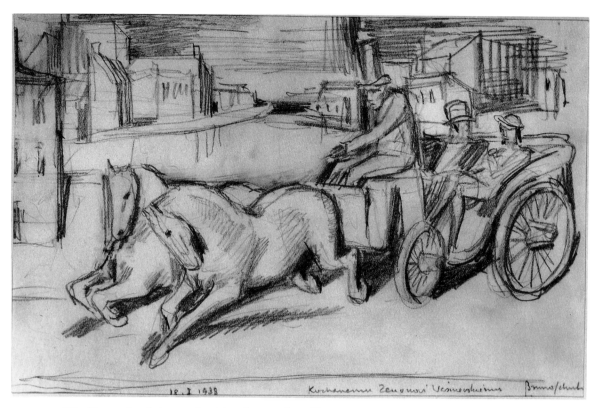

150. Bianca, her father, and a driver in a carriage, "Spring"

182. Untitled

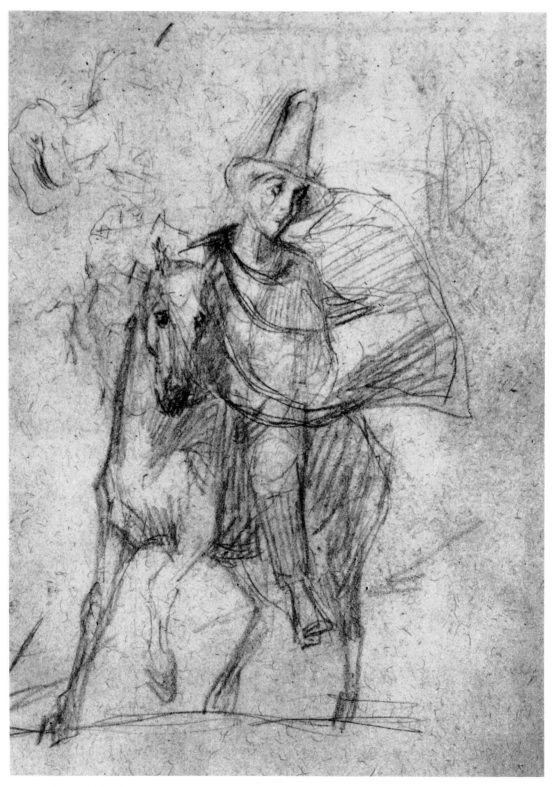

183. Untitled

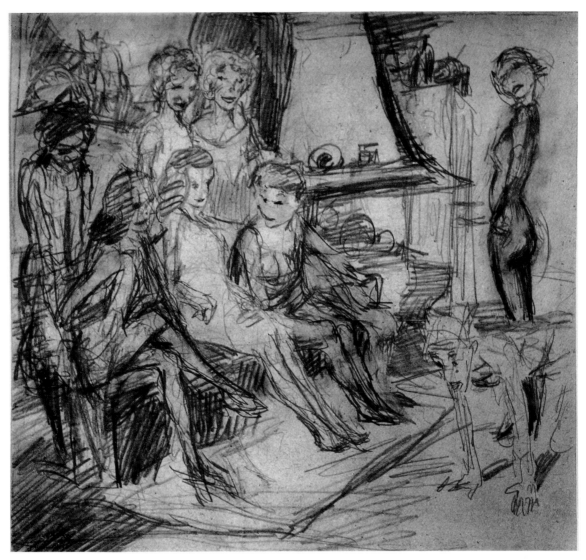

184. Untitled

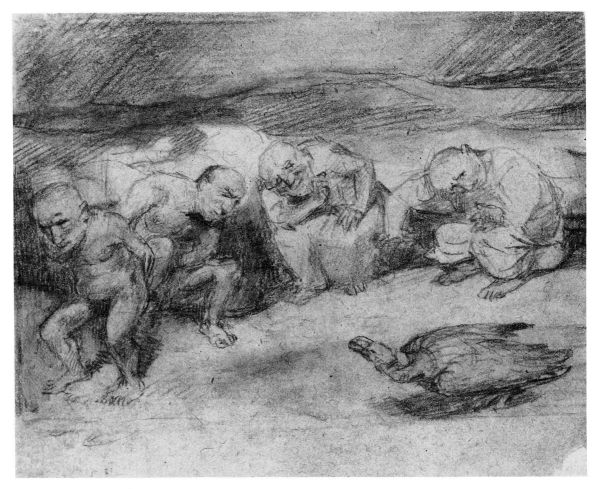

185. Untitled

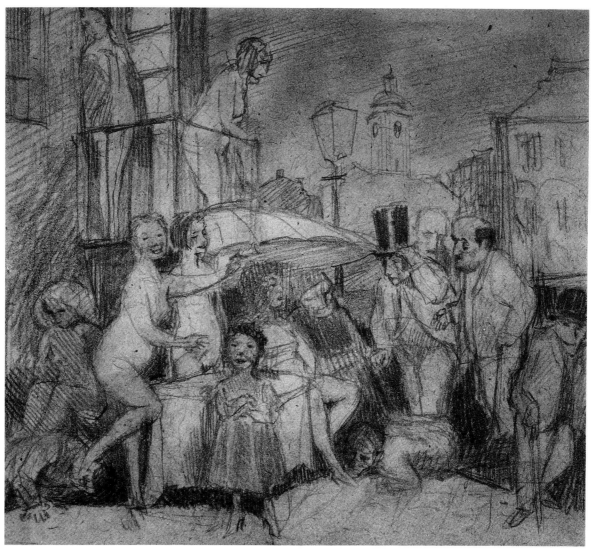

186. Untitled

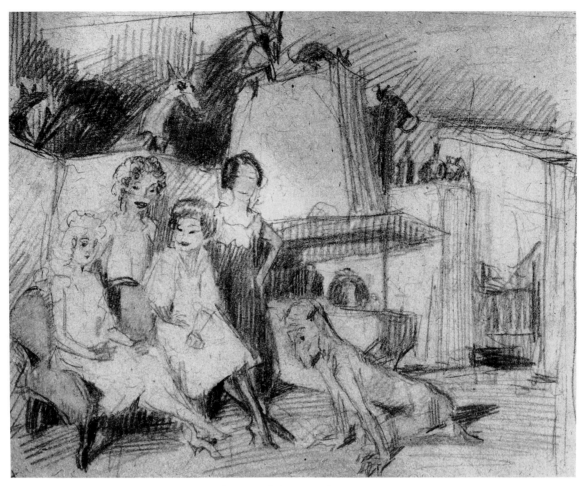

187. Variant, "Sanatorium under the Sign of the Hourglass"

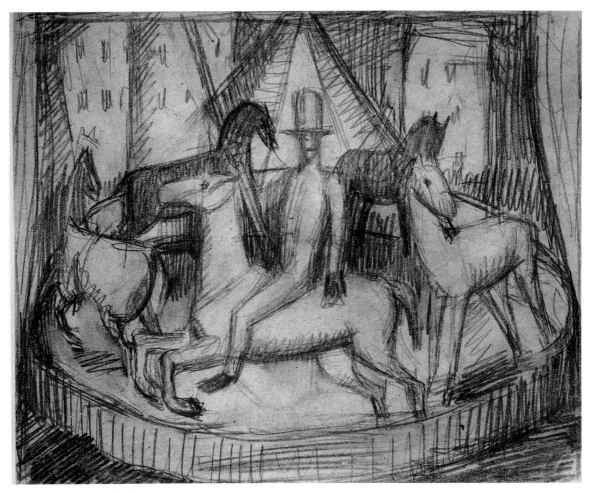

188. Untitled

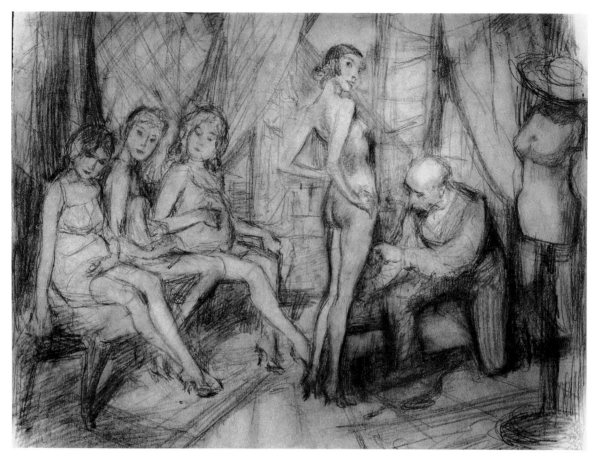

189. Untitled

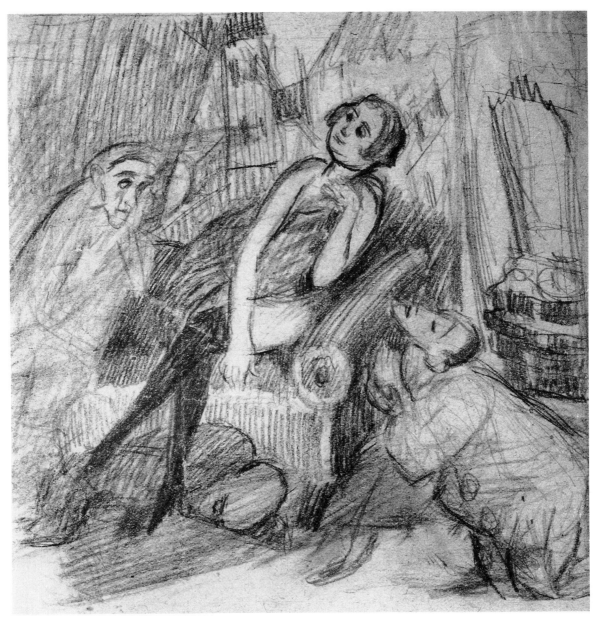

190. Untitled

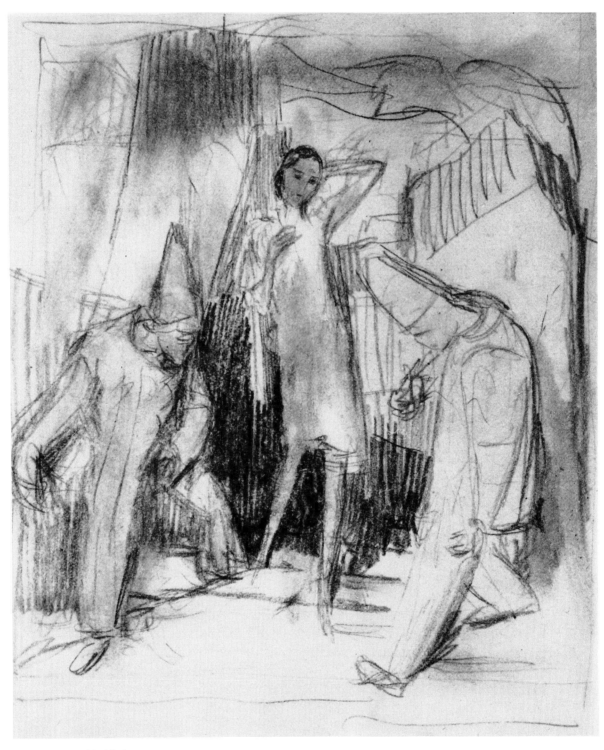

191. Untitled

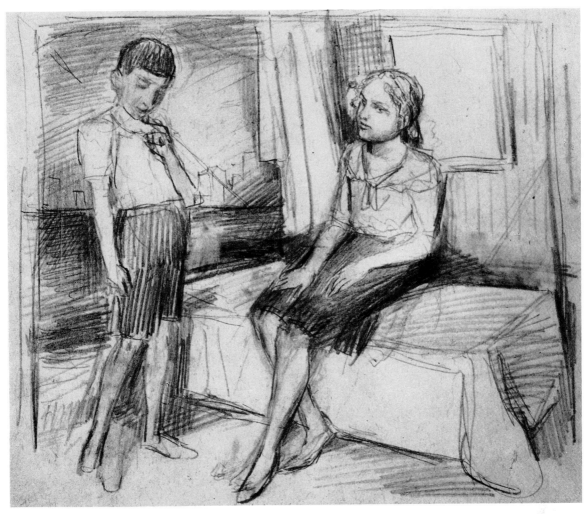

192. Untitled

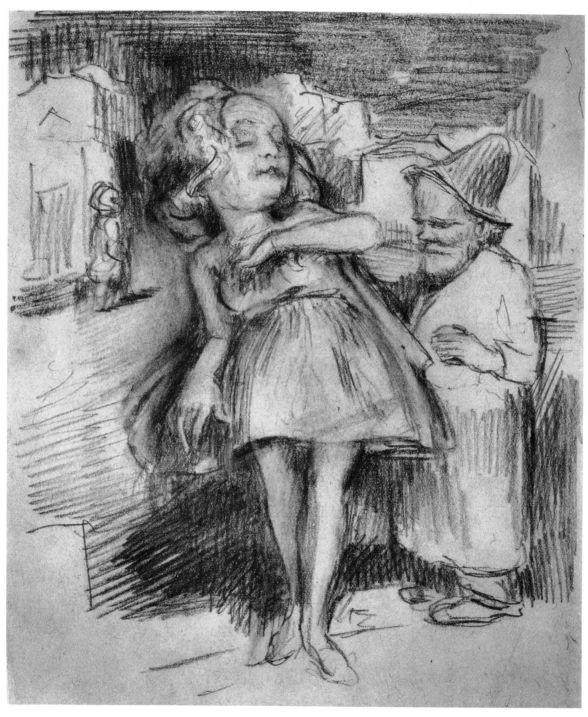

193. Untitled

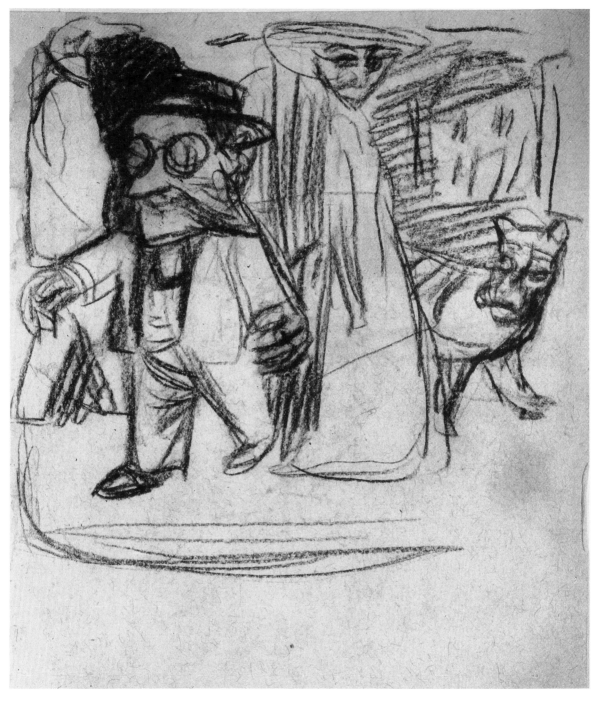

194. Untitled

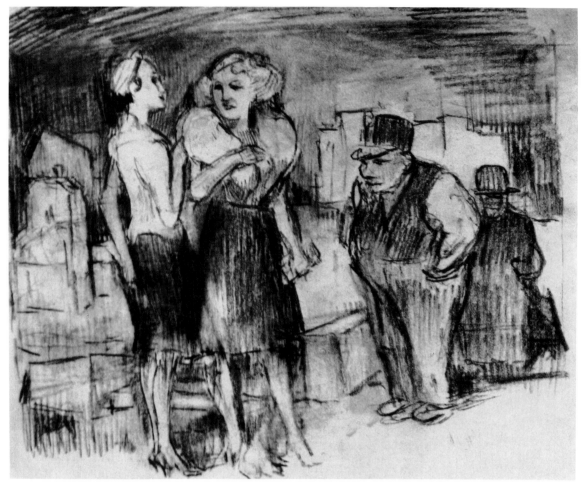

195. Untitled

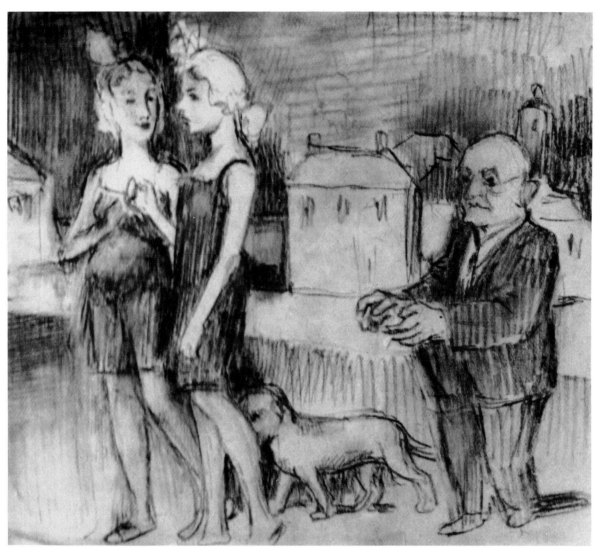

196. Untitled

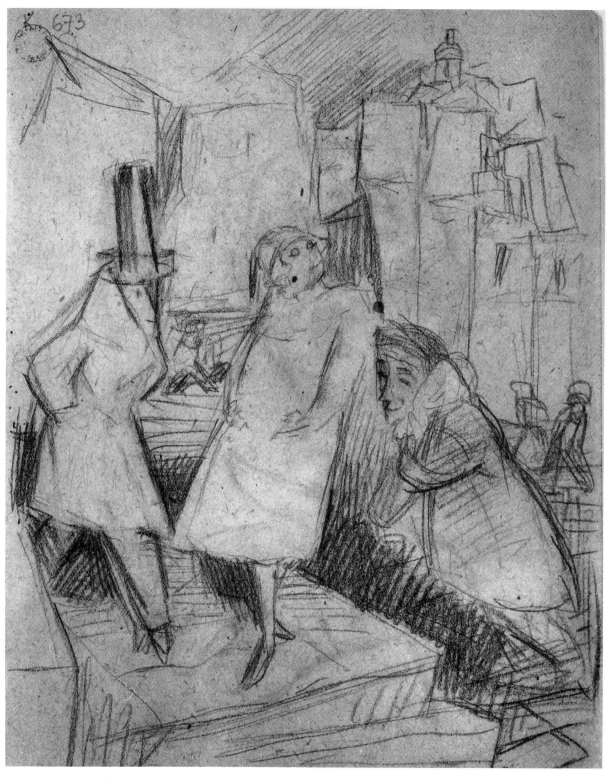

197. Untitled

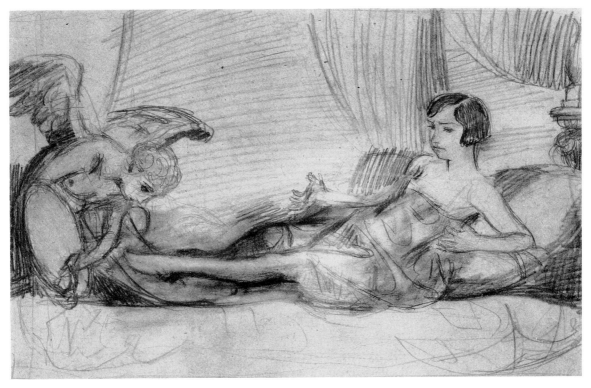

198. Untitled

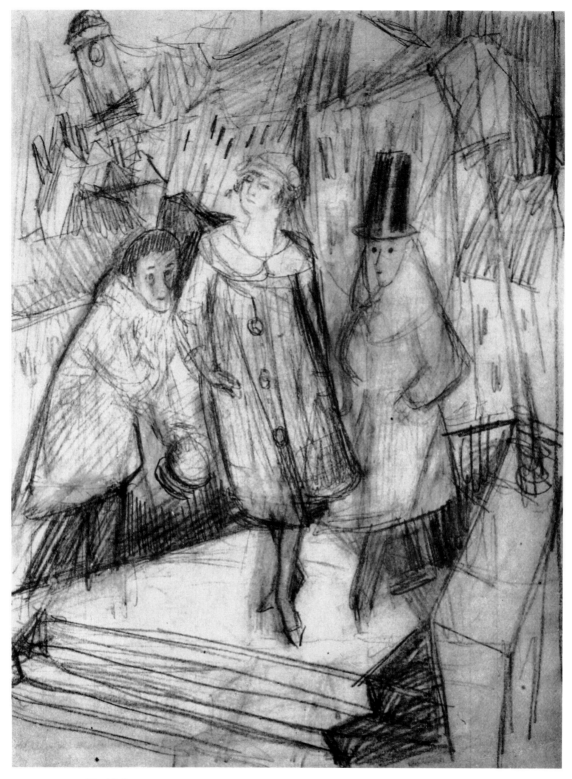

199. Untitled

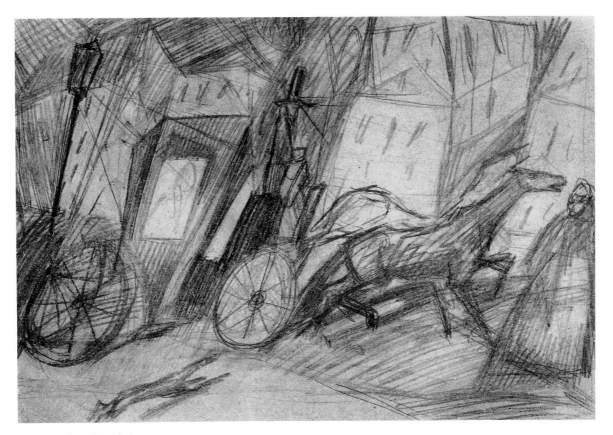

200. Untitled

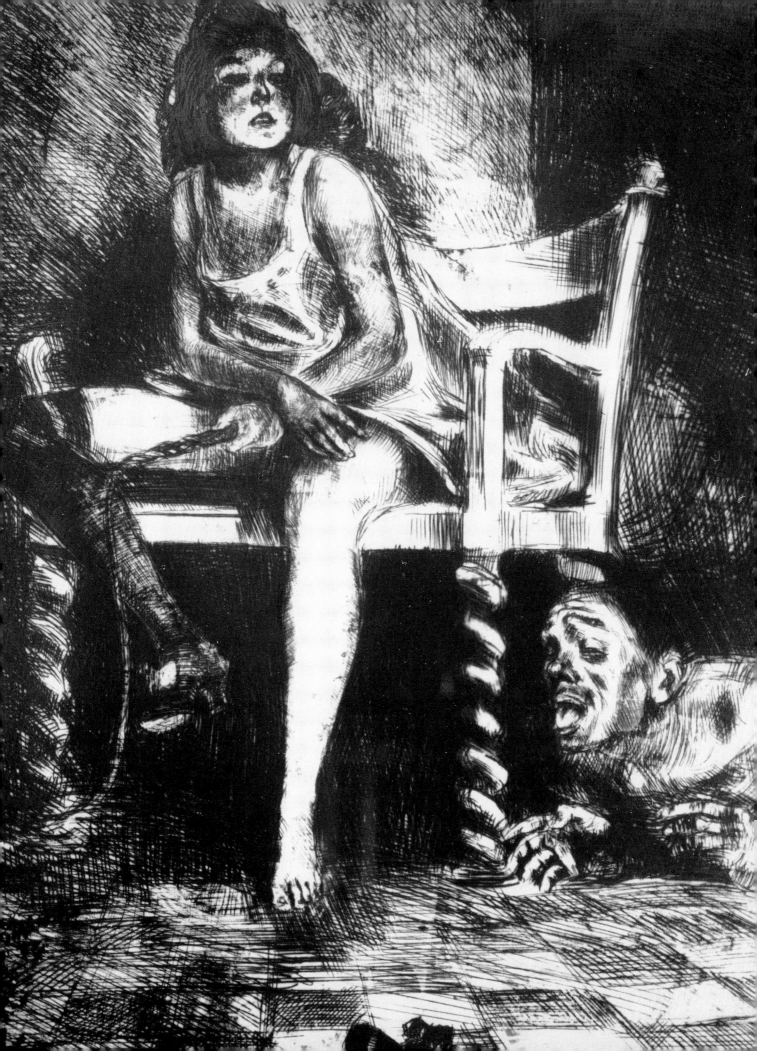

List of Engravings and Drawings

Abbreviations:

GP	Gallery of Painting, Lvov
JIH	Jewish Institute of History in Warsaw
ML	Museum of Literature in Warsaw
NMK	National Museum in Krakow
NMW	National Museum in Warsaw
NMWr	National Museum in Wroclaw
p.c.	private collection
l.o.	lost original
b.c.	black crayon
c.v.	*cliché-verre*
p.	pencil
t.p.	tracing paper

Size of pictures is given in centimeters. Schulz's original titles are in italics. All other titles are provided by the editor.

1. *The Book of Idolatry*

1. The cover of *The Book of Idolatry*, drawing on cloth, ink, NMW

2. Frontispiece of *The Book of Idolatry*, drawing on cardboard, ink, NMW

3. Frontispiece of *The Book of Idolatry*, drawing on cardboard, ink, NMK

4. *Dedication (Introduction)*, self-portrait, c.v., 13 × 17.5, p.c.

5. *The Eternal Tale*, c.v., 16 × 10.6, p.c.

6. *The Infanta and Her Dwarfs*, c.v., 18 × 13, NMW

7. *Undula, the Eternal Ideal*, c.v., 10 × 14.9, p.c.

8. *Undula with the Artists*, c.v., 9.8 × 14.5, p.c.

9. *Undula Walks into the Night*, c.v., 11.6 × 8.4, NMW

10. *Undula at Night*, c.v., 15 × 10.5, p.c.

11. *A Bench*, c.v., 14 × 18, NMW

12. *Tribe of Pariahs*, c.v., 8.7 × 11.8, p.c.

13. *Procession*, c.v., 17.5 × 23.2, p.c.

14. *Pilgrims*, c.v., 17.5 × 23.5, ML

15. *Garden Games*, c.v., 9.8 × 14.8, p.c.

16. *The Enchanted City I*, c.v., 11.8 × 16.7, NMW

17. *On Cythera*, c.v., 11.4 × 18, NMW

18. *Susanna at Her Toilet*, c.v., 8.5 × 13.3, ML

19. *Mademoiselle Circe and Her Troupe (Circus)*, c.v., 12 × 16.7, ML

20. *The Beasts*, c.v., 22.5 × 16.5, p.c.

21. *The Enchanted City II (Revolution in City)*, c.v., 16.5 × 22, p.c.

22. *Rites of Spring*, c.v., 11.6 × 17, NMW

23. *Eunuch with Stallions*, c.v., 15.5 × 23, p.c.

24. *The Feast of Idolaters*, c.v., 8.6 × 11.7, NMW

25. *The Book of Idolatry I*, c.v., 16.9 × 11.3, NMW

26. *The Book of Idolatry II*, c.v., 13.7 × 23, p.c.

2. Masochistic Scenes

27. *A Meeting*, b.c., l.o., photocopy p.c.

28. *Undula Takes a Walk* (see cat. no. 21), 1919, b.c., l.o., photocopy p.c.

29. Pilgrims (see cat. no. 14), 1921, p., 18 × 23, p.c.

30. Two women and a group of men behind a partition, bef. 1933, p., 17 × 20, ML

31. Three girls on a bench and a man, ca. 1933, p., 15.5 × 20, ML

32. Three women on a sofa and a kneeling man, ca. 1933, p., ink, 16 × 20.3, ML

33. Three women on a sofa and a man on all fours, ca. 1933, p., 17.5 × 22.5, ML

34. A girl seated on a daybed and a kneeling man, ca. 1933, p., 19.5 × 28.5, ML

35. A woman on a daybed and a kneeling man staring at her feet, ca. 1933, p., 19.5 × 28.5, ML

36. Three women on a sofa, a maid, and kneeling men, ca. 1936, t.p., ink, 17.5 × 23.5, ML

37. A seated girl and a standing boy, bef. 1934, p., 21.2 × 34, ML

38. Two seated girls, one treading on a dwarf's head, bef. 1936, p., 21.2 × 34, ML

39. Three women and a man on all fours kissing the foot of one of the women, bef. 1936, p., 21.2 × 34, ML

40. Three women on a sofa and a standing woman treading on a crawling figure, ca. 1933, p., 17 × 20.5, ML

41. A woman with a dog and a whip, and a man kneeling at her feet, bef. 1935, p., 16 × 20.3, ML

42. A naked reclining woman and a man's head visible from behind the bed, bef. 1933, p., 15.5 × 19.5, ML

43. A naked woman on a daybed and a kneeling man, bef. 1935, p., 15 × 19, ML

44. A naked woman on a sofa and a naked man on the rug, bef. 1935, ink, 14.5 × 17, p.c.

45. A naked woman seated on a bed and two men, ca. 1933, p., 13.5 × 19, p.c.

46. *Bacchanalia*, 1920, b.c, ink, 23.5 × 30.5, NMWr

47. Vassals' procession, bef. 1935, p., 19.5 × 22, ML

48. A girl in a town and a man bowing to her, bef. 1933, p., b.c., 18 × 23.3, ML

49. Two women, one naked, one dressed, walking down the street, followed by a dwarf, bef. 1935, p., 20 × 29, ML

50. A woman in a shirt at a shop door and a dwarf, bef. 1935, p., 21.5 × 15.8, ML

51. A woman and two dwarfs, bef. 1933, p., 19 × 29, ML

52. A woman in the street followed by a man, ca. 1933, p., 28.3 × 18, ML

53. A girl in a bonnet against a town landscape and a kneeling man, ca. 1933, p., 18.8 × 15, ML

54. An elder man, a naked woman, and a man, ca. 1930, p., 15.5 × 15.5, ML

55. A woman sitting on the shoulders of a man, bef. 1933, p., 19.6 × 12.6, ML

56. A woman with a whip and a man dodging a blow, bef. 1933, p., 13 × 16.5, ML

57. A woman with a whip and a kneeling man, ca. 1932, b.c., 19.5 × 15.2, ML

58. A man on all fours and a departing woman, ca. 1934, p., 16 × 20, ML

3. Nudes

59. Nude in an antique bed against a town landscape, ca. 1930, p., b.c., 17 × 21, ML

60. Two women, sketch, ca. 1935, ink, 18.5 × 13.5, p.c.

61. Nude against a landscape, ca. 1934, p., 15 × 20.5, ML

62. Nude women in a drawing room, bef. 1936, p., 15 × 17.8, ML

63. Nude and semi-nude, sketch, ca. 1933, p., 19.2 × 29, ML

64. A reclining nude girl, bef. 1934, p., 15 × 19, p.c.

4. At the Table

65. Three figures at a table, ca. 1922, sepia, 16.6 × 22.5, NMW

66. Five figures around a table, ca. 1933, p., 14.2 × 16.5, ML

67. Two women and two men in hats at a table, ca. 1933, p., 14.5 × 19, ML

68. Two women and a man at a table, bef. 1935, p., b.c., 15 × 18, ML

69. A woman and two figures at a table, bef. 1933, p., 15.5 × 18.5, ML

70. Four figures at a table, bef. 1933, p., 14.5 × 17, ML

71. Two nude women and two old men at a table with an open book, ca. 1937, p., 16 × 20, ML

72. Two men and two women in hats at a table, 1935, p., 19.5 × 24, ML

73. Two nude women and a man at a table, bef. 1934, b.c., 15 × 20.8, ML

74. Two nude women and a man at a table. Under the table a figure on all fours and a dog, ca. 1933, p., b.c., 15.5 × 20, ML

75. A man seated between two nude women at a table, 1935, p., 21.7 × 26.5, ML

76. Two nude women and a man at a round table, ca. 1933, p., 20.8 × 22, p.c.

77. Two nude women and a man at a round table (variant of cat. no. 76), p., 21 × 22, p.c.

78. Jakub, Joseph, and a guest (portrait of the artist's father, self-portrait, and portrait of Emanuel Pilpel),ca. 1934, p., 15 × 17.5, p.c.

5. Jews

79. Jews at a well, sketch, ca. 1930, p., 15 × 18, ML

80. Jews at a table and a well, sketch, ca. 1930, p., 15 × 18, ML

81. At Jacob's well, bef. 1934, p., 12.8 × 13.8, ML

82. A crowd of Jews at a well, bef. 1936, t.p, ink, 13.6 × 19.5, ML

83. Jews in a town against a mirage of the Temple, ca. 1932, p., 15.5 × 17.5, p.c.

84. Jews against a Jerusalem landscape, bef. 1936, t.p., ink, 16 × 24, ML

85. Praying old man, bef. 1934, p., 15 × 20, ML

86. A Jewish street, bef. 1934, p., 16.6 × 20, ML

87. Old Jews and two boys in hats, bef. 1934, p., 14.5 × 19.5, ML

88. Four debating Jews, bef. 1934, p., 17 × 20.5, ML

89. Joyful Jews, bef. 1934, p., 16.8 × 19.5, ML

90. A prayer of thanksgiving at a well, bef. 1934, p., 21.2 × 29.7, ML

91. Three old men, bef. 1934, p., ink, 21.2 × 29.7, ML

92. A nude woman and two Jewish boys, ca. 1933, p., 19.5 × 28.5, ML

93. Jews at a table, 1938, p., 16 × 20, ML

94. Jews at a long table, bef. 1934, p., 22.5 × 25, ML

95. Jews at a long table, ca. 1932, p., 15.5 × 19.5, p.c.

6. Self-Portraits

96. Self-portrait with a condor and a group of old men, ca. 1930, p., 14.5 × 19, ML

97. Self-portrait at the easel, ca. 1920, b.c., ink, 52 × 37, GP (formerly in the collection of the artist's brother, Izydor Schulz)

98. Self-portrait with a procession, ca. 1920, b.c., ink, ca. 15 × 18, l.o., photocopy p.c.

99. Self-portrait with an easel, 1919, p., 43 × 29.5, JIH

100. Self-portrait and two portrait sketches, bef. 1933, p., 21 × 18, ML

101. Self-portrait, ca. 1930, p., 15.7 × 19.7, ML

102. Self-portrait, ca. 1933, p., 20 × 14.5, ML

103. Self-portrait, ca. 1935, p., 9.5 × 10.5, p.c.

104. Self-portrait and a study of a hand, ca. 1938, p., 20 × 14.5, ML

105. Self-portrait and a study of a hand, ca. 1933, p., 20 × 16, ML

106. Self-portrait and a study of a cat, bef. 1934, b.c., 18.8 × 14.3, ML

107. Self-portrait with a raised head, bef. 1934, b.c., 13.5 × 11, ML

108. Self-portrait, bef. 1934, b.c., 12 × 11, ML

109. Self-portrait, bef. 1936, b.c., 12 × 12, p.c.

110. Self-portrait, ca. 1935, p., 12 × 8, p.c.

111. Self-portrait, ca. 1933, p., b.c., 11.5 × 9.8, ML

112. Self-portrait, ca. 1935, p., 12.3 × 12.3, ML

7. Portraits

113. Portrait of the artist's mother, Henrietta Schulz, bef. 1931, p., 13 × 18.5, ML

114. Portrait of the artist's nephew Ludwik Hoffman, ca. 1934, p., ink, 16.8 × 12.8, ML

115. Portrait of the artist's friend Stanisław Weingarten, 1919, p., 42.5 × 29, p.c.

116. Portrait of Stanisław Weingarten, 1924, b.c., 27.3 × 30.3, ML

117. Portrait of the artist's friend Emanuel Pilpel, ca. 1934, p., 16.6 × 15.3, ML

118. Portrait of the artist's fiancée, Josephina Szelinska, ca. 1934, p., p.c.

119. Portrait of Maria Budratzka, 1919, p., ca. 50 × 38, p.c.

120. Portrait of Mścisław Mściwujewski, professor of Polish language and literature in the state gymnasium in Drohobycz, after 1932, p., 17.2 × 21.5, ML

121. Portrait of XY, ca. 1934, p., 15 × 20, ML

8. Book Covers

122. Project of a jacket for *Cinnamon Shops*, ca. 1932, ink, 19.6 × 16.3, ML

123. Project of a jacket for *Cinnamon Shops*, bef. 1933, p., ink, 19.5 × 16.5, ML

124. Project of a jacket for *Cinnamon Shops*, bef. 1933, p., ink, 19.5 × 16.5, ML

125. Project of a jacket for *Cinnamon Shops*, bef. 1933, p., ink, 19.5 × 16.5, ML

126. Project of a jacket for *Cinnamon Shops*, bef. 1933, p., ink, 19.5 × 16.5, ML

127. Project of a jacket headpiece for *Cinnamon Shops*, ca. 1932, ink, 13.2 × 13.2, p.c.

128. Jacket of *Cinnamon Shops*, 1934, printed from an ink drawing, 18 × 12.5, p.c.

129. Jacket of *Sanatorium under the Sign of the Hourglass*, 1937, printed from an ink drawing, 19 × 13, p.c.

9. Illustrations

130. Father in the Sanatorium, "Sanatorium under the Sign of the Hourglass," 1926, p., ink, 14.5 × 16.5, JIH

131. Joseph and Dr. Gotard, "Sanatorium under the Sign of the Hourglass," 1935, t.p., ink, 17.5 × 19, ML

132. Joseph and Dr. Gotard, sketch, "Sanatorium under the Sign of the Hourglass," bef. 1930, p., 14.5 × 15, p.c.

133. Joseph and the dog-man before metamorphosis, "Sanatorium under the Sign of the Hourglass," 1936, ink, 15 × 15.5, ML

134. Joseph and the dog-man during metamorphosis, sketch, "Sanatorium under the Sign of the Hourglass," bef. 1935, p., 15.5 × 13.5, ML

135. Joseph and a man turning into a dog, sketch, "Sanatorium under the Sign of the Hourglass," bef. 1935, p., 14.5 × 11, p.c.

136. Father, Joseph, and the terrorists, "Sanatorium under the Sign of the Hourglass," 1936, t.p., ink, 15 × 23.5, ML

137. Joseph on his way to the Sanatorium, sketch, "Sanatorium under the Sign of the Hourglass," bef. 1935, p., 13.5 × 13.5, p.c.

138. An automobile-telescope, "Sanatorium under the Sign of the Hourglass," 1936, t.p., ink, 14.5 × 18.5, ML

139. Father and Joseph, sketch, "Spring," bef. 1936, p., 14.5 × 17.7, p.c.

140. Assault of the figures from the exhibition, sketch, "Spring," ca. 1935, p., 16 × 20.2, ML

141. Wax figure exhibition, "Spring," ca. 1936, ink, ca. 16 × 20 (dedication: "To Dziunia Schmer with best wishes, 3 May 1938, Bruno Schulz"), l.o., photocopy p.c.

142. Joseph, Rudolph, and others, sketch, "Spring," ca. 1936, p., ink, 16.5 × 20.5, ML

143. Bianca with her nurse and two boys, sketch, "Spring," ca. 1936, p., ink, 15.8 × 20.3, ML

144. Bianca with her nurse and two boys, sketch, "Spring," ca. 1936, p., ink, 16 × 20.3, ML

145. Bianca with her nurse, Joseph, and Rudolph, "Spring," ca. 1936, 16 × 20 (dedication to the artist's niece, Ella Schulz: "To dearest Elżunia on her birthday, 5 June 1937"), p.c.

146. Bianca with her father in a cab, "Spring," ca. 1936, t.p, ink, 15.5 × 19.8, ML

147. Bianca with her father in a cab, sketch, "Spring," bef. 1936, p., b.c., 15.5 × 20, ML

148. Bianca with her father in a coach, "Spring," bef. 1936, ink, 16.4 × 20, p.c.

149. Bianca with her father in a carriage, sketch, "Spring," bef. 1936, p., 13.3 × 19.5, p.c.

150. Bianca, her father, and a driver in a top hat riding in a carriage, sketch, "Spring," p., 12.5 × 19.5 (dedication: "18 January 1938. To Dear Zenon Waśniewski, Bruno Schulz"), p.c.

151. Three girls in a carriage without a driver, sketch, variant of a drawing in "Sanatorium under the Sign of the Hourglass," bef. 1936, p., 14.8 × 18.7, p.c.

152. Two naked women in a cab, sketch, variant of a drawing in "Sanatorium under the Sign of the Hourglass," ca. 1936, p., 14.5 × 19.5, ML

153. A girl in a carriage with a driver, sketch, variant of a drawing in "Sanatorium under the Sign of the Hourglass," ca. 1936, p., 15 × 19, ML

154. Two naked women in a two-horse cab, variant of a drawing in "Sanatorium under the Sign of the Hourglass," ca. 1936, b.c., 16.5 × 20, ML

155. Two naked girls in a carriage with a driver in a top hat, variant of a drawing in "Sanatorium under the Sign of the Hourglass," bef. 1936, b.c., 16.3 × 20, ML

156. Two naked girls in a carriage, drawing in the book *Sanatorium under the Sign of the Hourglass* (1937), ca. 1936, t.p., ink, 17 × 26, ML

157. *Twilight*, "The Book," bef. 1935, b.c., l.o., photocopy p.c.

158. On the porch—a sleeping old man and a woman with boys, sketch, "The Book," bef. 1935, p., 21.2 × 17.5, ML

159. Organ-grinder in the yard, "The Book," 1936, ink, 16 × 19, ML

160. Organ-grinder, sketch, "The Book," bef. 1935, p., 19.5 × 15.5, ML

161. Organ-grinder among people in the yard, "The Book," 1936, ink, 16.2 × 19.9, JIH

162. At the table, sketch, "Dodo," bef. 1934, p., 13.5 × 19.5, ML

163. Three figures at the table, "Dodo," bef. 1934, b.c., 16.5 × 20.5, ML

164. Eddie, sketch, "Eddie," ca. 1934, p., 14.4 × 13.3, ML

165. Father floating over the lamp, sketch, "Eddie," ca. 1934, p., b.c, 14.5 × 11.8, l.o., photocopy p.c.

166. Sleeping Adela and Eddie, "Eddie," ca. 1934, p., l.o., photocopy p.c.

167. A retired man and boys, "The Old Age Pensioner," ca. 1936, t.p., ink, 12.8 × 16.8, ML

168. A man swept away by the wind, sketch, "The Old Age Pensioner," ca. 1935, 13.8 × 13.8 (dedication to an actress, Kazimiera Rychter, dated 24 March 1936), ML

169. Father and merchants, sketch, "The Night of the Great Season," bef. 1936, p., 16.3 × 18.2, p.c.

170. A group of naked figures, drawing in *Sanatorium under the Sign of the Hourglass*, 1937, t.p., ink, 16.5 × 23, ML

171. Seven naked figures at a table, drawing in *Sanatorium under the Sign of the Hourglass* (1937), ca. 1936, ink, 8.3 × 12.5, p.c.

172. Six naked figures at the table, sketch of a drawing in *Sanatorium under the Sign of the Hourglass*, 1937, p., 13.5 × 18.5, p.c.

173. A man with a cane and a woman with a dog in the street, sketch of a drawing in *Sanatorium under the Sign of the Hourglass* (1937), ca. 1935, p., 20.3 × 16, ML

174. Two women and a dwarf in the street, sketch of a drawing in *Sanatorium under the Sign of the Hourglass*, 1937, p., 15.5 × 20, ML

10. Varia

175. The artist, the sponsor (self-portrait and portrait of Stanisław Weingarten), and models, 1921, b.c., ink, 33.4 × 27, JIH

176. A young Jew and two women on the stairs, ca. 1922, oil on canvas, l.o., photocopy p.c.

177. Two women and two men (self-portrait and portrait of Stanisław Weingarten) on city steps, 1920s, ink, 12 × 16, GP

178. Project of *ex libris* for Stanisław Weingarten, ca. 1920, b.c, ink, 28.5 × 17.5, p.c.

179. *Ex libris* for Stanisław Weingarten, after 1920, offset, signed, 11 × 7.5, p.c.

180. Project sketch of *ex libris* for niece and nephew, Ella and Jakub Schulz, ca. 1930, p., 13 × 8, p.c.

181. Two men and a book, ca. 1933, ink, 19.8 × 12.5, p.c.

182. King, queen, and the sleeping court, bef. 1936, p., 10.5 × 18.5, ML

183. A boy in a cape on horseback, bef. 1934, p., 15 × 18, ML

184. Sketch of a group of women at the fireplace and the dog-man, ca. 1933, p., 20.7 × 22.8, p.c.

185. A condor and old men, ca. 1930, p., 14.5 × 19, ML

186. A fantastic-masochistic scene in Drohobycz, ca. 1930, p., 15.5 × 17.5, p.c.

187. Women on a sofa among fantastic creatures and a dog-man, sketch of a drawing in *Sanatorium under the Sign of the Hourglass* (1937), ca. 1935, 14.7 × 17.3, ML

188. Circus merry-go-round, bef. 1933, p., 15.6 × 19.6, p.c.

189. Scene in a tailor's shop, bef. 1930, p., 25.4 × 32.6, p.c.

190. A woman in a boudoir surrounded by idolaters, ca. 1930, p., 15 × 14.5, p.c.

191. A girl and two harlequins, ca. 1933, p., 16 × 14.7, ML

192. A girl and a boy, ca. 1933, p., 19.5 × 28.5, ML

193. A woman and an old man, bef. 1930, b.c., 21 × 17, ML

194. A man and a woman with a dog, ca. 1932, p., 20.5 × 16.5, ML

195. Two women and two men in the street, bef. 1933, b.c., 15.8 × 20.3, ML

196. Two girls walking with a dog, and an old man, ca. 1932, b.c., 15.7 × 19.7, ML

197. A woman and two men on street steps, ca. 1933, p., 20 × 16, ML

198. Reclining woman and a cherub holding a mirror at her feet, bef. 1930, b.c., 17.5 × 27, ML

199. A woman and two men against a geometric city landscape, ca. 1933, p., 23.5 × 18, ML

200. A two-horse carriage driving through the city, geometric drawing, bef. 1932, p., 19.3 × 17.4, ML